P9-CJL-564

Tibet

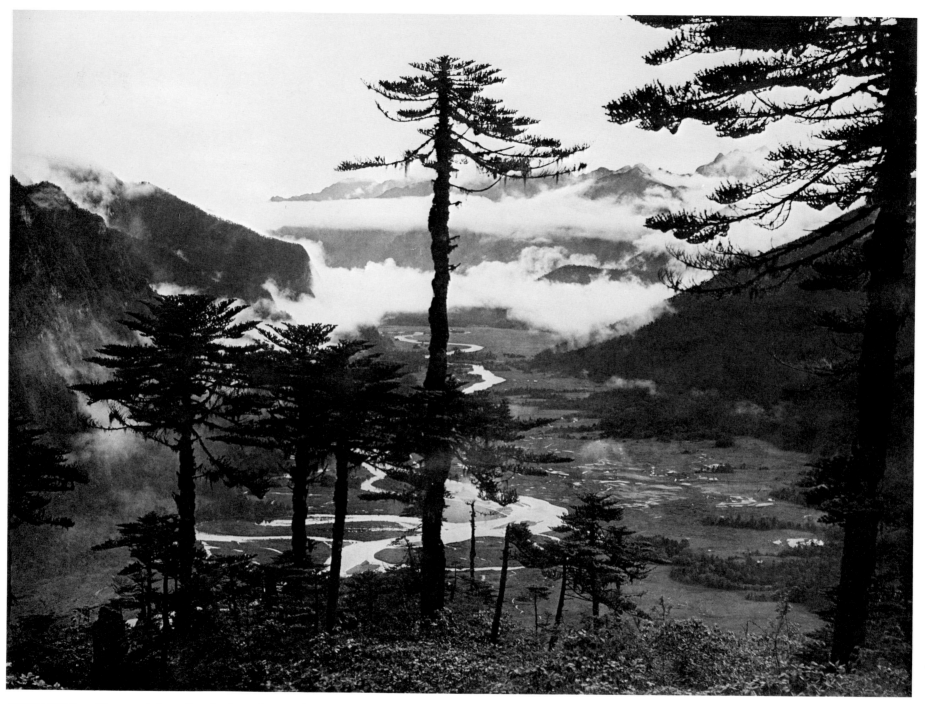

GEORGE SHERRIFF View north from Tum La down the Nagchu, 1938

Tibet *The Sacred Realm*

PHOTOGRAPHS 1880-1950

Preface by Tenzin Gyatsho, His Holiness the Dalai Lama

Chronicle by Lobsang P. Lhalungpa

Photographs from the archives of the
Academy of Natural Sciences, Philadelphia;
Alexandra David-Néel Foundation; The American
Museum of Natural History; Archives Nationales; Bibliothèque
Nationale; India Office Library; Musée de l'Homme; National Army
Museum; Newark Museum; Philadelphia Museum of Art; Rose Art Museum,
Brandeis University; Royal Botanic Garden (Edinburgh); Royal Geographical
Society; Saint-Louis Foundation; Société de Géographie; Sven Hedin
Foundation, Ethnographical Museum of Sweden; and from
Anthony Aris; Joan Mary Jehu; The P. W. Laden-La Collection;
Howard and Jane Ricketts Collection; The Saland
Family Collection; The Right Honorable The
Viscount Scarsdale; Faith Spencer-Chapman;
Sir George Taylor

AN APERTURE BOOK

Copyright © 1983 Aperture, Inc.;
Library of Congress Card Catalogue No. 82–72809;
ISBN 0–89381–109–2, cloth; ISBN 0–89381–121–1, paper;
ISBN 0–89381–120–3, museum catalogue edition

Staff for *Tibet: The Sacred Realm, 1880–1950*:
Editor-Publisher, Michael E. Hoffman; Associate Editor, Carole Kismaric;
Project Editor, Lauren Shakely; Copy Editor, Eleanore W. Karsten;
Production Manager, Charles Gershwin; Designer, Wendy Byrne;
Editorial Assistant, Scott Rucker.

All rights reserved under International and Pan-American Copyright
Conventions. Published by Aperture, Inc., in association with the
Philadelphia Museum of Art. Distributed in the United States by
Viking Penguin, Inc.; in the United Kingdom and other world markets
by Phaidon Press Limited, Oxford; in Canada by Van Nostrand Reinhold,
Ltd., Scarborough; and in Italy by Idea Books, Milan.

Aperture, Inc., publishes a periodical, portfolios, and books
to communicate with serious photographers and creative people
everywhere. A complete catalogue is available on request.

Manufactured in the United States of America.
Composition by David E. Seham Associates. Halftone negatives
by Michael Becotte. Printed by Murray Printing Company,
Westford, Massachusetts. Bound by Publishers Book Bindery,
Long Island City, New York.

"Tibet: The Sacred Realm, 1880–1950" is an exhibition presented
by the Alfred Stieglitz Center at the

PHILADELPHIA MUSEUM OF ART, March 20–May 22

The exhibition was directed by Michael E. Hoffman and coordinated
by Martha Chahroudi. The exhibition will travel to the

INSTITUTE FOR THE ARTS, RICH UNIVERSITY,
Houston, September 23–December 31, 1983

ASIA SOCIETY, New York, March 1–May 27, 1984

PREFACE

Science and technology have made our world smaller. Unlike earlier

ༀ་་་་་་་་་་་་་་་་་་་་་་

times, what happens in one part of the world today affects the rest.

ༀ་་་་་་་་་་་་་་་་་་་

Therefore, it seems important to have a better understanding of the

ༀ་་་་་་་་་་་་་

varied cultures, faiths, traditions, and races and to foster closer rela-

ༀ་་་་་་་་་་་་་

tions among people of differing backgrounds.

ༀ་་་་་་་་་་་་

To this end Michael Hoffman, an American, has taken the initiative

ༀ་་་་་་་་་་་་་

in collecting and arranging this exhibition and publication of old

ༀ་་་་་་་་་་་་

photographs concerning Tibet and the Tibetan people. Lobsang P. Lha-

ༀ་་་་་་་་་་་

lungpa has prepared a chronicle to accompany the photographs. I

ༀ་་་་་་་་་་་

hope readers will gain a general understanding of the conditions and

ༀ་་་་་་་་་་་

life of the Tibetan people and their traditional customs and culture.

ༀ་་་་་་་་་་

While one may find an inkling of it in the photographs and their

ༀ་་་་་་་་་་

captions, the Doctrine of the Buddha was actually very influential in

ༀ་་་་་་་་་་

the lives of the Tibetan people. For example, except among the migra-

ༀ་་་་་་་་་་

tory nomads of northern Tibet, who had no permanent settlements

ༀ་་་་་་་་་་

but lived in tents, monasteries were found throughout the country.

ༀ་་་་་་་་

The study of Buddhism was primarily the concern of the monks

ༀ་་་་་་་་་

living in the monasteries. There was no such strong tradition of study

ༀ་་་་་་་

among the lay people, but because of their strong faith and devotion

ༀ་་་་་་་

to the Doctrine, representations of the Buddha's body, speech, and

ༀ་་་་་་་་

mind could be found on the altar of every home, before which the

ༀ་་་་་་་

family would offer butter lamps and pray daily.

ༀ་་་་་་་

Following the most tragic event of 1959, more than 100,000 Tibet-

ༀ་་་་་་་

ans managed to flee into exile and have come into contact with differ-

ༀ་་་་་་་

ent people. A number of interested persons have told me that they

ༀ་་་་་་

learned from their observations that Tibetans have a unique character

ༀ་་་་་་

and way of life. They find Tibetans cheerful, respectful of others, con-

ༀ་་་་་་

tented, honest, and able to accept hardship easily. This is unquestiona-

ༀ་་་་་་

bly the effect of the Buddha's Doctrine rather than a feature unique to

ༀ་་་་་་

Tibetans. It is unnecessary to discuss here whether the Buddha's teaching is beneficial for future lives, but, for the fact that it is beneficial in this very life, we are striving to preserve and promote the Doctrine.

In Tibet, the Chinese have endeavored for nearly three decades to eradicate the Buddha's Doctrine, seeing no benefits but only faults in it. Yet, because of strengthening faith among Tibetans, some measure of religious freedom has recently been granted.

Of the many exclusive traditions maintained in Tibet, the practice of medicine is considered one of the most important, and medical practitioners have treated Tibetan people over the centuries according to this tradition. In this twentieth century, rapid scientific and technological developments in medical diagnosis and treatment have been of extensive benefit to society. Nevertheless, there remain a number of ailments that cannot be treated by these modern methods but have been successfully cured by Tibetan medicine. Consequently, the number of people turning to Tibetan medicine is increasing. Even the Chinese Communists, who have persistently denigrated and attacked the Buddha's Doctrine as well as Tibetan culture and traditions, have been compelled to recognize its value and are fostering its practice and exporting its medicinal pills to China.

One aspect of suffering that all beings wish to avoid is the variety of sicknesses which arise from an imbalance of the constituent elements of the body. With this in mind we are making every effort to improve the practice of Tibetan medicine in order to contribute toward the well-being of suffering millions in the world.

I would like to thank all those by whose effort these photographs have been arranged and express my good wishes to all who view them.

Tenzin Gyatsho, His Holiness the Dalai Lama, December 24, 1982

In the beginning the great god Cha, The All-Knowing One, created the universe out of the five elements. He created the heaven with its thirteen ascending layers and the earth with its thirteen descending layers. Inside the domes of heaven and earth there emerged light and darkness, representing positive and negative principles. From the interaction between the two emerged golden and turquoise flowers. *From the union of the two was born a son, The Immaculate Lord of the Universe, and a daughter, The Excellent Life. These were the heavenly ancestors of the gods who were believed to be the protectors of the four continents and also of the first king, Nyatre Tsanpo, the protector of the "Land of the Snowy Mountains."*

Ancient Bon myth of creation

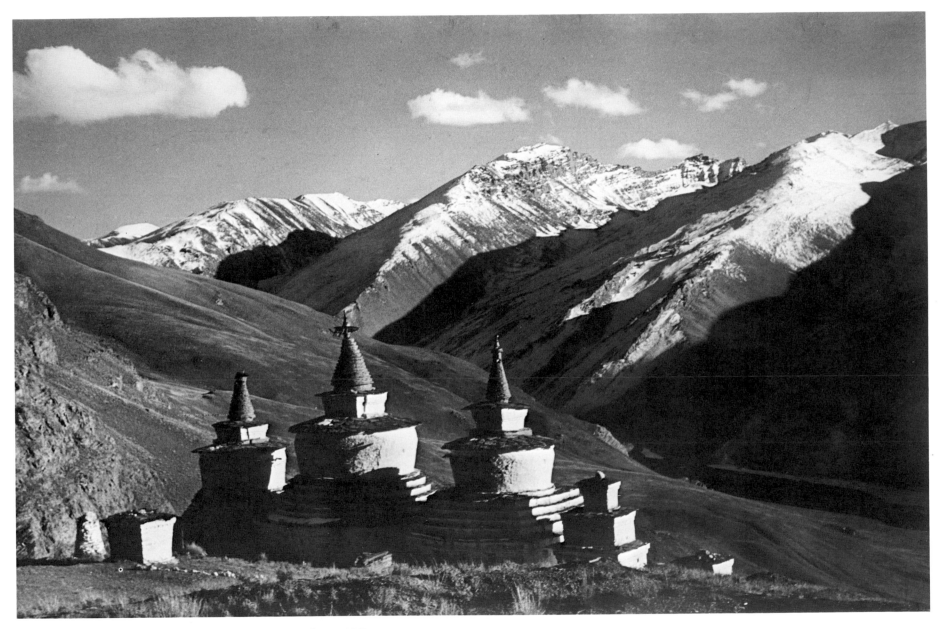

ILYA TOLSTOY Chortens *(stupa)* at Siling monastery, November 1, 1942

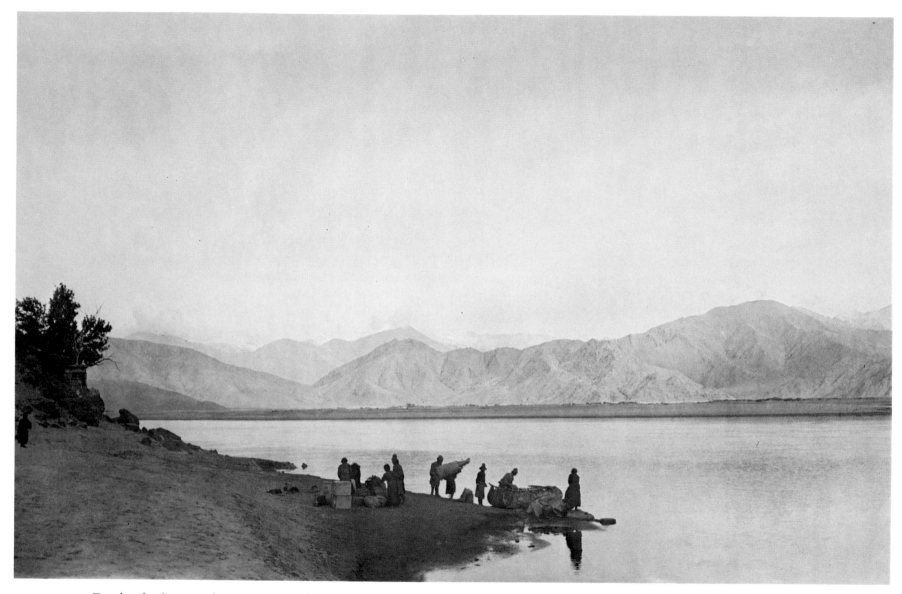

GEORGE TAYLOR Travelers loading coracles at Kongka, for ferrying across the Tsangchu, 1938

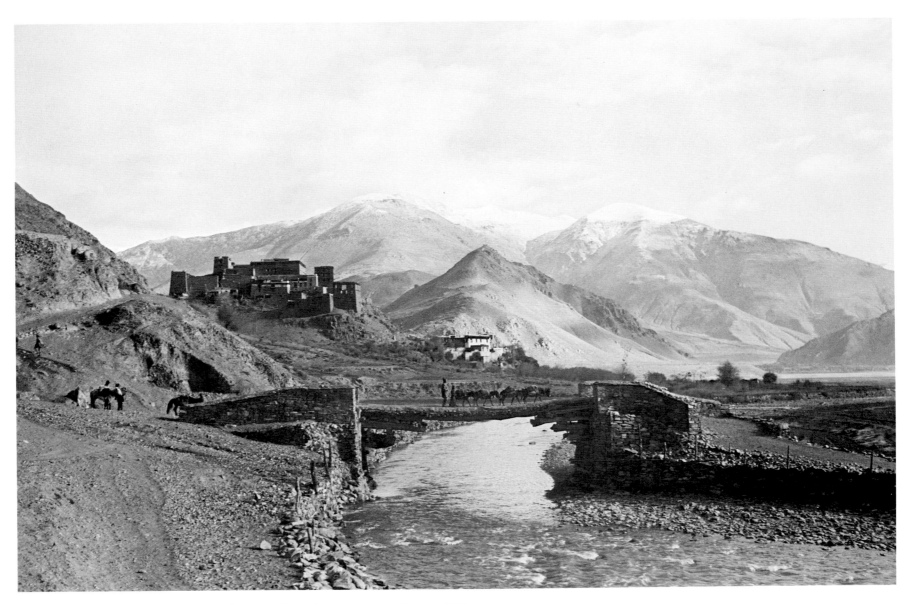

GEORGE TAYLOR Cantilever bridge over tributary of Tsangchu River at Rong Dzong, 1938

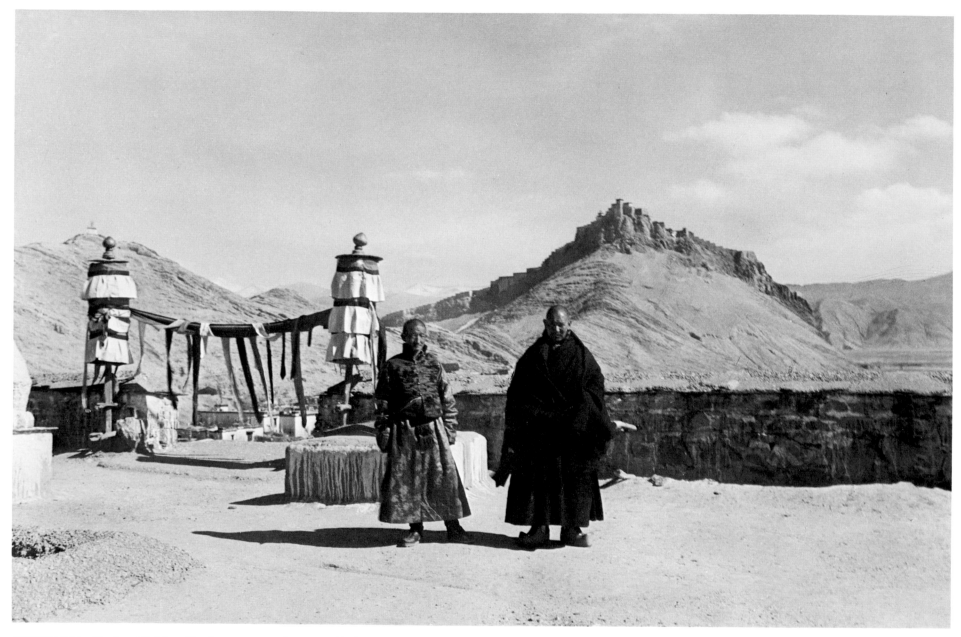

GEORGE TAYLOR Monks at Palkhor Chode monastery, Gyantse, with Gyantse Dzong in background, 1938

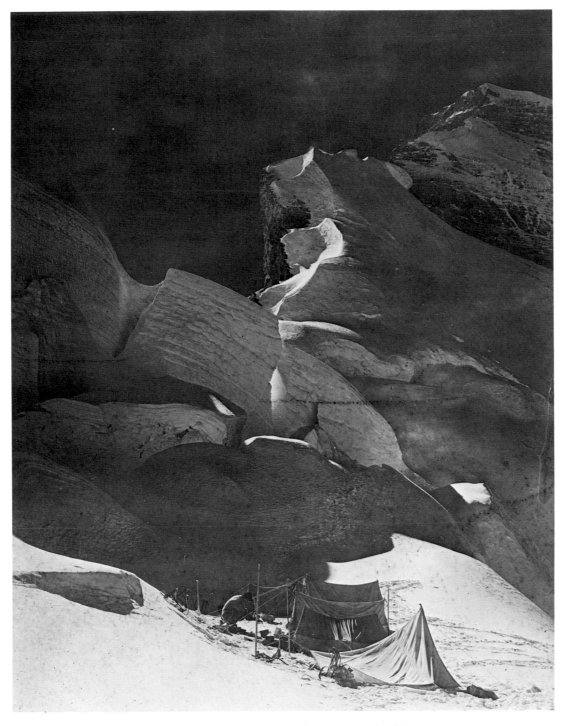

JOHN NOEL North Col camp, north peak, Mount Everest (Jomo Langmo), 1922

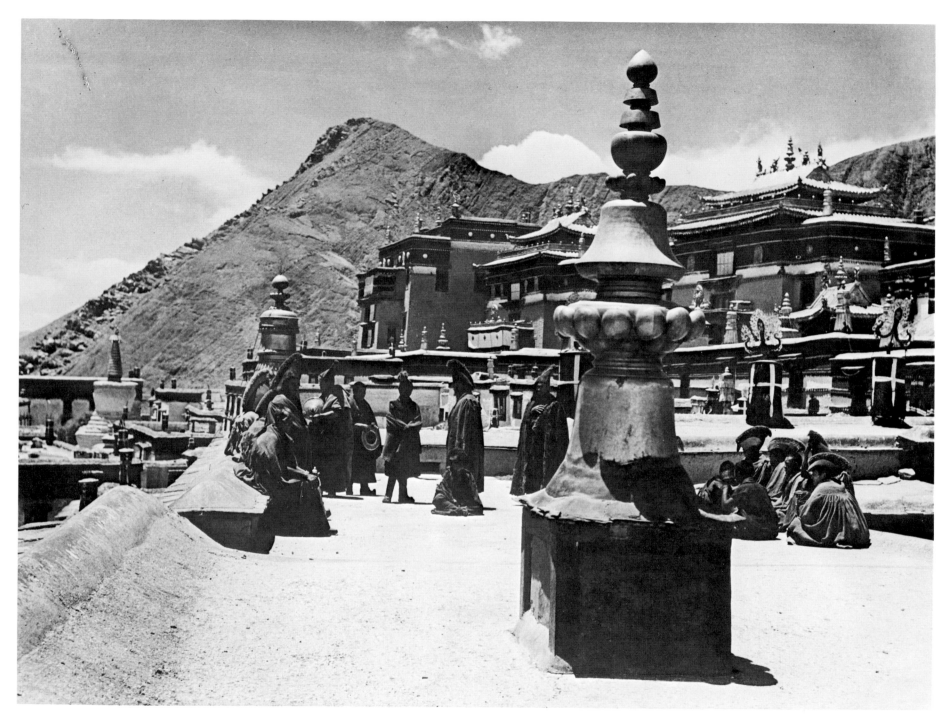

HEINRICH HARRER Monks at Tashilhunpo monastery, 1949–50

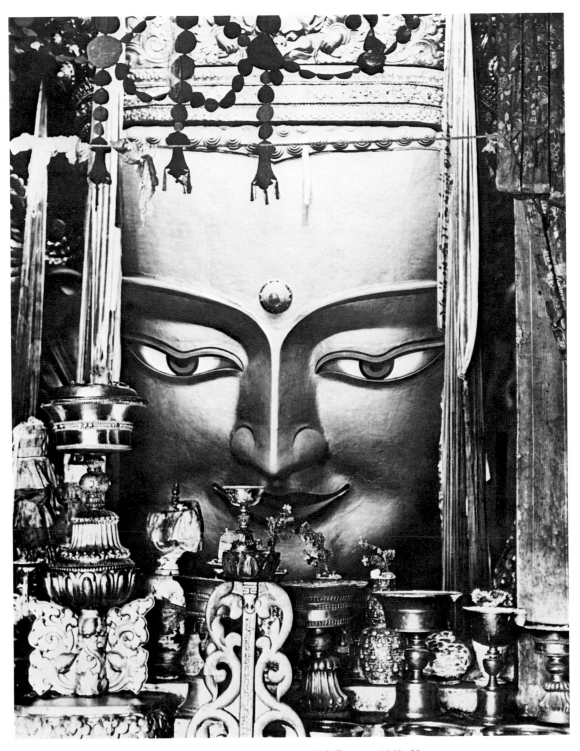

HEINRICH HARRER Maitreya, the Buddha to Come, statue at Tashilhunpo, 1949–50

15

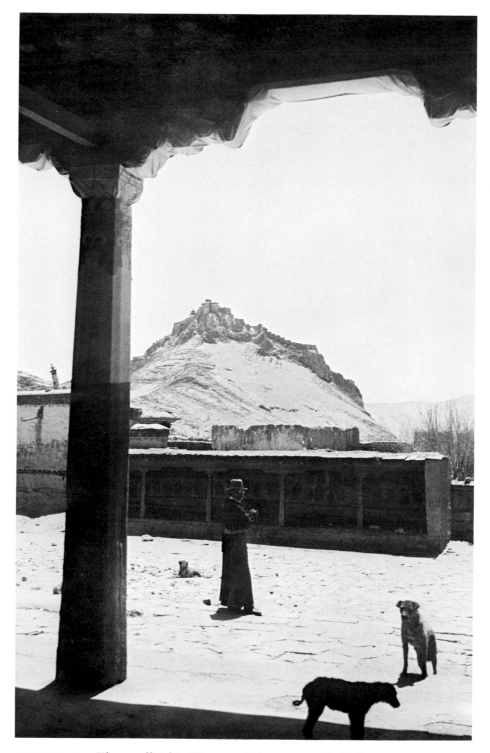

GEORGE TAYLOR Tibetan official in Western-style hat, courtyard of Palkhor Chode
monastery, Gyantse, with Gyantse Dzong in background, 1938

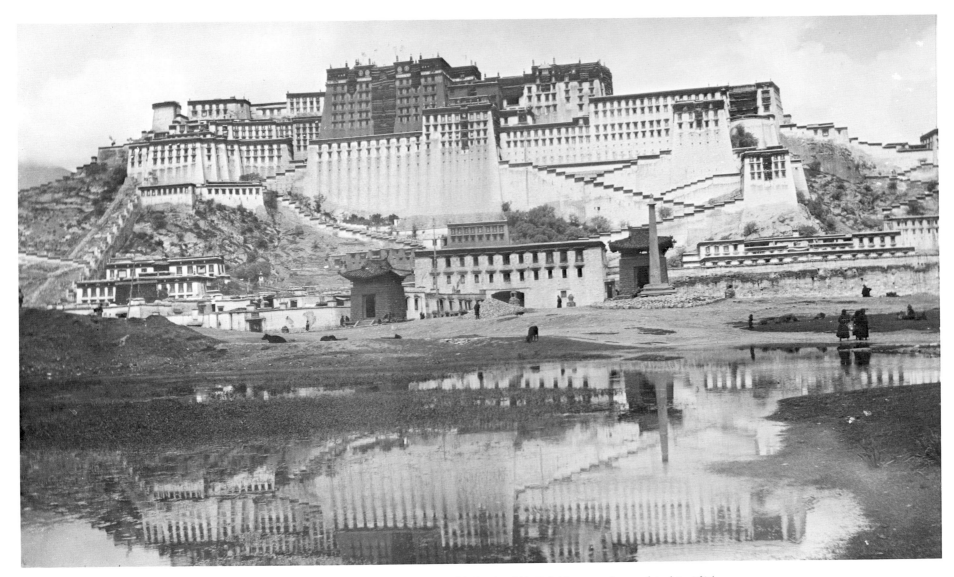

LESLIE WEIR Potala Palace from the south, about 1930. The Potala was started about 1645 by the fifth Dalai Lama and completed in 1694.

TIBET WAS MY COUNTRY, the holy city of Lhasa my home. For twenty-three years I lived there, happy and secure in the traditions of our ancient Buddhist culture. I had been posted in India in 1950 when the Chinese invaded Tibet, and since then, like 100,000 other Tibetans who became exiles, I have not returned to live in my native land. Today Tibetan refugees are scattered—from India and the Himalayan countries to Europe, from North America to Australia. Although they have successfully adapted to their new environments and have—out of necessity—assimilated into other societies, most still retain a deep longing for the cool, dry highlands of Tibet and nostalgia for traditional Buddhist culture, for the tightly knit, warm communal life, for the innocent gaiety, the music, the festivals, the rituals, and the harmonious lifestyle of a twelve-centuries-old society. Thirty-five years after my departure from Tibet and three years after the doors to my country have again hesitantly been opened, I look back and compare, remember, and analyze. The old Tibet will never be revived. Having lived in India and North America for several decades, I see more clearly than ever how very special our old way of life really was.

From my birth in 1924 until the age of twenty-three I was educated in the traditional Tibetan way, first by my father, then by tutors, both laymen and lamas. During those years I underwent a combination of secular and religious training, and became deeply engrossed in advanced religious studies. When I was sixteen, my studies were briefly interrupted when I became a monk official in the Dalai Lama's government.

To function in both a secular and religious role was not unusual in Tibet. Since the seventh century A.D., when King Songtsan Gampo introduced Buddhist religion and arts, the history of Tibet has been mainly a Buddhist history. Buddhist traditions and culture, inextricably synthesized with the ancient animistic faith of Bon and the special Tibetan way of life, made Tibet a uniquely spiritual country. Before the Chinese take-over in the 1950s Tibet had several thousand monasteries and nunneries, and any boy could become a novice monk at the age of seven, a girl a nun at the age of ten. When I left Tibet in 1947, several hundred thousand Tibetans were monks. Half the officials in the central Tibetan government were monks from leading monasteries, working with their counterparts, aristocratic lay officials.

TWELVE CENTURIES OF TIBETAN HISTORY A kingdom that proudly traced its origins to the second century B.C., Tibet became a great military power in the seventh century. At about the same time, Buddhism began to emerge under Songtsan Gampo as a vital force in the life of the people and the affairs of the nation. By the ninth century, however, as a result of a royal feud over succession, Tibet had become a land of many self-governing principalities, each struggling for supremacy or survival. In 1207 Tibetans yielded to the increasing power of Genghis Khan. This event marked the beginning of a long and close relationship between the Mongols and the Tibetans. Genghis Khan's successor, Kublai Khan, converted to Tibetan Buddhism in 1270, and the Mongols embraced the faith with great enthusiasm. During this period Tibet showed an ever-increasing fervor for

Buddhism and for learning. Tibetan intellectuals journeyed to India and Nepal, monasteries and libraries were established throughout Tibet, and the influence of monks and eminent lamas increased. In 1578 the leader of the Tumat Mongol tribe, Altan Khan, conferred the title Dalai Lama upon the third grand lama of the Drepung monastery. The fifth Dalai Lama assumed political control of Tibet in 1642, and the Dalai Lamas exercised temporal and spiritual power until 1959.

From the late seventeenth to the early twentieth century Tibet underwent several agonizing periods of upheaval. The ninth through the twelfth Dalai Lamas died at an early age under mysterious circumstances, leaving control of the state in the hands of regents, some of whom were ambitious but incompetent. As the Manchus—like the Mongolians before them—ousted the Chinese Ming dynasty in the seventeenth century, the first Manchu emperor, Shun-chih, invited the fifth Dalai Lama to Peking and honored him in 1652. The relation between the two rulers was officially hailed as the bond between a religious teacher and a lay patron. The Manchu emperors, however, actually sought to gain—and did gain, to a limited extent—political control over Tibet and Mongolia through patronage and military power.

The Manchus were not the only foreign invaders. Tibet faced other incursions from Kashmir and Nepal on the western frontier. British colonial forces steadily encroached on Tibet's border with Indian territories, culminating in the military expedition of 1903–04 led by Colonel Francis Younghusband. Supposedly a mission intended to establish trade relations with Lhasa, the British move was largely inspired by British mistrust of relations between Tibet and Russia, specifically a fear of Russian influence on the northern border of British India. The outcome was that Tibet was forced to sign a treaty giving the British extraterritorial rights within Tibet and establishing trade. This colonial heavy-handedness in turn aroused suspicions in the Manchu regime, leading to the invasion of eastern Tibet in 1906 and Lhasa in 1910 by Chinese troops. The thirteenth Dalai Lama fled to India, but the British did not help Tibet to drive back the Chinese. Tibet expelled the Chinese in 1912, by which time China itself was in chaos: the Nationalist Party, the Kuomintang, was emerging as the dominant force after the Chinese civil war that followed the overthrow of the last Manchu ruler. The British organized a tripartite conference at Simla attended by Tibetan, Chinese, and British representatives, at which they proposed to divide Tibet into an Inner Tibet and an Outer Tibet: the border regions in the north and east were to be under Chinese control, the remaining Tibetan territory under the authority of the Dalai Lama. A dispute over the exact demarcation of these territories brought the conference to an end. Since the Chinese refused to sign the tripartite treaty, the British and Tibetans signed, canceling the provisions favorable to China.

Throughout this history the tradition of the Dalai Lama dominated Tibetan affairs. As the incarnation of the Bodhisattva Avalokitesvara, the Buddha of Compassion, the Dalai Lama is not selected, but reappears in the person of his successor, found in a nationwide search conducted by the high lamas. The saddest event of my childhood was the passing away into the Pure Realm of the thirteenth Dalai Lama in 1933. The last decades of his reign had brought Tibet unparalleled stability,

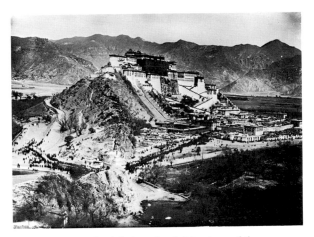

Alexandra David-Néel described this view of the Potala Palace, which she photographed in 1924, as an "immense tapestry . . . spread out before my feet . . . a white, red, and gold mosaic, of which sables and the thin azure ribbon of the Kyichu form the distant border."

described by His Holiness in his national testimony: "Ever since I returned from [exile in] India to our sacred land of Bö, we Tibetans, high and low, have enjoyed a golden age marked by undisturbed peace, freedom, and well-being." His Holiness's passing impressed all Tibetans as a catastrophe that would shake the foundation of our nation. Everyone was overcome with immense grief and the fear of an uncertain future. I saw the anguish in my father's face when he prayed day after day to the Three Precious Jewels for an early reincarnation of the departed lama. To the people of Tibet the Dalai Lama was more than the sovereign ruler; he was the supreme teacher and the cohesive power that held our nation together.

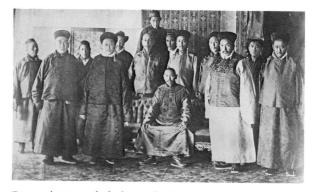

Dressed in travel clothing, the thirteenth Dalai Lama, Thubten Gyatsho, poses about 1910, during his exile in India, flanked by a staff of high officials. (Photographer unknown)

A NEW DALAI LAMA ✿ To find the new Dalai Lama the government consulted high lamas and the chief state oracle for prophetic guidance, and even sought—with the help of the regent—direction through visions in the Sacred Lake, Lamoi Latsho. Finally, when they had located a likely candidate in the person of a three- or four-year-old boy, they examined the child, testing him with questions, and his ability to distinguish between the Dalai Lama's personal effects and artful copies of them. Several years later, in 1939, followed the happiest event of my youth, when it became known that the reincarnation of the Dalai Lama had been found in eastern Tibet. To all Tibetans it seemed then that the sun of happiness would once again shine on our country. Together with my family I joined in celebrations and rejoicing, especially when the small fourteenth Dalai Lama, his parents, relatives, and the official entourage arrived in Lhasa from faraway Amdo province in northeastern Tibet. Each stage of his journey was marked by a ceremonial reception until the group at last arrived in a grand procession to the Plain of Fulfillment, Dhoguthang, some five miles east of Lhasa, where hundreds of tents had been set up in preparation. The Dalai Lama's regent, the high officials, and the entire government moved to the tent city. Abbots of the various monasteries, regional representatives of the people, and foreign dignitaries assembled at the tent hall known as the Great Peacock. At the head of the procession were monk musicians, each group led by colorful banners, and secular troupes performing dances. A large contingent of foot soldiers from the Tibetan army—which had about 15,000 troops in all—flanked the route as a guard of honor. Representatives of British India, the Chinese government, Nepal, Inner Mongolia, Bhutan, Sikkim, and Ladakh joined the officials in welcoming the Dalai Lama, each bearing a *khata,* the white silk scarf that Tibetans offer as a symbol of respect. On the third day of celebration the party moved to Norbu Lingka, or Jewel Palace, the Dalai Lama's summer residence. Official ceremonies continued for several months, as the new Dalai Lama's tutors performed religious ceremonies and initiation rites.

MY FATHER 🐚 Besides these special moments, my strongest personal memories of Tibet are those of my religious training. At an early age I perceived that religious endeavors were the most significant pursuits in life. This feeling was largely the upbringing given me by my father, an unusually studious and learned man, who continued the family tradition of eclectic religious pursuits.

As a young boy my father had entered the Drepung monastery of the Gelukpa order, the "Yellow Hat" order, to which the Dalai Lama traditionally belongs. When he was about seventeen years old, the Dalai Lama recognized and installed him as the chief state oracle. As such he had to leave Drepung and move to the oracle's own monastery of Nechung, just down the hill. For the next several years he carried out his duties making prophesies for the government and the country. An important figure in the old government of Tibet, the chief state oracle—indeed, all oracles in Tibet—had to be spiritually pure in order to contact good rather than evil forces.

The ritual of consultation with the oracle was quite elaborate. Sitting on his throne in the great assembly hall of Nechung, the oracle slowly went into a trance to the sounds of the deep chants and invocations by the Nechung monks. Within a short time his eyes closed partially while his mouth opened wide and his tongue curled upwards. He then made eerie hissing sounds. Only when he was deep in his trance could he support his formal headdress, which was so heavy it took two men to lift it onto his head. He then rose, raised the ceremonial sword, and danced slowly around the room, finally prostrating himself three times before the image of the great tantra mystic Padmasambhava and the Dalai Lama. He then received the cabinet members and other officials who came to seek his counsel. One by one they approached for his blessing, while he heard a list of questions read by a high official who stood nearby. The oracle whispered the answers to his monk-secretary, who wrote them on wooden slates. The questions, compiled by the Dalai Lama and his cabinet, were designed to help establish policy, usually for the coming year: Will there be any foreign invasions from neighboring countries this year? If so, what can we do to prevent them? How will the crop be? And so on. The answers were later transferred into the formal government records.

Such trances are physically painful and a heavy psychological burden as well. I am sure my father felt the weight of his responsibility, especially knowing that his predecessor had been dismissed for false prophesies. In the end, circumstances allowed my father after several years of duty to leave his post and retire for some time to our ancestral home of Lhalung. He went into retreat to consider his future. Eventually, he decided that the strain and responsibility were more than he could bear and that he would rather lead an ordinary life. In 1921, he quietly married a young woman from Lhasa and resigned his position.

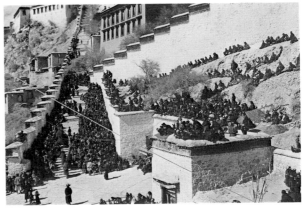

People congregate in the afternoon by the steps of the Potala to watch a gymnastic performance during the Monlam (New Year's) festival. For anyone in government service, going to work each day meant a very long climb up the steps. (Frederick Spencer-Chapman)

FAMILY LIFE Like many upper-class families in Tibet, the Lhalungpas had a townhouse in Lhasa as well as a family estate in the country. It was at the townhouse, near the central Jokhang Temple, that my parents chose to live. The house was a modest two-story structure of stone built around a square courtyard of slate tiles. On its ground floor were the stables, the servant's quarters, and a utility room; on the second floor, the living quarters, the kitchen, and—the most important part of a Tibetan house—the shrine room. We children slept on separate cushions on the floor of our rooms. Prayer flags in different colors were raised on long poles at four corners of the enclosure on the flat rooftop, and just beyond the front gates were two high platforms of two steps each

for mounting horses. In those days only the Dalai Lama owned automobiles, which he used on the paved five-mile road from Norbu Lingka, the Summer Palace, to the Jokhang in Lhasa and the Potala Palace (the Dalai Lama's principal residence). As a child I once saw him in his yellow car on the streets of Lhasa, a strange sight, his driver honking to clear a path among horses and pedestrians.

After his resignation from the position of chief oracle, my father remained in private life, advising relatives and friends on family and legal matters, pursuing his studies in Buddhist practice, and at the request of the Dalai Lama, managing a relative's estate.

When I was five or six years old my happy existence was clouded by the death of my mother during childbirth. My father remarried shortly thereafter; our stepmother had been a nursemaid in our house, and times were often difficult for our family, which eventually included my brother, two sisters, and me, and our three half brothers and five half sisters.

In old Tibet when a child was born, Tibetan parents traditionally consulted astrologers, oracles, or high lamas for guidance concerning education and career. For my elder brother, Jampa, and myself my father asked the well-known mystic astrologer Dorzinpa from the sacred mountain Tsari in the south to draw up our horoscopes. My horoscope indicated that I would become a monk, would travel abroad during the prime of my life, and would eventually live in exile. My father still had ties with the Dalai Lama, so he turned to him for further, decisive direction in determining our futures. In written instructions, bearing his private red seal and accompanied by a gift of sacred statues, the Dalai Lama advised my father that both of his sons should become monks. Part of his letter read: "After sound education both sons should join the ecclesiastical service of my government." Based on this counsel, my father decided that we should have a secular as well as a religious education. Suitable arrangements were made for our initial secular schooling in Lhasa.

Secular instruction was designed mainly for lay people and included courses in reading, writing, mathematics, and crafts. Tibetan society was structured in my childhood as it had been for centuries, and this structure was reflected in education. The children of most villagers received no formal education, but were trained in the traditional crafts, such as weaving, carpentry, and wood carving. On the estates, where as many as 500 families worked the land—both the landlords' and their own farms—some of the farmers' children became servants, traveling with the noble families to their townhouses in Lhasa. Because these servants became responsible for the managerial tasks of running the estates as secretaries, treasurers, and stewards, they were educated along with the children of the landlords' families. In turn these educated servants often became merchants, making up an independent middle class.

FIRST SCHOOL ☸ My brother was six and I four when we first began to attend a coeducational school near Ati Park in eastern Lhasa. Like all Tibetan schools it was free of charge. It was run by an educated layman, a married man who made a living as a secretary to a wealthy merchant in town. I was so small that a servant still had to carry me to and from school each day on her back. In our first

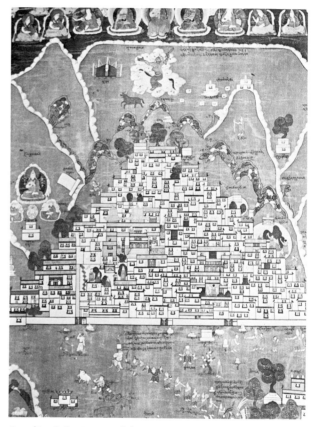

A stylized depiction of the Drepung monastery, this painting shows a complex that housed 10,000 monks. Hermitages for those choosing solitary meditation dot the mountainside above. Below, monks cross the plain toward another monastery, Nechung, to consult its famous oracular lama. Drepung was founded in 1416 by a disciple of Tsongkhapa, the great reformer.

lesson we learned to chant religious liturgy and to read and write the two main scripts, Umay—used mostly for handwriting, and Uchen—the script for book printing. Sitting cross-legged on cushions, we wrote from left to right with a bamboo pen and ink on rolls of paper on our laps. Our books were about two inches high and ten inches long, printed from hand-carved wood blocks.

ADMISSION TO DREPUNG MONASTERY My brother was ten and I was eight when my father decided it was time for us to enter Drepung, the monastery where he had been educated. With four colleges, nearly one hundred institutes, and more than 10,000 monks, the monastic complex of Drepung—about five miles west of Lhasa—was a town in itself. Our admission ceremony to Loseling College and Gyalrong Khangtshan Institute was a grand occasion: celebrations began on an auspicious date and lasted for three days. My father offered two feasts, one to the more than 4,000 monks of the main college and one to the nearly 500 monks of the Gyalrong Institute. Every monk received some tea, rice pudding, and a token gift of money; functionaries received a larger amount of money, befitting their greater responsibilities.

My brother and I were taken before the abbot, who performed the preliminary ordination leading to monkhood. Our hair had already been shorn save for a little tuft at the crown. After briefly chanting a sutra—a passage selected from the teachings of Buddha—the abbot snipped off the little tuft of hair. Blessing us with a *khata,* the white ceremonial scarf, with a strip of red silk knotted in the middle, he gave us each a religious name. Shaving the head and discarding lay dress and secular name symbolized renunciation of worldly life. Dressed in the monk's maroon robes and accompanied by our tutor, Geshe Khenrab Aungchuk, one of the resident *geshes* of the monastery, my brother and I then participated in the monastery's daily assembly. Every monk student of the great Gelukpa monasteries had a personal tutor, a *geshe* ("doctor of metaphysics"), but the student lived with an ordinary senior monk who acted as his guardian.

After a few months' stay at Drepung, my brother and I became familiar with monastic life and routine, and returned to Lhasa to resume our secular studies, visiting Drepung from time to time for special festivals. On each visit we refreshed our knowledge of the sacred liturgy and memorized new texts. Whenever our tutor came to our home—for several weeks in every quarter—he recited sutras or simple discourses illustrated by parables.

Soon Jampa and I entered a more demanding school, an institute in the capital in which more than one hundred children studied common literary subjects, while a small group, tapped to become physicians, received instruction in the science of healing and herbal pharmacology. In addition to the traditional gifts to the teachers of money, food, and practical items during their child's enrollment in the school, parents organized a ceremony to mark his or her matriculation and graduation. While children celebrated the day with performances of liturgical chants and the recitation of poems in praise of Manjusri, the Bodhisattva of Wisdom, parents met privately with the teachers.

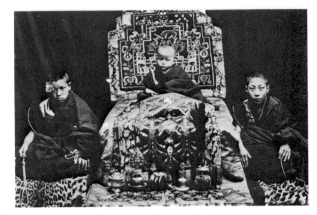

A very young *tulku,* or reincarnation of a grand lama who is said to have been reincarnated continuously for three hundred years, sits on his throne between his companions in studies and play. (Alexandra David-Néel)

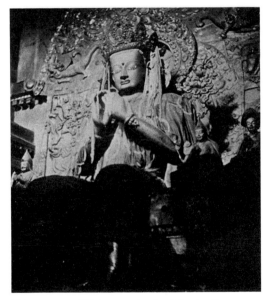

This statue of Maitreya, the Buddha to Come, with the founders of Drepung monastery beside him, was part of that monastery where the author received his first religious education and was ordained a monk. (J. Claude White)

Despite my pleasant recollections of those festive celebrations, some of my memories of my schooling are harsh. Discipline in Tibetan schools was very strict and corporal punishment frequent. In a large ground-floor hall all the students of the school—differentiated by rows according to their level of education—sat on cushions on the floor, working at their lessons under the supervision of senior students. Three times a day the students' work would be examined; students discovered to be idle were punished. All day we memorized and chanted sacred liturgy, studied the basic lexicon of thirty consonants and four vowels, completed exercises in grammar and arithmetic, and practiced writing and spelling different scripts. Creative exercises were rare, and my energy and curiosity often landed me in trouble. I could not resist entertaining my fellow students with jokes and riddles, and showing off designs I had cut out of paper. Sometimes I had only to arrive at school to receive a beating; my teacher—a hard, insensitive man—would hurry down the staircase as I came in the door. Somehow he had received word from my home that I had been naughty, and would order me to receive one of two punishments. The worst was supposedly a flogging with a bamboo stick on the back of the legs while I was lying on the floor, but the lesser of the two punishments caused me more trouble. Instructing me to puff up my cheek, the teacher would snap a bamboo stick against it, sometimes hurting my ear as well.

Fortunately, my family often visited the country estate of our cousin, Drumpa, outside Lhasa, where I could compete with Jampa and Drumpa at horsemanship, running, archery, and mountain climbing. Like most Tibetans we learned to ride at a very early age, and archery was a favorite sport of Tibetans of all classes, with frequent contests.

FESTIVALS 🐚 What we children liked best were the festivals. At least one occurred every month, and the family often made pilgrimages to cave temples in the mountains, some still being used by mystics, who chose to spend a certain amount of time—sometimes their whole lives—walled inside, frequently with only a small hole through which the charitable passed them food and other necessities. A lama in a cave retreat who did not wish to be disturbed would hang a sign to that effect at the mouth of his cave, but some mystics led less ascetic lives and would receive visitors on festival days, distributing the much-sought-after pills they had made from herbs and bestowing their blessings. I remember one lama whose cave was as comfortably furnished as a room in a house. These pilgrimages were always combined with a picnic, so they became recreational as well as religious outings.

One such occasion I recall with particular pleasure was a trip to the tantric monastery of Gungthang, some ten miles east of Lhasa, across the Kyichu River, where for two days we enjoyed the performances of sacred dances by the monks. Like all Tibetan monasteries, Gungthang was built around a central courtyard, with a main gate—a break in the side of the building opposite the main entrance on the inside of the yard. Assembling in the courtyard, the audience of monks and villagers sat facing the main entrance. The performance began at the top of the long steps leading to

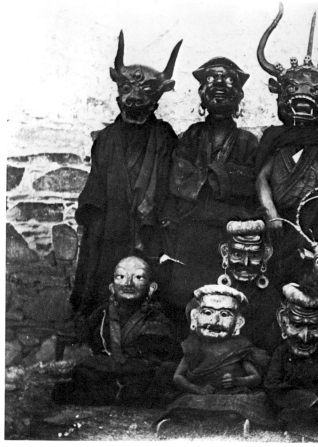

The masks worn by these monk dancers represent the faces of the guardian deities. The deer (center) dances are very flexible and acrobatic, calling for great skill on the part of the dancer. Masked dancing was incorporated into Buddhism from Bon, the animistic religion of Tibet that preceded Buddhism. (Alexandra David-Néel)

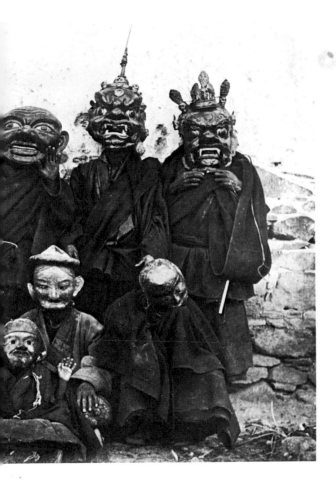

the main entrance: first the monk musicians appeared—carrying the big brass horns, reed instruments, drums, bells, and the horns made of human thigh bones (Tibetans don't consider these human relics morbid, but rather, symbolic of an acceptance of the cycle of life and death), preceded by novices carrying incense pots and colorful banners mounted on poles. Circling the courtyard, they took their seats and began the chanting of the ritual to consecrate the courtyard as "indestructible holy ground."

The first dancers to emerge were the Black Hat Dancers, about thirty monks representing the order of mystics at whose invitation the assembly of meditational deities and their retinues would dance in subsequent enactments. The movement of all the dances, some performed by monks wearing elaborate masks and costumes, is slow and stately. Every form, gesture, sound, or word conveys a different message—experienced inwardly by the dancer and expressed outwardly to the initiated observers—a summation of the compassion and wisdom of life and the sublime potentials of understanding of meditation and other sacred action. To be done well, the dance must be the manifestation of the dancer's insight into basic truths. Though impressed by the spectacle at Gungthang, I did not appreciate the meaning of the dances until much later, when I had reached an advanced level of Buddhist training.

TIBETAN BUDDHIST EDUCATION ❖ Whatever the limitations of the free secular schools, they did help channel my energy toward the discipline of studying, taught literary skills, and instilled a sense of moral responsibility. My father strongly influenced my religious training, as did my relatives, some of whom were learned lamas, monks, and nuns. My father's conversations with highly placed friends enriched my knowledge of the history of our nation. He loved to talk and to give advice; relatives often came to him with their problems—a legal matter, a family dispute—and he would counsel them. His religious inclinations were eclectic, and I was exposed not just to one sect, as might be expected, but to many lamas and monks from different orders and different ways of interpreting Buddhist scripture.

Tibetans say that the object of education is to crack the shell of ignorance, expand the intellect, and thereby encourage the achievement of supreme wisdom, the essence of enlightenment. Although many parents considered higher secular education as merely a useful vehicle for advancing a career in the much-coveted civil and ecclesiastical services of the Dalai Lama's government, others, including my father, saw it as a strong foundation for religious studies.

At the age of twelve, after eight years of basic secular education, I started advanced studies in both secular and religious subjects when I joined my elder brother and a cousin for private instruction. Luckily, my father had retained as our tutor an eminent lama teacher, Kachen Rinpoche, from Kilkhang College of Tashilhunpo monastery, who happened to be in Lhasa to edit and publish the complete philosophical manuals of his monastery. An outstanding scholar with an encyclopedic mind, he was also a master grammarian, writer, poet, physician, and a great mystic—an interesting

combination for a monk whose primary field was philosophy. Under Kachen Rinpoche's guidance, we studied the lexicon, philosophical terminology, and etymology, grammar, composition of prose and poetry, and basic Sanskrit.

I was especially taken with the complex Tibetan system of writing poetry and the dramatization of classical tales, and enthusiastically composed voluminous exercises in these, while studying the major treatises on the subject. Even secular topics had a religious orientation and spiritual content, a feature I sometimes neglected in my enthusiasm. One morning I presented Kachen Rinpoche with a poem of four stanzas I had written that dealt with nature: the realistic approach versus the impressionistic or intuitive approach. Some lines discussed animals and scenery; the last few verses described the form and beauty of the feminine figure. I eagerly watched for Rinpoche's reaction to my work. He read it with little expression, but when he had finished he grinned and said, "You have certainly maintained the realistic approach. Your description of the feminine form is very good. Remember, though, that poetry is the medium of religious communication and, as such, an expression of a sublime experience. There is no place in Buddhist poetry for sensuality."

After three years with this patient and compassionate teacher, my brother and cousin terminated their studies in order to enter government service, my brother as a monk official, my cousin as a lay official. I chose to continue my monastic studies in order to prepare for higher, esoteric training. With my old monastic tutor, Geshe Aungchuk from Loseling College, I studied Buddhist logic, metaphysics, and meditation, according to the sutras. The Gelukpa order, to which Drepung belongs, divides all philosophical subjects into five categories; other orders divide them textually into thirteen categories.

The ultimate goal of the carefully disciplined Buddhist education is a harmonious balance between faith and discrimination, rational view and meditative insight, compassion and wisdom, and every Tibetan order approached the fundamental teachings in a three-level system known as Keybu Sumgyi Jangchub Lamrim ("The Stages of Enlightenment for Three Kinds of Seekers"). The first stage, which I had begun at the moment of my initiation ceremony at Drepung monastery, seeks to instill the basic tenets of Buddhism as a foundation for a spiritual life. Seekers learn that man is master of his own destiny, or in the Buddha's words, that "the nature of enlightenment remains unknown and unexplored in the stream of consciousness of every being."

In the beginning, our contemplation took the form of a rational appreciation of life's diverse, even mystical aspects. As trainees we focused on the brutal realities of disease, decay, and death, which threaten our fragile existence every moment. Such an objective analysis gave us a proper understanding of the instability and impermanence of life. Throughout our daily contemplation and actions we had to develop our spiritual potentials. At this early stage of our training we were therefore faced with the problem of striking a practical balance between material survival and spiritual pursuits, between self-interest and humanistic concern.

In order to gain control over inner reality and tame its destructive forces, we first had to under-

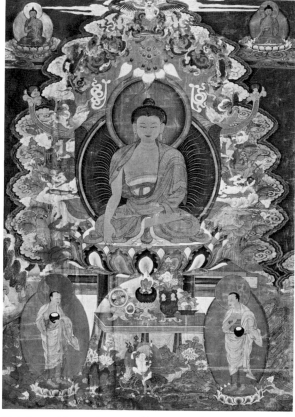

This late-eighteenth- or early-nineteenth-century *tanka*—literally "banner," a Tibetan religious painting on cloth—shows Gautama, the historical Buddha, calling the earth to witness and support his rightful claim to enlightenment, referring to an episode in which he successfully overcame the assaults of the demon Mara. Two of his favorite disciples flank the altar placed before him.

stand the Buddhist doctrine on the cosmic law of causality, called in Tibetan *ley,* or "conscious action," and in Sanskrit *karma.* Karma, we learned, is the dynamic interaction between causes and conditions that creates the incessant chain reaction in cosmic evolution, stabilization, devolution, and annihilation into a complete void. As long as the interaction and interpenetration of matter and energy persist, the cosmic creative and destructive process will continue. When one universe annihilates itself, another proceeds with its evolutionary stage. In the human sphere this means that happiness and misery are the inevitable results of conscious actions, which determine not only a person's lot in this life, but his continuing fate in the cycle of death and rebirth.

As principles for governing our daily behavior toward others, we were taught

Ten positive principles:

To protect life,
To maintain chastity or sexual ethics,
To share one's possessions or riches
 are the three physical acts.

To speak truthfully,
To speak about good qualities of others,
To speak gently and pleasantly,
To speak on beneficial topics
 are the four vocal acts.

To develop nonattachments,
To be kind to others,
To hold the right view of life and reality
 are the three mental acts.

And ten negative principles:

To take life by various means,
To take things that have not been given,
To indulge in sexual promiscuity and
 misconduct are the three physical acts.

To lie,
To slander,
To use abusive language,
To indulge in harmful gossip
 are the four vocal acts.

To covet another's wealth,
To entertain malicious intent against others,
To hold the wrong view of life and reality
 are the three mental acts.

The training of the first stage leads to the second stage, known as the intermediate aspirant. The object of this stage is purely spiritual: a quest for freedom from the inner malaise of lust, hatred, and ignorance and also from the cycle of death and rebirth. The process of self-transformation is based on and guided by the doctrine of the Four Noble Truths. The first truth is that all life abounds in miseries; the second, that causes for all these miseries exist; the third, that there is a possibility of eliminating them; and the fourth, that there is the Noble Path of Liberation.

During this stage of my training, which I began when my brother, cousin, and I received private lessons, I learned to synthesize meditation, psychology, and discipline. Early in this level we concentrated on the contemplation of the active and potential miseries that afflict not only the lower realms of beings, but human and celestial beings as well. Later we worked at developing a yearning for liberation, and with a determination strengthened by that yearning, we began scrupulously to

Buddha Calling the Earth to Witness (top), a fifteenth-century copper statue from western Tibet, represents Akshobhya, the Immutable Buddha. His attention is held by the *dorje,* a thunderbolt scepter symbolic of transcendent wisdom, in his left hand. *Mahakala* (bottom), literally the "Great Black One," is a late-eighteenth-century Tibetan bronze. It depicts the six-armed guardian of the faith in his angry aspect; the skullcap and chopper in his principal hands symbolize the severing of attachments.

apply the threefold path: higher moral ethics, mastery of the mind through meditative peace, and an analytical examination of the selfless stream of consciousness.

By the time my brother and cousin were ready to enter government service, I had embarked on the pursuits of the third stage, which offers a great challenge and opportunity: a challenge that demands will power, courage, vision, sensitivity, and dedication—and an opportunity to serve humanity by working toward lasting happiness and inner freedom. After taking the Bodhisattva vow in the presence of my lama, I began a rigorous period of self-examination and meditation, as well as complex intellectual analytical thinking. Because meditators must know how to resolve contradictions between their inbred notions and perceptions of reality, they must apply all knowledge they have acquired to this stage, experience as well as the doctrines and theories they have studied.

Upon the completion of training based on the sutras, I began my esoteric training in the Buddhist tantra, or mysticism. Three factors were considered indispensable for such higher training: choice of the right teacher, the maintaining of a pure and harmonious relationship between teacher and disciple, and the right motivation. Tibetans believe that religious teachers play such a vital role in spiritual life that they should be chosen with utmost care. The continuing relationship requires not only that the teacher show concern, patience, and kindness, and that the student respond with respect, faith, and trust, but that a lasting bond between the two and genuine reverence on the part of the student grow stronger as the studies proceed. The emphasis on motivation encourages a radical transformation of the ego and an elevation of consciousness, which in turn inspires the values of compassion and concern for all sentient beings.

Throughout my education I tried to maintain the best relationship with my many lama teachers, of whom there were some two dozen, belonging to several different religious orders. Their continued guidance and friendship supported me during my rigorous training and acted as a stabilizing influence in my life. My special interest in Buddhist psychology and logic was, again, inspired by my father's interest in these fields. He used to recommend these two studies as powerful intellectual tools for sharpening intelligence. Buddhist psychology is a unique system. Based on the model of individual personality as a "stream-consciousness" rather than an absolute entity, it contradicts many of the presumptions of Western psychology. Instead of emphasizing the resistance of psychoneurotic disorders to treatment, Buddhist thought promotes psychological insight and meditational methods for taming the ego and overcoming inner delusion.

Far from being purely dialectical, logic is indispensable in analytical meditation and is a spiritual process. It gives meditators an unclouded vision and sharp discernment in determining perception of apparent or ultimate reality.

During my advanced training I spent long hours each day in religious exercise, such as mantra chanting and solitary meditation. I began to realize that the true aim of Buddhist training was a great personal commitment to attain enlightenment, not just for one insignificant seeker but for all sentient beings, and—perhaps even more important—I saw what a humble mind could and must

The two long pages are from a Tibetan manuscript with musical notation given for some of the words; the figures represent, from left to right, Milarepa, the translator Marpa, and Gampopa. The shorter page is from a medical manuscript and contains drawings of herbs. Students in class would read such books sitting cross-legged on mats or cushions. The books are roughly two inches high and ten inches long, and read from left to right.

achieve in developing hidden potentials. The systematic means to achieve these aims are the three principles known as the Three Wheels: the Wheel of Study consists of listening, reading, composing, debating, and critical examination; the Wheel of Contemplation consists of inner quiet and insight; the Wheel of Beneficent Action consists of protecting all life and giving the gift of teachings to others. Now, to reach a truly awakened state, I had to harmonize intellectual comprehension with contemplative insight. Hence meditation became an essential aspect of my life.

Buddhism as a path of spiritual development does not consider scholarship to be a purely intellectual pursuit; rather it is always treated as a means of exploring the deeper nature of reality. A scholar with little inner attainment was usually an object of criticism and ridicule. An old Tibetan anecdote illustrates this:

> Once the assembly of Druk Ralung monastery was all set to perform the final phase of the great rite called "The Burning of the Effigy of Evil." Their chief abbot was ill, and Drukpa Kunlek (the "crazy mystic") lunged forward and seized the dough effigy. While puzzled monks watched, Kunlek rushed straight to the abbot's chamber with the dough figure in his hand. The shocked abbot rose from his bed and asked, "What is this crazy man doing?" Kunlek replied, "Venerable Sir, I looked all over and found no evil dwelling anywhere outside. So now I am throwing this effigy at the evil which is dwelling inside you." Before finishing the sentence, he hurled the figure at the abbot's chest, who fell back in a state of shock. By the time the abbot had recovered his senses, his disease was all but gone. He then admitted that he had not overcome his inner delusions.

Although my religious training was on the right course, I was not quite sure how much further I could go with my studies, since I had been predestined to become a monk official. Under the circumstances, a shift from the comprehensive path of tantric training to the simple mystic path seemed more suitable for me. Yet the urge for deeper knowledge of esoteric Buddhism and more comprehensive meditational experiences was strong. From my elder brother I learned that even after becoming a monk official I would have the freedom and time to carry on my personal training. Most young officials did not receive an active assignment for several years.

BECOMING A MONK OFFICIAL In 1940, when I was sixteen, I entered government service. The occasion was celebrated in a tent—white, with the auspicious symbols appliquéd upon it in red, yellow, and blue—placed on the rooftop terrace of our house in Lhasa, the customary religious ceremony performed by a group of monks. New prayer flags were raised on their tall poles, and a stream of relatives and friends arrived to wish me well. A year later I received my first appointment: I joined the staff of the Tse Yigtshang (Grand Secretariat) of the Dalai Lama and went every day to work in the Secretariat in the Potala Palace and at Norbu Lingka in the summer.

Unlike Western offices, Tibetan offices are not compartmentalized. Some thirty of us young

officials, along with the four higher-ranking secretaries, worked together in the same hall. Sitting cross-legged on cushions on the floor, we wrote as we had in school—on paper held in our laps. (This Tibetan posture for reading and writing made adaptation to Western ways difficult for me later on; I found it odd and uncomfortable to sit in a chair and bend over a table.) The files were rolled and stacked in cupboards against the wall. Our duties included drafting official documents and forwarding petitions to the Dalai Lama and his cabinet. At lunchtime, we adjourned together to a large hall with tall pillars, where we were served a meal made in the Dalai Lama's kitchen, usually *tsampa,* a Tibetan dish of roast barley flour mixed with butter and tea to make a paste; a special cake made of cheese and butter and sugar; and salted butter tea.

Meanwhile, my advanced studies and meditation continued for another seven years, until I left Tibet in 1947. In addition to exoteric and esoteric metaphysics and meditation (the teachings of sutras and tantras) of the Gelukpa order, I studied esoteric teachings under lamas of other orders.

An eclectic approach to Buddhism did not mean that there were no sectarian or petty political differences among Tibetans. In my youth I was once the unhappy witness to a heated debate between my tutor, a Gelukpa scholar, and two married mystics of the Nyingmapa order, which took place by accident in our shrine room. Normally, my father took care to ensure that the services conducted in our house by different orders occurred on separate occasions, but this day the visits of the monks from the two orders coincided. During the long tea break, a friendly conversation soon turned into an unpleasant confrontation, with each side hurling questions and challenges at the other. Faces reddened and voices rose in anger.

The main point of contention was the concept of ultimate reality, what might seem to Westerners unlikely to spark such a heated debate; but it was a traditional conflict between these two factions. Tibetan Buddhism was then—and is today—represented by four main orders. In order of their founding, they are: the Nyingmapa, the Ancient Mystic Order, begun in the eighth century by Padmasambhava and known in the West as the Red Hat Order; the Sakyapa, "The Order of the White Earth," founded in the eleventh century by Konchog Gyalpo; the Kagyupa, "The Order of the Oral Transmission," originating in the eleventh century and sometimes called the Order of the White-Robed Yogins; and the Gelukpa, "The Order of Virtue," known in the West as the Yellow Hat Order, dating to the fifteenth century, when it was founded by Tsongkhapa. In the dispute the Nyingmapa argued that the ultimate reality is an eternal spiritual essence called Perfect Awareness, and by extension that a seeker of enlightenment has no need of inner development: he must discover the truth by contemplation of the Great Essence, the universal absolute. The Gelukpas contend that if the innermost nature of man were already perfect and absolute, spiritual development would be unnecessary. Therefore, they believe that the nature of man is not absolute but relative, a stream of consciousness void of essence or substance. Even in a culture as harmonious as that of Tibet, there was room for disagreement, which in its milder manifestations enriched my religious experience.

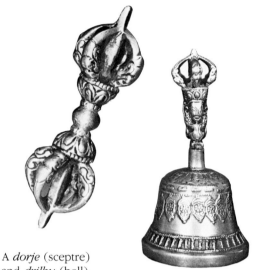

A *dorje* (sceptre) and *drilbu* (bell), the most important ritual objects, symbolizing wisdom and compassion respectively, are handed together to new initiates and ordained monks.

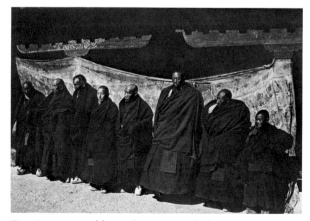

Five important abbots, the master of chanting, the master of discipline, and a young novice, all of the Gelukpa order await a visitor in the courtyard of the Drepung monastery. (Brooke Dolan)

TEACHINGS OF THE GREAT LAMAS 🔱 It was my good fortune to be able not only to study with many lamas, but more important, to have access to the three preëminent teachers of the time: Ling Rinpoche, the Dalai Lama's junior tutor, later to become his senior tutor; Trijang Rinpoche, the Dalai Lama's chief advisor on metaphysical dialectics, later to become his junior tutor; and Tri Rinpoche, the supreme patriarch of the Gelukpa order. Each of these eminent lamas had a distinct personality, but they shared not only great warmth and compassion, but also a distinct aura of saintliness acquired through years of esoteric meditation and spiritual development. Thousands of lamas, scholars, mystics, monks, and nuns among their disciples bore eloquent testimony to their incomparable scholarship and attainment. Each Rinpoche was an outstanding poet, writer, debater, logician, and philosopher—qualities highly regarded in our society. To me the three Rinpoches embodied all the qualities that make a Buddha, a fully enlightened being. While in their presence, I had a feeling not only of great elation, but often, during initiations, of losing my concrete sense of self and of merging into a state of higher awareness.

Among the teachings I received from Ling Rinpoche, the most important for my esoteric practice, was the long discourse on the Mystic Order of Wrathful Manjusri and the secret oral instructions. This consisted mainly of the doctrine and the meditation known as the Creative and Enlightening Stages. Lasting for many weeks, this major discourse combined two different systems of mystic orders representing the entire tradition of the Supreme Tantra (Anuttra Tantra) known as "The Illusory Manifestation and Lucid Awareness of an Enlightened State." Sitting for hours and days among a small group of lamas and scholars, I felt privileged to be allowed to listen to the discourses in the exquisite setting of Ling Rinpoche's beautiful residence in the Dalai Lama's Summer Palace complex.

My meetings with Trijang Rinpoche were more frequent, as I was one of his regular disciples and did some secretarial work for him. I received many important teachings from him. Much of my time I devoted to the step-by-step meditation based on the doctrine of the Great Stages to Enlightenment (Lamrim Chemo). This was a compendium of the moral and metaphysical doctrines derived from the entire collection of sutras, the Tripitaka. This was followed by Rinpoche's teachings on the training of the mind, designed to develop the psychological capacity of turning misery into happiness, depression into joy, and self-love into universal love and compassion for others. After that Trijang Rinpoche graciously permitted me to join a group of learned disciples so as to receive a series of major initiations on the Mystic Triad (De Sang Jig Sum), three meditative deities that embody compassion, wisdom, and the power of enlightenment. Among these initiations were courses on esoteric doctrine, explanations, techniques of higher yoga meditation, and the harnessing of inner heat (Kundalini) for spiritual transformation. They formed the major system of the Supreme Tantra. Once I was well prepared to go into a long-term meditational retreat, I received the necessary secret instructions from Rinpoche given to a small number of practicing initiates.

Just before I left for India, Trijang Rinpoche gave me much good advice: "Your friend, Kushow

The tree of masters, representing the spiritual succession and hierarchy, through whom spiritual teachings are transmitted, is depicted in a *tanka*. At center is the Adibuddha, or Primordial Buddha, in blue, holding the *dorje* in his right hand and the *drilbu* in his left.

Lodro, abandoned his home and position of monk official in order to spend the rest of his life in mountain solitude. His father came to see me with the request that I persuade him to change his mind, and I advised Kushow Lodro against it. The mere renunciation of the materialistic life cannot assure the realization of the spiritual goal, which was his real purpose in doing this. Often a monastery or mountain solitude is used as a safe haven into which to escape from life." Continuing in a gentle, reassuring voice, Trijang Rinpoche said, "You are now well prepared for your higher esoteric practice. I want you to continue it. India, the homeland of Buddha, would be conducive to your continued devotion and your contribution to the Buddhist tradition. The teachings of the highest tantric yoga are most effective for self-realization. You well know that they were originally expounded to a married man who achieved inner illumination without having to renounce his worldly life." Rinpoche's references to my friend Lodro and my future in India proved to be prophetic: Lodro died young after only a few years of meditation in solitude. And I was to marry a few years later, in India.

Tantric mysticism (Vajrayana) was held in the highest esteem in Tibet. As the only rapid path to self-realization, it offers many different methods that can successfully be applied by people of diverse intellectual capacity. Buddhists traditionally regard physical and mental yoga as the most effective panacea against the inner malaise of man. These views were confirmed to me during encounters with the mystics in the caves of the Celestial Mountains of Yerpa, near Lhasa, and lay initiates among the simple country folk. All my lama teachers, regardless of order, likened the efficacy of tantric mysticism to the alchemical transformation of base metal into gold. One such method, called the Transcending Wisdom, helps meditators gain instant self-control and thereby transform negative impulses, emotions, or passions into a state of quiescence, joy, or equilibrium.

The warnings of the lamas also ring in my ears: "Never use these wonderful methods purely for sensual gratification, selfish purposes, or egoistic motives! To do so would be like using a golden casket as a refuse bin! True illumination can be realized only when the mystical practices are based solely on the Enlightening Mind [Bodhicitta]." Bodhicitta, the genuine wish to lead all sentient beings toward liberation and enlightenment, is the heart of the exoteric teachings. It also forms the foundation of Buddhist mysticism, Vajrayana, an approach different from the moralistic, rational system known as Hinayana, which constitutes the basic Buddhist teachings.

The seeds of self-realization having been germinated by the initiation process, I now set out to bring them into full bloom by the nourishment of meditation. A traditional Tibetan saying cautions:

Every sentient being is the source of Buddha;
Buddhahood cannot be realized unless one meditates,
Just as milk is the source of butter,
but butter cannot be obtained unless one churns the milk.

For my meditation I spent several months at the mountain retreat of my granduncle Gonsartse Rinpoche, not far from our ancestral home of Lhalung. During this first of many retreats, I medi-

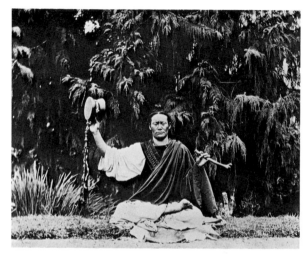

A *ngakpa,* a tantric mystic, prepares to celebrate the rite of Cho; in his hands he holds a small tambourine and a trumpet made from a human thigh bone. Cho consists of a meditation in which the celebrant renounces his ego by imagining that he is leaving his physical body to become one with a meditational deity. The ritual takes place in a cemetery or wood believed to be haunted by spirits who, the mystic imagines, carve up his body and consume it. *Ngakpa* were thought to be able to perform the more seemingly magical rites of Tibetan Buddhism, and they had to be spritually pure and virtuous. (Alexandra David-Néel)

tated for four sessions a day, fourteen hours in all. Gonsartse Rinpoche graciously invited me to lunch almost every day, and I reported my progress, and also received teachings directly or indirectly related to my practice. Occasionally his most important disciple, Taktsher Thubten Norbu, joined us for a quiet meal and discussion. He, too, was meditating in a special retreat at the beautiful mansion in the garden.

During my later visits to his residence, Gonsartse Rinpoche permitted me to study his collection of Tibetan sacred sculptures and *tankas,* or "scroll paintings," including those he brought back from his travels to India, Mongolia, and China. He explained to me the symbolism of Buddhist iconography, sacred dance, and music, which inspired me to pursue subsequent research. These art forms are not merely aesthetic objects but valuable educational tools that convey many levels of meaning, heightening insight into the mystic doctrine. Many questions formed in my boyhood about esoteric culture finally found their answers there.

During one of my last visits to him, Rinpoche gave me a final lecture on the common and conflicting sectarian doctrines. He urged me to continue with my eclectic studies, saying: "The deeper you explore them, the more convinced you will become of the fundamental unity of all our traditional orders!"

Not long after that I went to visit a holy woman mystic named Jetsun Lochen at her nunnery in the Juniper Forest, thirty miles from Lhasa, in order to receive from her the highest esoteric teachings and initiations of the Nyingmapa order, known as Atiyoga. Her religious center was situated on the high slope of Mount Gangri Thokar (Whitehead Mountain), one of the most sacred places in Tibet. The only daughter of poor parents, Jetsun Lochen had shaped her own destiny in childhood. Showing intense interest in religious songs and studies, she had risen to the eminence of a revered lama. Long before I went to her, my family had been among her ardent followers. Some of my close relatives were nuns at the nunnery.

During my first two-week visit I met with Jetsun Lochen for several hours a day, sometimes in the company of her main disciples. She was an extraordinary woman, small in stature, with a serene face radiating compassion and sensitivity. Only her white hair betrayed her age: she died a few years later at the age of one hundred thirteen. In her presence we felt an awesome power that permeated our whole stream-being. Her teachings and blessings have given me inner strength and inspiration ever since. To me she was the personification of the great woman teachers of Tibet.

Endorsing my eclectic attitude, she said to me: "I always looked upon every Buddhist order as being a different vehicle capable of transporting fortunate seekers across the great ocean of Samsara [the cycle of birth and death]." The essence of her message can be summed up as follows: What matters most in this troubled world is compassion and wisdom. The form and institution of the practice matters less. A seeker who perceives the illusory nature of all things is on the threshold of wisdom!

As my studies continued, my career led me in another direction, one that reflected the changing place of Tibet in the modern world. During the time of the thirteenth Dalai Lama, Tibetans began to

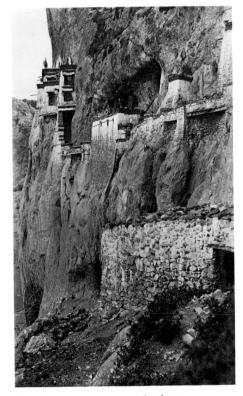

The Tingsum nunnery is built on and into the side of a sheer cliff. Men and women were considered equal, and life in a nunnery was much the same as that in a monastery. No nuns, however, were in government service. (Leslie Weir)

recognize that the survival of the nation required modernization. Modernization, in turn, demanded a different kind of education for Tibetans, one that provided for technology and for interpreting the foreign languages of those who brought these new methods and ideas to Tibet. The thirteenth Dalai Lama had been among the first to foresee Tibet's future needs. Soon after his triumphant return home from British India, he sent a few intelligent students to England to be trained as electrical engineers, geologists, and technicians. The English school he opened in Gyantse did not last long in the face of conservative opposition. By the early 1940s a modern school had opened in Lhasa, but it created new problems. In keeping with Western methods of teaching, instructors did not discipline students as much as Tibetan teachers or interfere with their studies. The children so treated—finding this freedom so different from their upbringing and the traditional Tibetan way of life—began to behave badly at home. Parents objected and organized support among the monks; eventually the school was closed.

In 1947 I was summoned by the office of the fourteenth Dalai Lama's regent, where the secretary read an order that placed me in charge of a new project. About ten students, ranging in age from eight to twelve years, would be sent to the Jesuit College of Saint Joseph's in Darjeeling ("Dorjeling" in Tibetan), West Bengal, India, where they would receive both a modern and a traditional education, eventually returning to Tibet to become technicians, administrators, teachers, and diplomats. In addition to supervising the traditional education of these government-sponsored students, my task was to oversee about fifty others already independently enrolled in several modern schools in the Darjeeling area. I was also given general responsibility for cultural matters of Tibet in northern India. After my appointment the number of Tibetan students in India increased to more than one hundred and would probably have gone up to well over one thousand during the next decade. But political events in our homeland changed all this.

In 1950, three years after my arrival in India, disturbing news arrived from home about the invasion of eastern Tibet by Chinese Communist forces. By 1951 the entire country was occupied. The government and my father pressured me to return home. Though torn by their pleas, I grew to believe that two somber prophesies I had heard before leaving Tibet would come true sooner than expected. In his testament of 1931, the thirteenth Dalai Lama had predicted:

In the future this system [the Communist system already established in Ulan Bator, Mongolia] will certainly be forced—either from within or without—on this land, which cherished the joint spiritual and temporal system. In such an event, if we fail to defend our land, the holy lamas, including the Victorious Father and Son [the Dalai Lama and the Panchen Lama] will be eliminated without even a trace of their names. The properties of the Incarnate Lamas and the monasteries along with the endowments for religious institutions will equally be eliminated. Moreover, our political system, originating from the three ancient kings, will be reduced to its empty name. My officials, deprived of their patrimony and wealth, will be subjugated like slaves by the enemy, and my people, subjected to fear and misery, will be unable to endure days or nights. Such an era will certainly come!

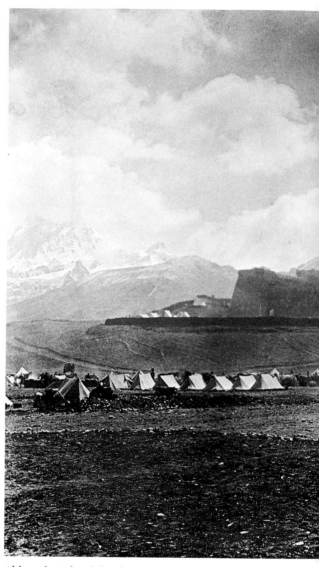

Although isolated for the most part from the rest of the world, Tibet has been invaded a number of times. Here, the British army is encamped before the Phari fortress during the successful invasion of 1903–04 led by Colonel Francis Younghusband.
(J. Claude White)

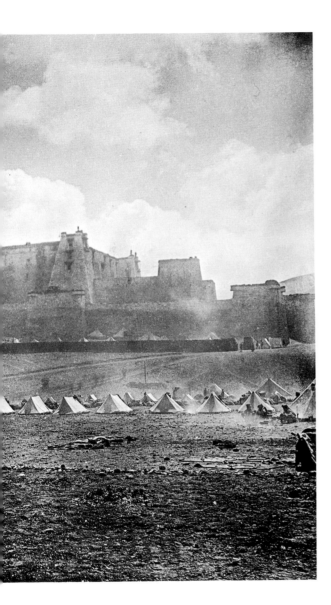

A more specific prophesy had been voiced by my granduncle, Gonsartse Rinpoche, in 1946. When I stayed with him on my meditational retreat, he mentioned the prophesy of our beloved thirteenth Dalai Lama. Then, with tears in his eyes, he added, "These terrible events will take place within the next decade and nothing will stop them. But the flame of the Dharma [Buddha's teachings] will not die!"

I had married in 1949, and I now had to make a painful decision—not only for myself but also for my new family—between life in newly independent and free India, but as a permanent exile and without any material support from home, and life in occupied Tibet under a regime I did not believe in. By deciding for freedom, as would the Dalai Lama and some 100,000 of my fellow Tibetans soon thereafter, I was not to see my country again for three decades.

A JOURNEY ACROSS TIBET ☸ During the summer of 1947 I was happily oblivious of these future events and eagerly looked forward to my first journey abroad. India's long struggle for freedom had just culminated in independence, and like many of my countrymen, I was anxious to visit the land of Buddha and Gandhi.

Our Lhasa house bustled with activity as my departure day approached. Family members and servants packed my clothes, books, religious objects, gifts, and travel provisions, while friends dropped by with presents and *khata* (ceremonial white scarves). In our country it was customary to show respect or greet someone, to express happiness or sorrow by presenting with outstretched hands a *khata* to the other person.

Communications and modes of travel in Tibet were still old-fashioned. The route from Lhasa to Darjeeling, over three hundred miles across rough caravan trails and high mountain passes, usually took three weeks on horseback, although it could be covered by fast runners in less than ten days. I planned to make the trip in six weeks, because I wanted to visit friends, lamas, and holy places along the way.

For traveling on official assignment, the Council of Cabinet Ministers issued me an official document addressed to the administrators and elders of districts along the route with instructions to provide me and my party with lodgings and replacement horses, for which I was to pay but a minimal fee. Certain farmers and landowners all over the country had to provide these services for the government in lieu of paying a land tax. The unpaved caravan routes were maintained by volunteers as a religious act, often poor people who accepted donations from travelers.

Before leaving I sent advance notice to the village elders of each district where I intended to stop, giving them the approximate date of my arrival and the number of horses that would have to be cared for. Handwritten on a big sheet of paper and wrapped around an arrow, this notice passed through a system of relay runners, each ten or so miles beyond the last, beginning with a runner provided by an agency in Lhasa. This was a modified version of our ancient communication system in which messages were wrapped around arrows and shot to the next village. (Similar systems are said to have existed among other ancient cultures in various parts of the world.)

In the meantime, I received my official credentials, almost three feet long and sealed with the large red seal of the Dalai Lama's regent. The document specified the nature and scope of my assignment.

FINAL AUDIENCE WITH THE DALAI LAMA 卍 To take official leave from the government, I could have attended either a daily morning tea ceremony at Norbu Lingka, or a special ceremony at which the Dalai Lama—then only twelve years old and still under the guardianship of the regent—presided and would give his personal blessings. The day I chose was a great Buddhist festival: Drukpa Tshezhi, the "Fourth Moon of the Sixth Month," commemorating the first setting in motion of the sacred Wheel of Law by Buddha in the Deerpark at Sarnath more than 2,500 years ago. Early that morning I rode with my servant to Norbu Lingka, a few miles west of Lhasa. Before the ceremony began, I registered my departure with a protocol officer who acted as the government's chronicler. At about eight in the morning the ceremony began in a large ceremonial hall, with all participants—about three hundred monk officials, the regent, and the Dalai Lama—being served Tibetan tea and sweet rice. The Dalai Lama, seated on the Lion Throne, first received homage from the regent, who, prostrating thrice before him, offered the three symbols for body, speech, and mind: a sacred image, a book, and a small bronze *stupa*—a container for sacred objects—followed by a *khata*. His Holiness blessed the regent by gently touching heads, then with his right hand blessed all the resident monk officials who lined up according to rank and seniority by touching them or passing his hand over them. Two huge monk bodyguards on either side of the line regulated the crowd movements to and from the throne. The Dalai Lama could not be approached directly; instead, the line detoured to the right so as to pass the Dalai Lama from the side. Next the officials leaving on various assignments and I offered our *khata* and were blessed. Before leaving the hall we all received a strip of silk, with a knot in the middle, that had earlier been blessed by His Holiness. Nearly every Tibetan possessed a strip of silk (*sungdhu*) blessed by a lama, which he cherished and wore close to his body.

No Tibetan undertook an important task without first arranging a religious service at home or making offerings in the temple. On the day before my departure I went to the Jokhang, the seventh-century central temple in Lhasa, to make offerings in front of the sacred statues placed there when the temple was built. On the route to the Jokhang, with its complex structure and dazzling golden roof, our servant accompanied me and carried the offerings: *khata* to be placed on the statues, clarified butter for the butter lamps, incense, and monetary gifts.

SAYING GOOD-BYE 🐚 My departure finally came on a warm, sunny day in early August. The short summer rains had ended and a gentle breeze was blowing. The sky over Lhasa was the clear sapphire blue typical of the highlands of Tibet—fine traveling weather, indeed!

My entire family, with the exception of my father, gathered in the courtyard of our house, wearing festive brocade robes. Father remained alone in the shrine room on the top floor of the house,

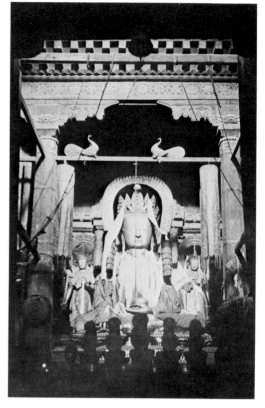

Gyantse, protected by a hilltop fortress, was the largest caravan stop in the Tsang region. The statue of Buddha was photographed in a Gyantse temple in 1910. (Leslie Weir)

saying his prayers for my safe journey. When I entered to pay my respects and to ask for his blessings, he admonished me to make good use of my years abroad and to represent my country and His Holiness the Dalai Lama proudly.

My family and our retainers gave me an emotional farewell in the courtyard. Each one presented me with a *khata*. I mounted my favorite gelding, which had been saddled with its finest saddle cover as befitted the horse of a traveling monk official. As I bent down to tuck the folds of my clothes under one leg, my round, fur-and-brocade-trimmed hat slipped off my head and fell to the ground. Normally a small matter, this incident was considered inauspicious on such an occasion, and I remember feeling instant apprehension. Was this a sign that I would never see Lhasa again?

One of our trusted servants, Jampa, over six feet tall and ruggedly handsome, wearing his silver *gau* (a small portable shrine containing a sacred Buddhist image), led our little caravan through the gate into the streets of Lhasa.

Lhasa in our language means "The Divine Land." Founded during the seventh century in the broad Kyichu Valley, near the banks of the Kyichu River, a tributary of the Tsangpo (the upper course of the Brahmaputra), the capital of Tibet is, at 12,000 feet, one of the highest in the world. The city is dominated by three rocky hills, the most prominent of which supports the massive structure of Tibet's best-known monument, the Potala Palace, seat of government and residence of the Dalai Lama.

In 1947 the city had fewer than 100,000 inhabitants, most of whom lived in traditional flat-roofed stone houses in what would today be called the old part of town. The focal point of this old town was the Jokhang.

Encircling the city—including the Potala, which was on the other side of a park from the center of town—was the Lingkor road. As the holy city of Tibetan Buddhism, Lhasa attracted pilgrims, who joined many local people in circumambulating the city on the Lingkor. But Lhasa was not only a religious center, it was also the seat of the central government, the center of Tibetan culture and trade. Although Tibet was relatively isolated—its history made it wary of foreigners and Lhasa was known in the West for centuries as "The Forbidden City"—it was always open to neighboring peoples, and saw a continuous stream of visitors, pilgrims, and traders from as far away as Mongolia, China, Bhutan, India, and Ladakh. During the major Buddhist festivals the city swelled to more than twice its size, as tens of thousands of monks and pilgrims crowded into the ancient citadel.

LAST SIGHT OF LHASA 🐚 Our caravan slowly wound its way through the streets of Lhasa and past the towering walls of the Potala into the countryside. About three miles beyond the city limits, at the foot of a mountain, we stopped and rested for a few hours. In traditional Tibetan fashion, my sisters and friends had preceded us to a garden to arrange for one last picnic with butter tea and cookies. As we sat laughing and joking, I occasionally glanced back east toward the Potala Hill and its enormous palace, remembering how I had climbed its many hundreds of steps to the Grand Secretariat every day during the last seven years. The afternoon sun reflected brilliantly off the

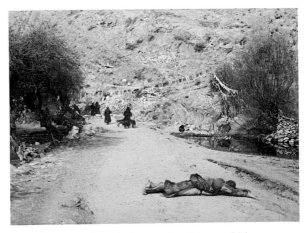

If a pilgrim to Lhasa believed that this would be the only chance in his life to make the holy pilgrimage around the city on the Lingkor, it was customary to do it fully prostrate, which took from three to five days. Many Lhasa residents made the pilgrimage daily on foot. (Brooke Dolan)

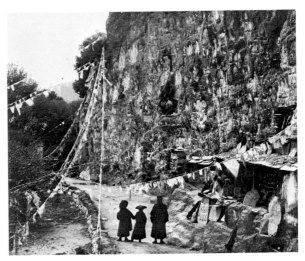

Hundreds of Buddha figures have been carved in the rocks on the south side of Chakpori (Iron Hill) along the Lingkor road in Lhasa. The polychrome figures are retouched on religious festival days by monks and laymen alike as an act of devotion. (J. Claude White)

golden rooftop temples that house the tombs of former Dalai Lamas. As excited as I was to set out on this first long trip abroad, I also felt pangs of sadness at having to leave this lovely, peaceful city, apprehensive about my future life beyond the high Himalayan Mountains to the south.

As we moved on, we passed below the sprawling monastic city of Drepung, my former monastery. Below Drepung lay the smaller monastic complex of Nechung, residence of Tibet's chief oracle, surrounded by green poplar and willow trees. Nechung was a medium-sized monastery supporting about two hundred monks and well endowed with land. And high above Drepung I could barely make out the temple of Tenmai Zimkhang, a famous lady oracle who was consulted by the Drepung monastery.

We rode for another two hours beyond Drepung to a holiday retreat for the Nechung monks called Tshagur Lingka, situated in a broad, green valley. Here our little caravan spent the first night as guests of my uncle, one of the senior Nechung monks.

Nechung monks were known for their performing talent in sacred dances and folk operas. We had timed our arrival to coincide with the annual summer festival, when the monks were allowed to entertain lay people, families, and friends with performances of folk operas. Normally these operas were performed only by professional troupes. A huge white tent appliquéd in blue with the eight auspicious symbols—the parasol, the two fish, the conch shell, the eternal knot, the banner of victory, the Wheel of Law, the lotus, and the wish-fulfilling vase—was set up in front of the main hall. The monks sat in rows on one side, flanked by elegantly dressed visitors from Lhasa and ordinary village folk in colorful costumes. During the day-long performance of the opera *Norsang,* which told the story of Prince Norsang and His Quest for His Beloved, we feasted on several fine meals served in the Tibetan style on individual, low, hand-carved tables. Rice pudding, a snack, was followed by sumptuous meals of *tsampa,* yak meat, and noodles in soup, among the dishes.

The following day we continued our journey in a southwesterly direction, heading for the valley of the Tsangchu River, forty miles from Lhasa. Our caravan of three servants, five horses, and five ponies slowly proceeded along the well-worn trade route, led by an ever cheerful Jampa. He had many times before made this journey, accompanying other travelers to India, and pointed out to me the many holy and historical sites along the way. We stopped for a few hours in another broad valley to visit the tomb, at Nyethang, of the great eleventh-century Indian teacher Dipankara Atisa, who played a crucial role in a Buddhist revival in Tibet. The following day we passed the old castle of Chushul, perched on a knife-edge ridge five hundred feet above us, and the slightly lower fort—both in ruins. Situated in a strategic spot overlooking the trade routes from India, Nepal, Bhutan, and Shigatse to Lhasa, Chushul was an important stronghold in earlier days. From here we descended on extremely rocky and narrow trails into the valley.

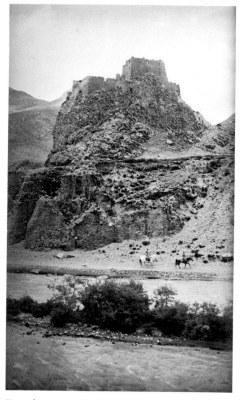

Travelers pass far below the castle and fortress at Chushul, which in earlier days protected numerous vital trade routes leading to Lhasa. (Leslie Weir)

TIBET'S SACRED GEOGRAPHY The great mountains and lakes dotting the land had a special significance for, and influence over, the lives and destiny of our people, representing a "sacred geography." They were considered the abodes of gods and goddesses, and the names for the

mountains and gods were the same. The most popular mountain deities, usually known collectively as war gods, were the thirteen Gods of the Monarch and the nine Gods of Creation. Two groups of female deities were associated with mountains and lakes: the twelve Eternal Protectresses and the five Immortal Sisters. Each peak around the country was the seat of a different deity, from Mount Amne Machin in the extreme northeastern Amdo region to Jomo Lhari on the southern border with Bhutan, and Mount Teci (Mount Kailas) in western Tibet near the Indian border. Mount Everest was known to Tibetans as Jomo Langmo and was considered the abode of the five Immortal Sisters. Among the lakes, the one held especially sacred was Lamoi Latsho, the Sacred Lake, which became associated with the selection process of the Dalai Lamas.

The vast northern plains of Tibet called Changthang are studded with lakes fed by mountain streams that never empty into the sea. By contrast, the waters from the southern ranges feed the springs of several of Asia's great rivers and finally flow into the Arabian Sea and the Bay of Bengal. Around the sacred Mount Teci rise the four rivers Tibetans call Senge Khabab ("Out of the Lion's Mouth"), Langchen Khabab ("Out of the Elephant's Mouth"), Macha Khabab ("Out of the Peacock's Mouth"), and Tachok Khabab ("Out of the Horse's Mouth"). They are respectively the Indus, which flows from Tibet through Ladakh, Kashmir, and Pakistan into the Arabian Sea; the Sutlej, which heads south into India eventually to become a tributary of the Indus; the Ganges, which crosses the Northern Plains of India to reach the Bay of Bengal near Calcutta; and the Tsangpo, which joins the Kyichu River near Lhasa to become the Tsangchu ("The Waters of the Tsang") and which, after having rushed east, then abruptly south, becomes the mighty Brahmaputra in Assam and almost meets with the Ganges at the Bay of Bengal. Other rivers that rise in northern and eastern Tibet flow into the Salween in Burma, the Mekong in Thailand, and the Yangtze and Hwang Ho (Yellow River) in China.

CROSSING THE TSANGCHU 🌸 We had to cross the Tsangchu, and early in the afternoon reached the ferry crossing at Chakzam Drukha, where the river flows at an altitude of 12,000 feet. Although the swift waters are extremely treacherous, the river is navigable for long stretches. Traditional Tibetan boats called coracles (*kowa* in Tibetan) ferried us across, but our horses and ponies had to swim alongside, held by their reins from inside the boat. This tricky operation was expertly handled by my servants and the boatmen, while I examined the coracles more closely. These primitive but extremely practical boats were constructed from several yak hides, sewn together and stretched over a frame. The strong currents always pull the craft downriver, so the boatmen had to carry their lightweight ferries back upstream before crossing again.

After stopping in a small village near the river, we began the slow ascent up the flanks of Kampa La (*la* means "pass" in Tibetan) to 16,000 feet to reach the first of several high mountain passes we had to cross. Bright sunshine, a pleasant cool breeze, and the many fine views along the way made the ascent easy. When we reached the pass, Jampa burst into a joyous "Key Key So So Lha Gyal Lo!" ("Victory to the Celestial Powers!"), as we all added a few stones to a cairn topped by prayer flags,

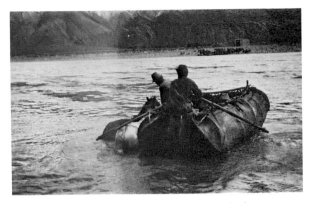

Two men in a *kowa,* a coracle made of yak skins stretched over a willow frame, help their horses to cross the Tsangpo River. (Leslie Weir)

This cairn of *mani* stones with its prayer flag has been built by travelers and added to by others as part of their religious devotions. They bring the stones to the site, where each chants the mantra given on the stone he deposits. (Roderick A. MacLeod)

which had been erected by travelers in lieu of a shrine. Most high passes and hilltops in Tibet were crowned by such cairns and flags.

Once across the Kampa La, we had our first view of the great Turquoise Lake of Yamdok, actually a vast saltwater inland sea. Only a small part of it was visible, since Yamdok measures about 150 miles in circumference. Jampa led us down into the lake basin and along the shores to the small town and fortress of Pedey for our next stop.

Yamdok means "The Upper Pastures." The area was renowned for yak meat, butter, and cheese. The milk of the female yak is thick and rich because of the nutritious high-altitude herbs in these meadows. (To Tibetans only the male is a *yak*; the female of the species is known as *dri*. When Europeans used to speak of our Tibetan tea as "yak-butter tea," we were always greatly amused.) The nomadic herdsmen of the Yamdok district kept large yak herds. These shaggy, sturdy beasts are to Tibet what cattle or water buffalo are to the lower regions of Asia. They not only provided food, but carried heavy loads, and even furnished a coarse wool out of which the nomads made their tents and blankets. But yaks thrive only at high altitudes and cannot survive in the tropical zones south of the Himalayas.

TSANG 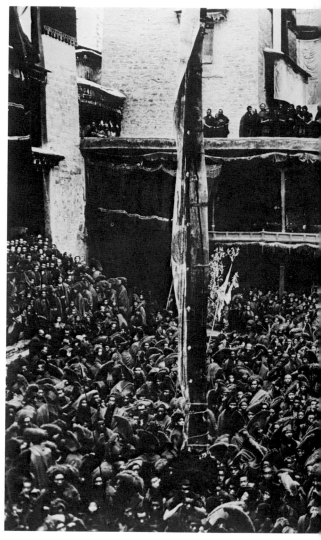 As we continued southwest toward the town of Gyantse, we left the U region and crossed into Tsang. The language spoken in Tsang differs somewhat from my native Lhasean, and there were other subtle changes, such as the headdresses of the women. The girls of Tsang wore elaborate dome-shaped decorations studded with turquoises, corals, and pearls on their heads and large amber and coral beads over their dresses. Turquoises could be found in certain regions of Tibet, but amber, coral, and pearls were brought by traders from as far away as Russia, Burma, and China.

Tibetans were keen traders, an occupation that followed naturally from a nomadic heritage. We encountered large caravans of merchants and pilgrims, united for mutual protection against robber bands. Sometimes they recited the verses of Tibet's great hero epic, the *Kesar Ling,* as they traveled. Traders journeyed south to India carrying wool, salt, musk, borax, and gold, and returned laden with tea, broadcloth, spices, and all sorts of manufactured goods. Often passing one another, we exchanged news and information.

Gyantse was the largest caravan waystation and the second largest town of the Tsang region. It was a welcome rest stop for my servants and animals, and I took the opportunity to visit the monastery and ancient fort. Friends invited me for picnics in the meadows near the Nyang River, where we looked out over fields of barley, mustard, peas, and wheat.

The normal route would have had us go due south from Gyantse toward the border, but I wanted to make a side trip to the provincial capital of Shigatse and the monastery of the Panchen Lama, Tashilhunpo.

The Panchen Lama, second only to the Dalai Lama in secular and religious importance, is also a reincarnation, discovered after the previous Panchen Lama's death in a manner similar to the

Hundreds of monks crowd the courtyard of the Tashilhunpo monastery near Shigatse for a special ceremony. Tashilhunpo is the seat of the Panchen Lama, who is second only to the Dalai Lama in importance. (C. Suydam Cutting)

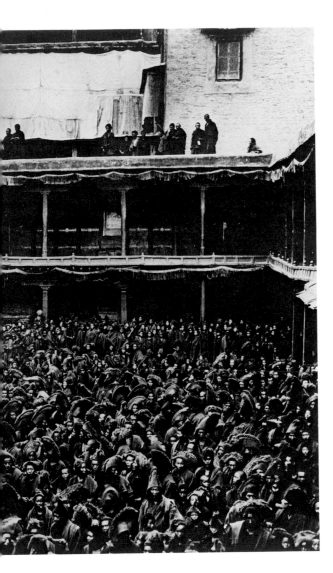

search made for the Dalai Lama's successor. The present incarnation of the Panchen Lama, then only ten years old, was away in eastern Tibet at the time. Still I desired to visit his monastery, one of the largest and richest in Tibet and, with its more than 4,000 monks, a town in itself. Having arrived at Shigatse, I followed crowds of pilgrims to Tashilhunpo, established in 1447, one-half mile beyond the city. The entire monastic complex comprised more than a hundred tombs of the former Panchen Lamas, and several large temples housing religious treasures. Like other great monasteries in Tibet, Tashilhunpo employed its own artisans year round for the printing of woodblocks for books and manuscripts, painters for religious scroll paintings and murals, sculptors, stonemasons, metalworkers, tailors, and others. The main hall of one of the temples housed an impressive statue, many stories high, of Maitreya, the Buddha to Come.

We had to retrace our steps to Gyantse before heading south on the final leg of our journey to the border. Just south of Gyantse, Jampa pointed out the monastic city of Ralung, the original seat of the Drukpa branch of the Kagyupa order, which has since spread to Bhutan and Ladakh.

AUTUMN IN THE HIMALAYAS With several other detours to monastic centers, our journey had already taken several weeks, and autumn was arriving. The temperature dropped as we crossed the many mountain ranges, all running parallel from east to west. One afternoon, while riding across the Kala Thang (*thang* means "plain"), we met a strange party moving the other way. An oddly dressed couple of indefinite origin, but certainly not Tibetan, greeted us politely as we passed. I had seen occasional Europeans and Americans in Lhasa, but these two seemed different: a white man dressed in a peculiar Tibetan costume, wearing a yogin's hat and Tibetan Buddhist prayer beads, accompanied by an Indian-looking lady in equally odd attire. That evening a sudden dust storm caused the two strangers to turn back and spend the night in the same guest house as our party. Thus I had my first encounter with Anagarika Govinda, the now-well-known German-born Buddhist scholar and writer, and his wife, Li Gautami, of Parsee origin, who were traveling to Tibet to continue Buddhist studies.

Flocks of wild geese accompanied us part of the way south. Here and there we spotted wild sheep, mountain goats, antelopes, gazelles, and herds of wild Tibetan asses called *kyang*. Occasionally an eagle or hawk swooped down to catch a marmot or rodent. Much to my joy we also caught a glimpse of some shy musk deer grazing on a mountainside. The air was fresh and the sky as clear and pure as the waters of Yamdok Lake. While we rested at the top of Tang La, 15,000 feet high, I remembered one of my favorite folk songs:

Above looms the blue sky, representing
The Wheel of the Sacred Law;
Below lies the pale earth, like an eight-petaled lotus;
Between them rise the majestic mountains,
Manifesting the eight auspicious symbols.
In the meadows grows a profusion of medicinal plants;

The valleys are adorned with green trees and fields,
While turquoise lakes and rivers dot the farther reaches.
Pure, crisp air forever refreshes life.
The moon shines brighter amidst the glittering stars.
The earth is full of precious treasures.
On this highland humans and nature coexist harmoniously!
The land where spiritual and human law reign supreme,
In the land where celestial powers are revered,
Where animals are partners in life's struggle,
Where birds fly without fear,
Where fish swim in freedom,
Where wildlife is protected,
Where men and women cherish inner peace and outer freedom.

DESCENDING INTO SIKKIM AND INDIA Once our caravan passed the trading center of Phari, we descended slowly from the Tibetan high plateau into the lower, semitropical regions of the Chumbi Valley. Just outside Phari we passed the great snow-covered mountain called Jomo Lhari, "The Celestial Mountain of the Goddess," near the border of Bhutan. Chumbi Valley, known to Tibetans as Tromo, is a wedge of southern Tibet cutting between Sikkim and Bhutan to within twenty-five miles of the plains of Bengal. It is one of the most fertile regions of Tibet. The people of Tromo profited considerably from the trade between Tibet and India, buying at Phari and selling at Kalimpong.

On a fine September day we finally crossed into the kingdom of Sikkim across the 14,000-foot-high Natu La—an unguarded frontier that would be a rarity between most countries today—and descended through lush tropical forests to Kalimpong, the busy trading town and caravansary in northern Bengal.

My first impression of neighboring Darjeeling was bewildering. It was only thirty miles from Kalimpong, but instead of being a bustling Indian market town it was a sedate, dignified, and thoroughly Anglicized British hill station. This small outpost in the northernmost corner of Bengal, below the towering mass of Mount Kanchenjunga, had, after all, practically been founded by the British during the nineteenth century as a summer capital for their civil servants and as a school and resort town for their families. Earlier the Darjeeling district had been part of Sikkim and Bhutan, and many Sikkimese, Bhutanese, and Tibetans still resided there. Besides many Tibetan Buddhist temples, there were Christian schools such as Mt. Hermon, Loreta Convent, and Saint Joseph's College, where I was to have my office. Darjeeling, "The Region of Thunderbolts," was to become my home for many years.

A barefoot nomad couple in rough clothing graze their *dzo*, hybrids that are half yak and half cow, on a broad *thang*, or plain, at Langong. (George Sherriff)

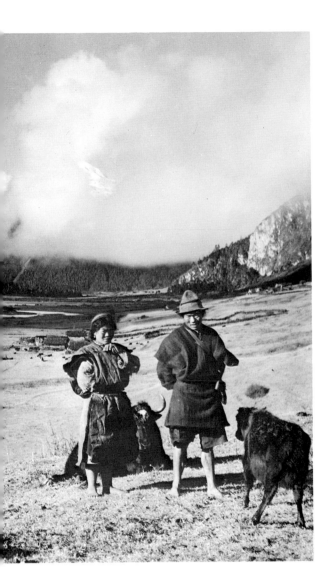

TIBET TODAY When I first arrived in Darjeeling I spoke only Tibetan, and during the next few years I spent all my free time teaching myself English and adapting to both Indian and Western ways. Once I had mastered the new language, I began to read voraciously, especially books about Tibet. At the same time I assisted many Western scholars in their research on Tibetan Buddhism, culture, and history. To my great dismay I discovered that the existing literature on Tibet, written mostly by Europeans, abounded in inaccuracies and exaggerations.

The Western world's image of Tibet had largely been formed through accounts of foreign travelers and writers beginning in the seventeenth century, while Tibet maintained semi-isolation and totally absorbed itself in a spiritual world. Travelogues, personal interpretations, and sensational narratives published on Tibet created a distorted image in the outside world. Although many of the authors were not scholars, but missionaries, trade agents, military officers, and adventurers, their writings are still, even today, considered authentic sources of research and information, much to the chagrin of serious scholars of Tibetan Buddhism and culture. The early travelers had but superficial knowledge of Buddhism in general, no real knowledge of Tibetan Buddhism, and often no knowledge at all of the Tibetan language.

Writers on Tibet fell into several categories. Some tended either to dramatize or distort various aspects of our culture out of ignorance, prejudice, or naïveté, depicting either a country of poor savages or a high plateau peopled by superhuman yogins and sorcerers. Recently, the Chinese Communists have added another myth by inventing stories of a cruel feudal society run by monk dictators. None of these characterizations evokes the Tibet that only Tibetans really knew, the Sacred Realm, which is now lost to us.

Today the Chinese call Tibet an "autonomous region," but the appellation is misleading. All responsible positions are held by Chinese; Tibetans serve only as minor functionaries. Tibetan life has utterly changed. Of more than 3,000 monasteries, nunneries, and temples only twelve remain, and they, like Drepung, Sera, Tashilhunpo, the Jokhang, and the Potala, have been made into museums. The others were destroyed by the Red Guards in the late 1960s and early 1970s during the Chinese Cultural Revolution. The Potala would have been destroyed also had it not been for the personal intervention of Chinese Premier Chou En-lai.

The Chinese banned religious education, but since 1979 they have allowed worship in the surviving temples and monasteries, the wearing of traditional Tibetan dress, and the use of the Tibetan language to some extent in secular education. There has also been some relaxation of the brutally harsh treatment of the people during the 1960s and 1970s.

Whatever the fate of Tibet, the spiritual essence of the Sacred Realm remains in the hearts of the Tibetan people. Our cultural heritage lives, too, in the handful of photographs taken in our country before 1950, all the more precious because they preserve a sense of a time and place that now exists only in our memories.

*Just as the lotus grows up from the darkness of the mud to the surface of the water,
opening its blossom only after it has raised itself beyond the surface,
and remaining unsullied from both earth and water, which nourished it—
in the same way the mind, born in the human body, unfolds its true qualities ("petals")
after it has raised itself beyond the turbid floods of passions and ignorance, and transforms
the dark powers of the depths into the radiantly pure nectar of Enlightenment-consciousness
(bodhicitta), the incomparable jewel (mani) in the lotus blossom (padma). Thus the saint grows
beyond this world and surpasses it. Though his roots are in the dark depths of this world,
his head is raised into the fullness of light. He is the living synthesis of the
deepest and the highest, of darkness and light, the material and the immaterial,
the limitations of individuality and the boundlessness of universality,
the formed and the formless, Samsara and Nirvana. Nagarjuna, therefore,
said of the perfectly Enlightened One: "Neither being nor not-being can be
attributed to the Enlightened One. The Holy One is beyond all opposites."*

Anagarika Govinda

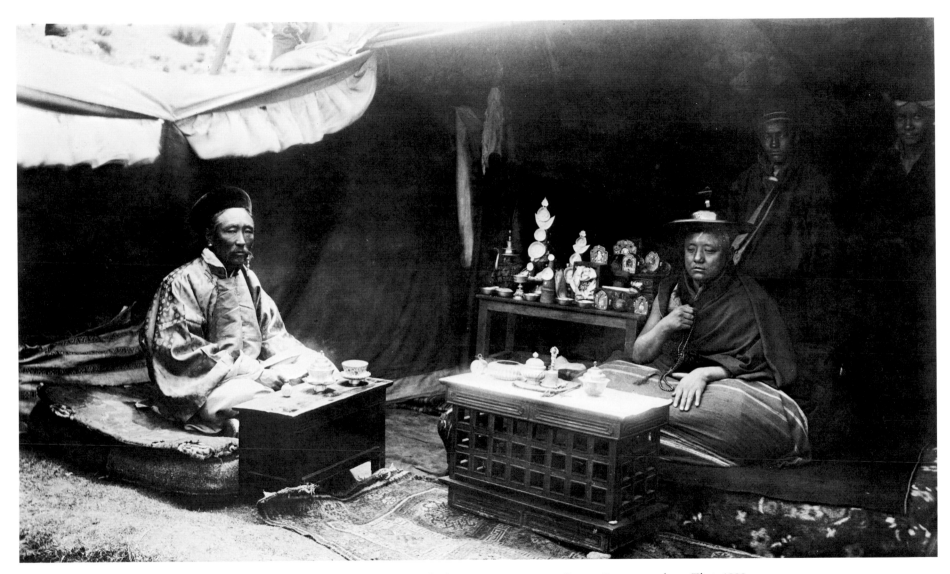

J. CLAUDE WHITE "Badula," an official from Lhasa, and the abbot of Tashilhunpo drinking tea in a tent near Kampa Dzong, southern Tibet, 1903

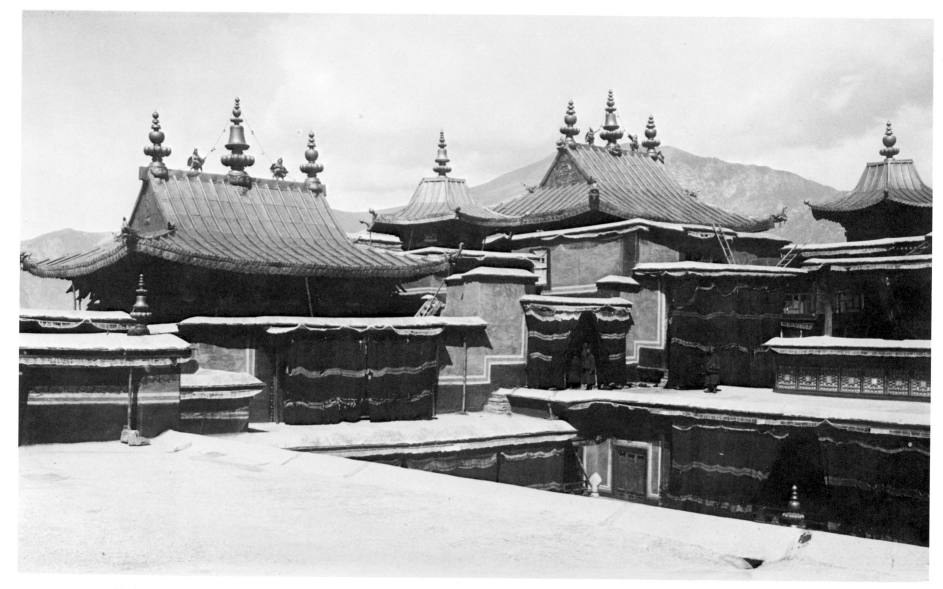

J. CLAUDE WHITE Gilded roofs of the Potala Palace, 1904

J. CLAUDE WHITE "Two men imprisoned for giving aid to travelers in Tibet," 1904. From the Tibetan point of view, these men were British agents. Here, dressed in official garb (the man on the left would have been the secretary of a district official), they have been released by British troops under Colonel Francis Younghusband.

J. CLAUDE WHITE Monument at western gate of Jokhang Temple commemorating a seventh-
or eighth-century treaty with China, 1904. The pock marks on the inscription were caused
by stones struck against the surface for the sound effect.

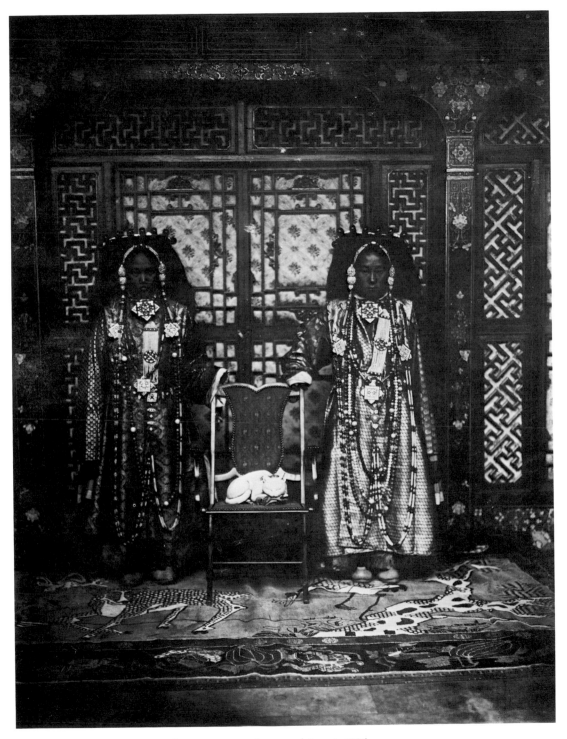

SONAM WANGFEL LADEN-LA Two Lhasa women and a porcelain cat, 1924

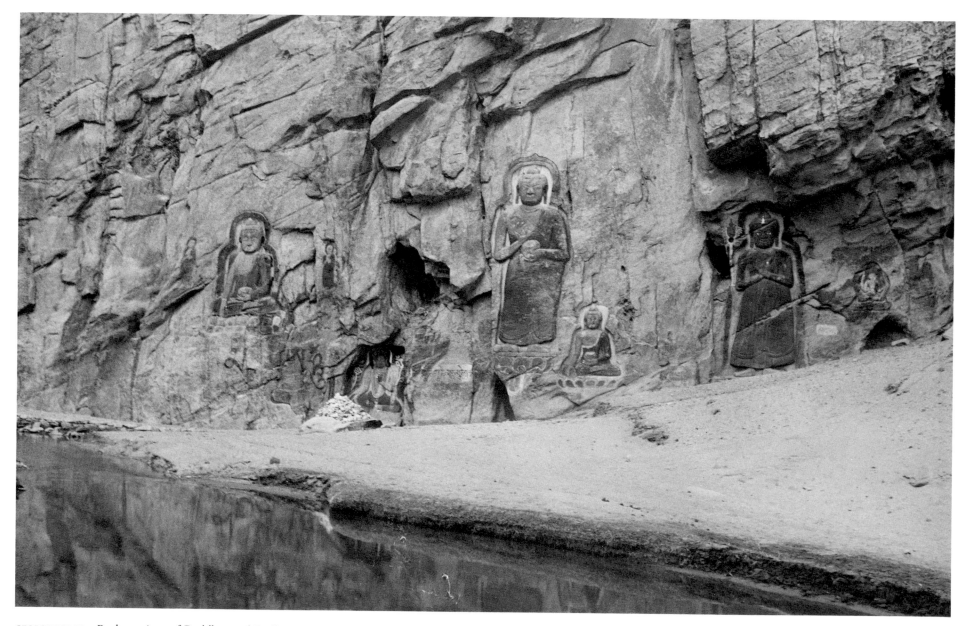

GEORGE TAYLOR Rock carvings of Buddhas and Bodhisattvas near Nyethang, twenty-five miles west of Lhasa by caravan route toward Gyantse, 1938

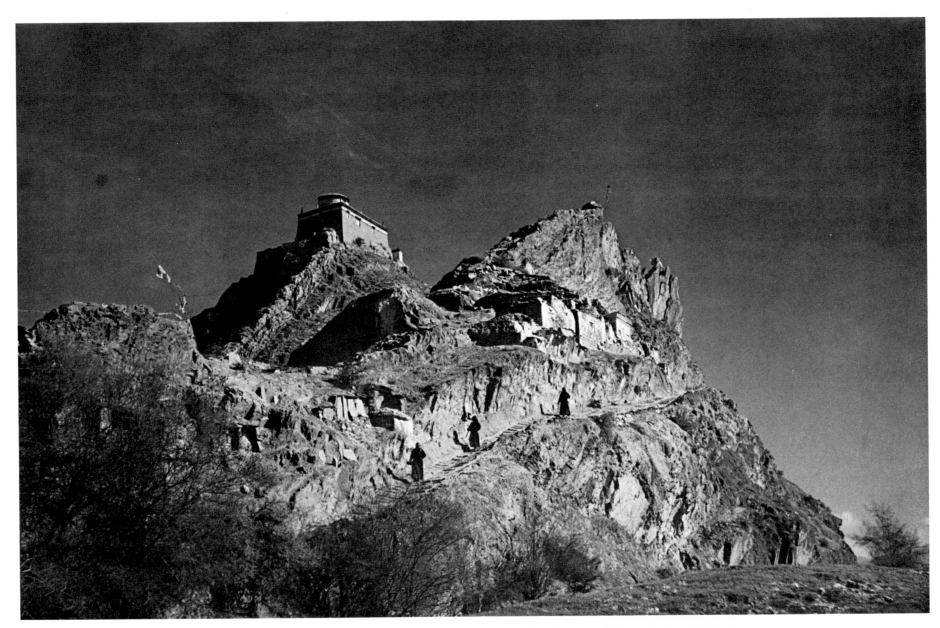

BROOKE DOLAN Chakpori, one of Lhasa's twin hills, with medical college on top and Lingkor, the holy walk around the city, below, 1942–43

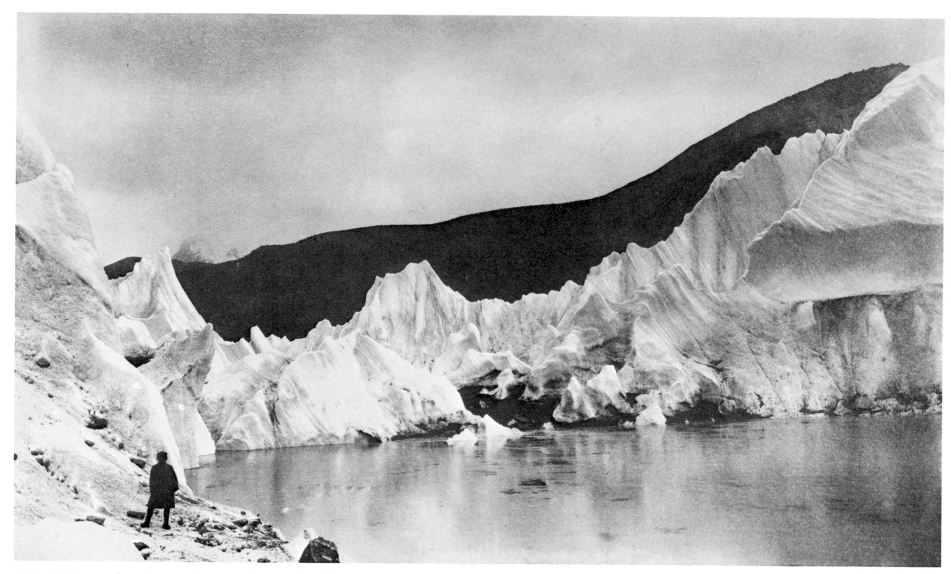

J. CLAUDE WHITE A glacier lake on the Sikkim-Tibet border, 1902

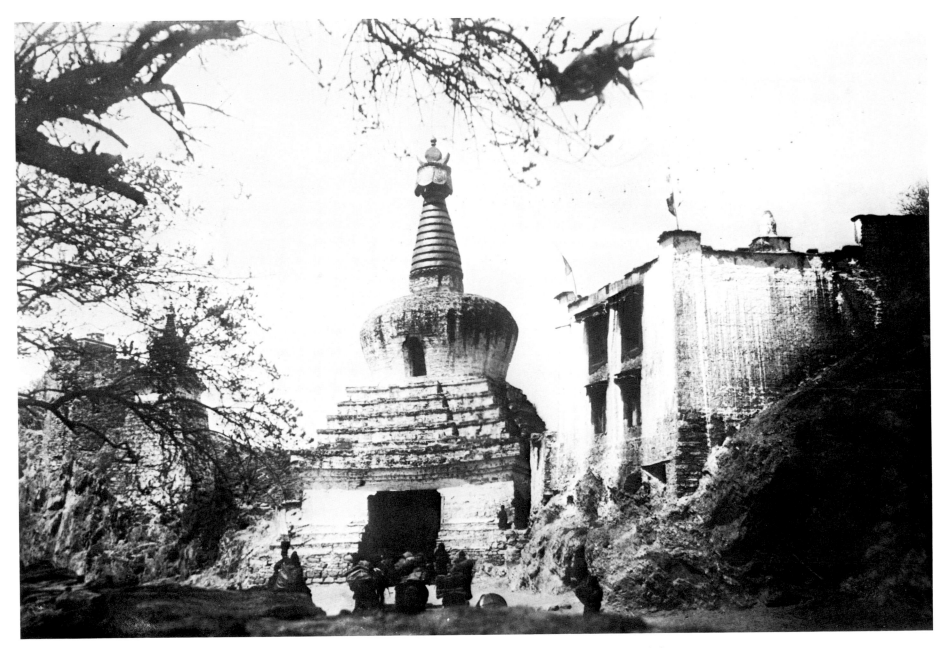

G. Ts. TSYBIKOFF West gate of Lhasa with Chakpori (Iron Hill) to left, 1900. This is one of the earliest known photographs of Lhasa.

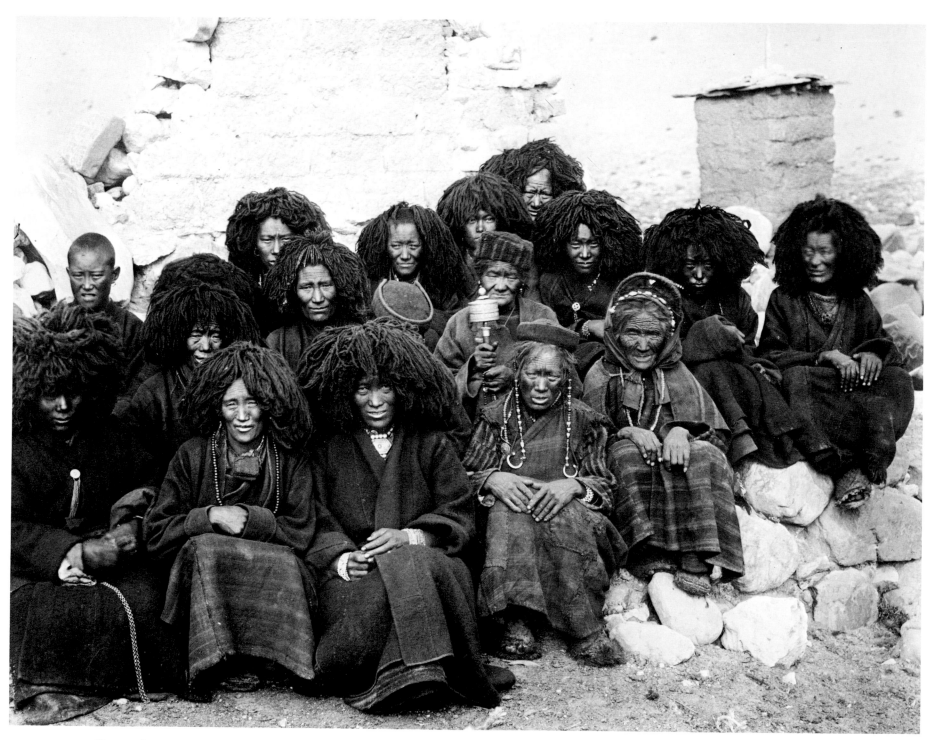

J. CLAUDE WHITE Nuns at the nunnery of Tatsang, 1903

54

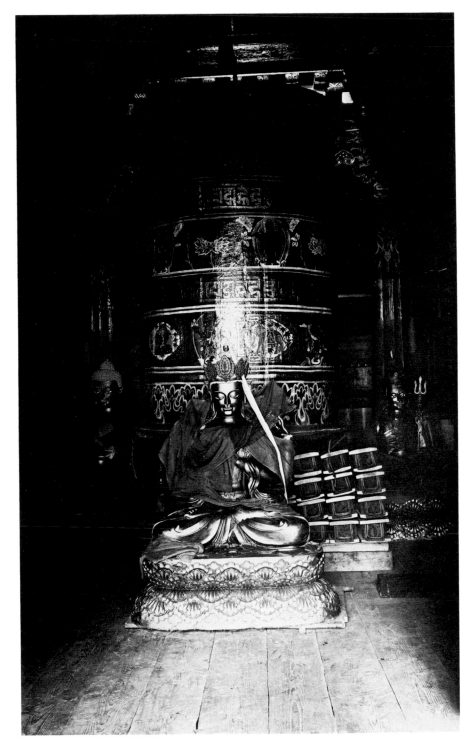

J. CLAUDE WHITE Prayer wheel at Lamteng, 1902

A certain villager had lived all his life by slaughtering animals for the market
and was deeply moved one day by the intelligence of a goat which somehow
pushed his knife out of sight as he was about to butcher it. Overcome with pity
for the goat, and with disgust for his long years of taking life,
he forthwith threw himself from the cliff by a monastery above Sera and
was transported straight to paradise. In a nearby cell in the rock, a hermit of
great reputation for self-denial and piety, who had witnessed this drama and its miraculous
ending, bethought himself that his own reward should at least be
equal to that of a foul-living butcher and resolved to follow his example.
But he was dashed to pieces at the foot of the cliff and
found his way to hell—not paradise.

Popular Tibetan story

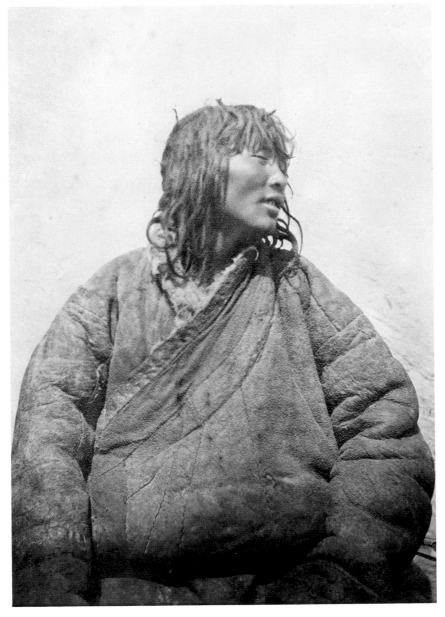

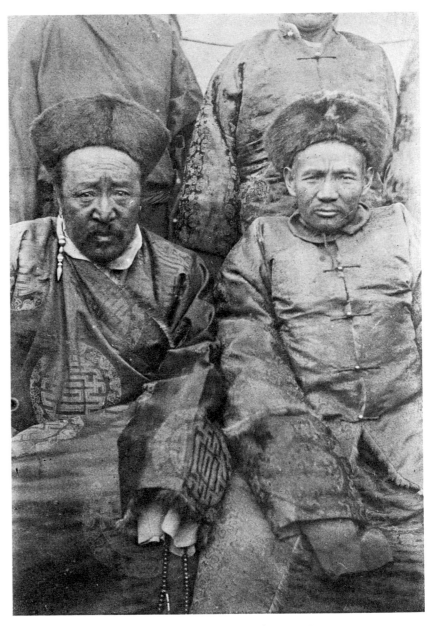

HENRI D'ORLÉANS Nomad in a sheepskin *chuba*, Changthang, 1890

HENRI D'ORLÉANS Officials from Lhasa, north of Lhasa, 1890

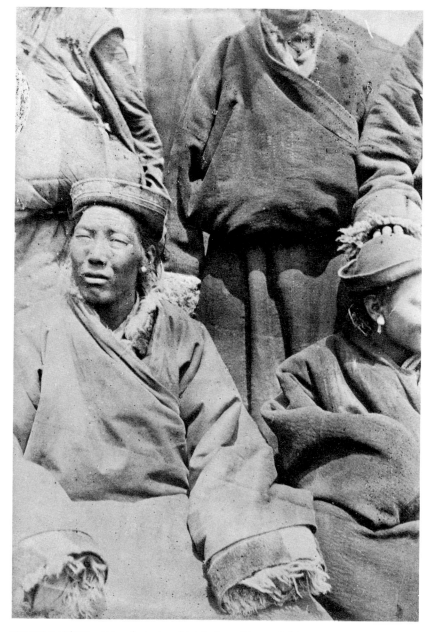

HENRI D'ORLÉANS Attendants to officials from Lhasa, 1890

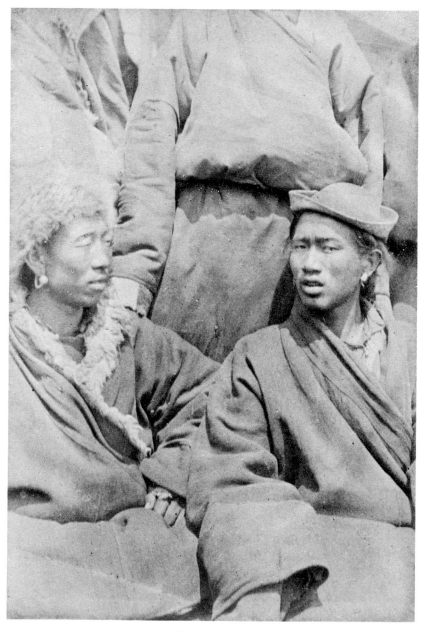

HENRI D'ORLÉANS Attendants to officials from Lhasa, 1890

58

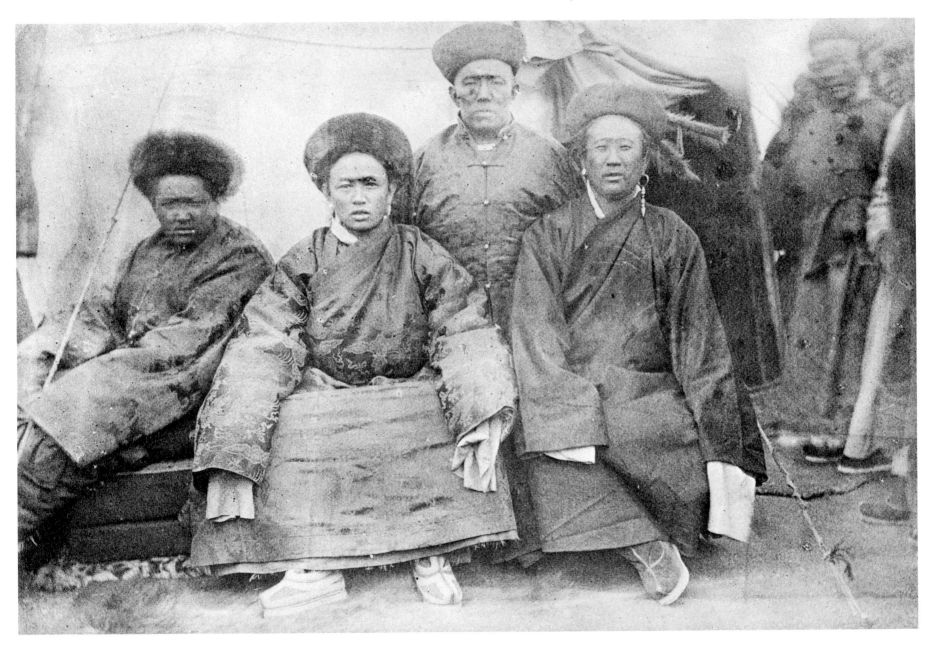

HENRI D'ORLÉANS Officials from Lhasa, north of Lhasa, 1890

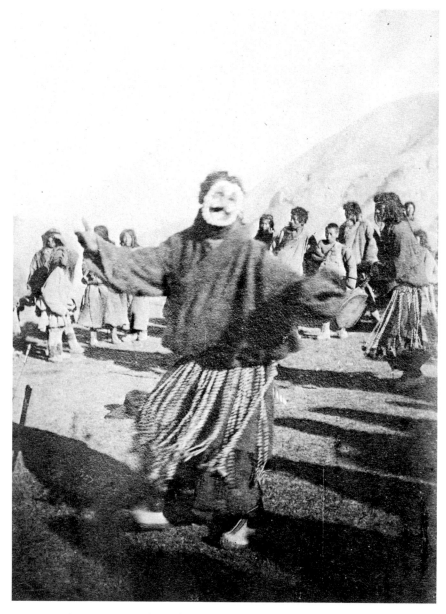

HENRI D'ORLÉANS Dancer of traveling Khampa troupe, Tacheling,
April 25, 1890

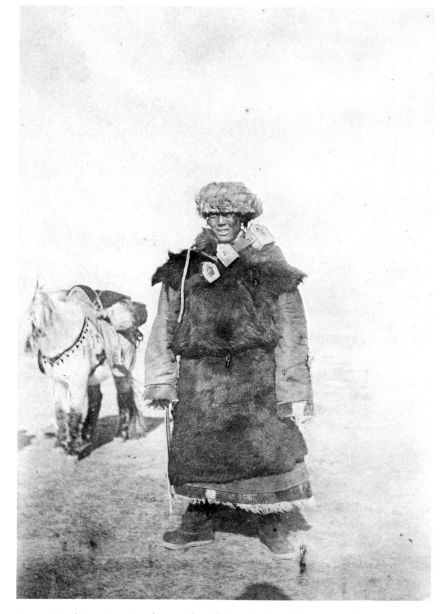

HENRI D'ORLÉANS An attendant to the Chinese Amban (representative
of the Manchu emperor), north of Lhasa, 1890

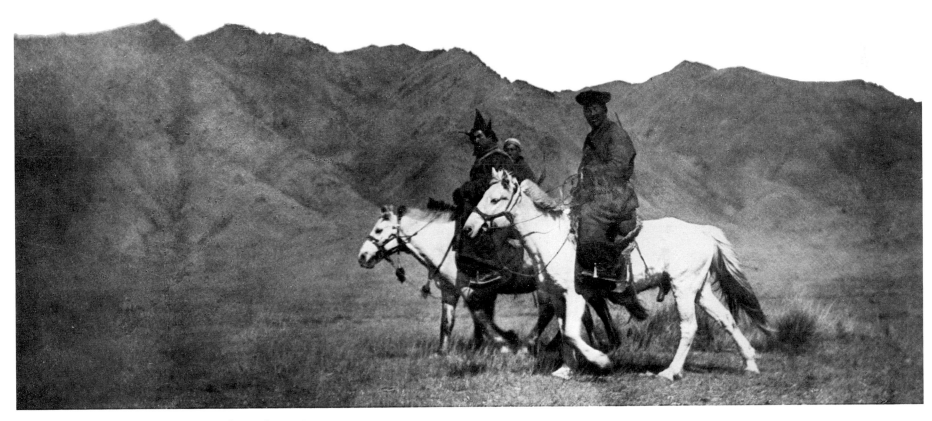

HENRI D'ORLÉANS Mongol horsemen, northern Tibet, 1890

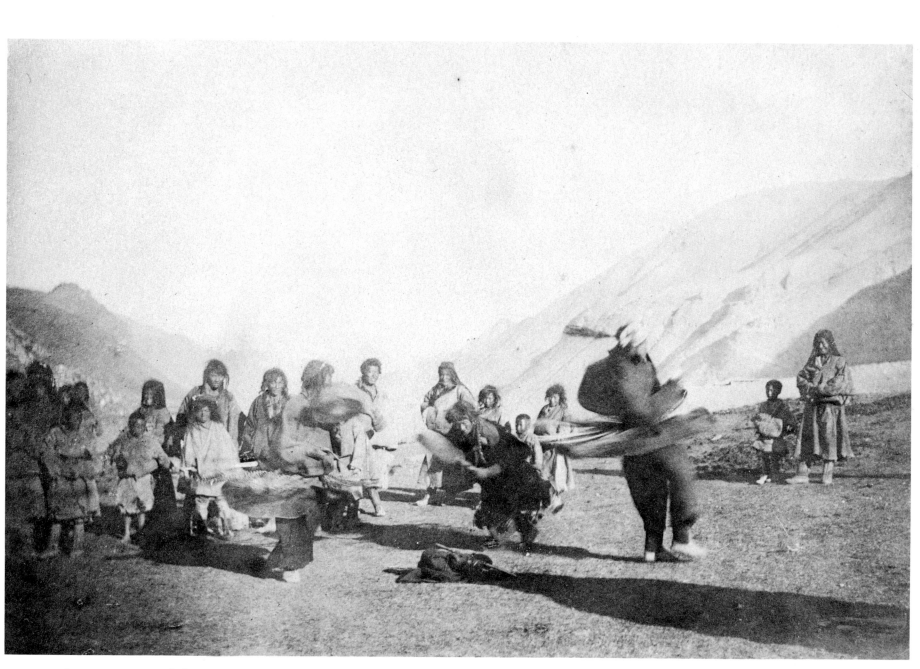

HENRI D'ORLÉANS Dancers at Tacheling, April 25, 1890

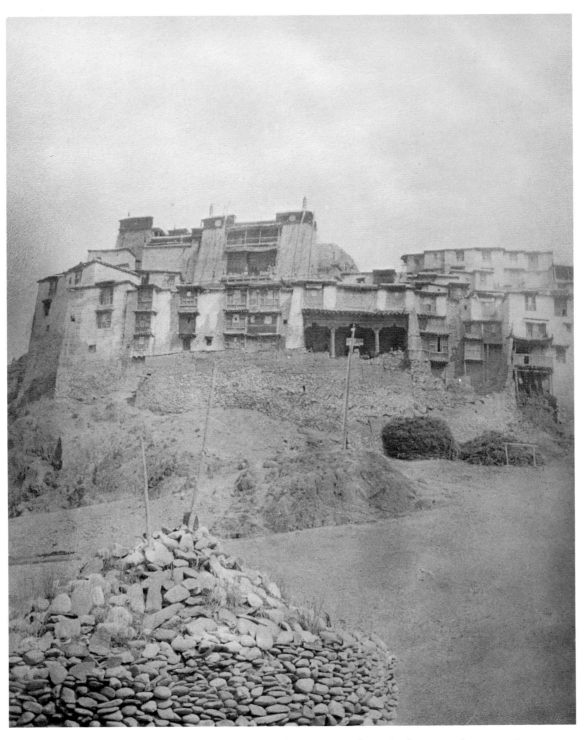

HENRI D'ORLÉANS Monastery at Sok, Tsang region, April 15, 1890. Rocks in the foreground are *mani* stones, painted with mantras and piled at the side of the road by travelers as an act of Buddhist devotion.

In its true state, mind is naked, immaculate;
not made of anything, being of the Voidness; clear, vacuous,
without duality, transparent; timeless, uncompounded, unimpeded, colorless;
not realizable as a separate thing, but as the unity of all things,
yet not composed of them; of one taste [of Ultimate Reality],
and transcendent over differentiation.

Based on the teachings of Padmasambhava

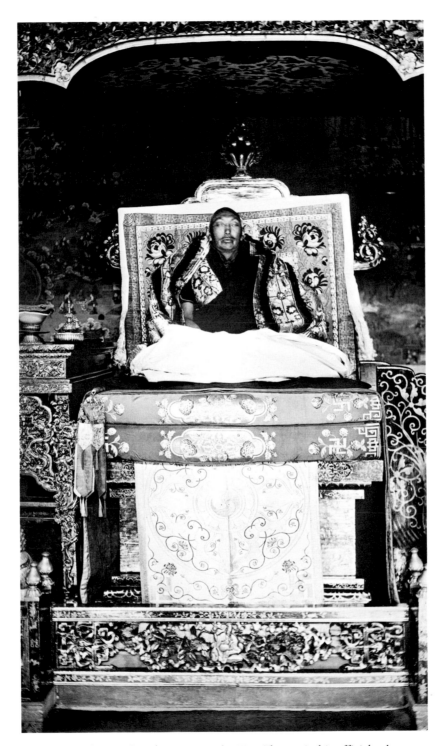

LESLIE WEIR Thirteenth Dalai Lama on the Lion Throne in his official robes, about 1930. The dishes to his right are sacred vessels, and he is surrounded by Buddhist symbols. Seen here near the end of his life, the thirteenth Dalai Lama is weakened by illness.

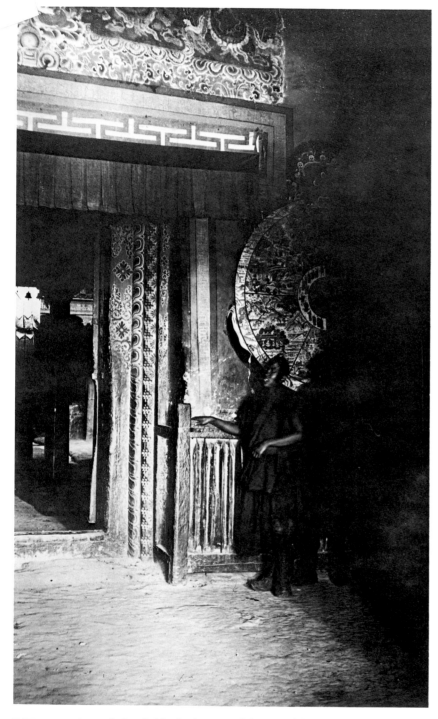

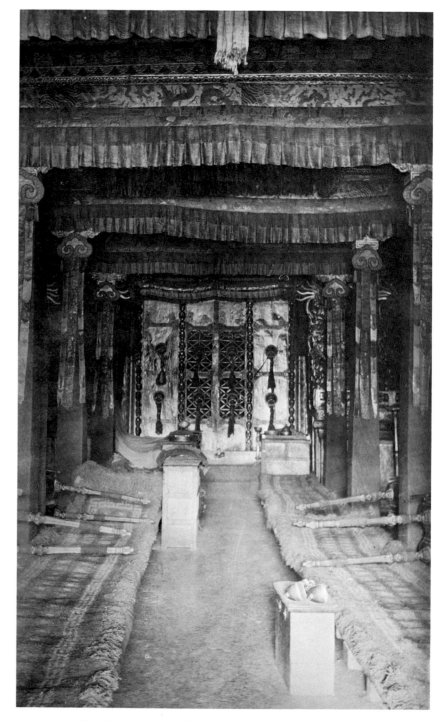

LESLIE WEIR A monk (probably the keeper of the temple) with the
Wheel of Law, Gyantse, about 1930

LESLIE WEIR Chief state oracle's chapel at Nechung monastery,
about 1930

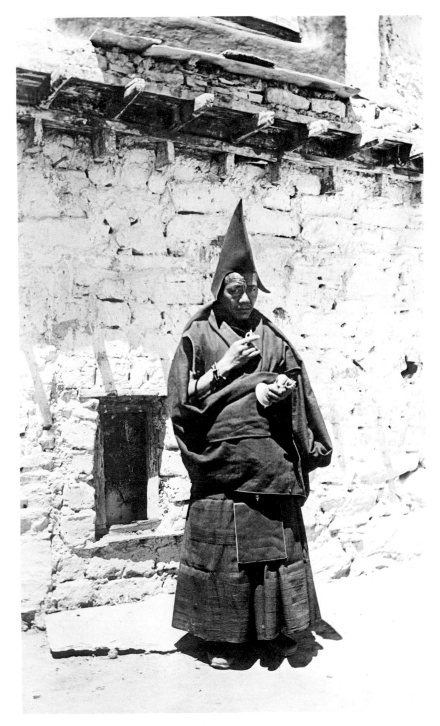

LESLIE WEIR Lama of Jong temple, about 1930

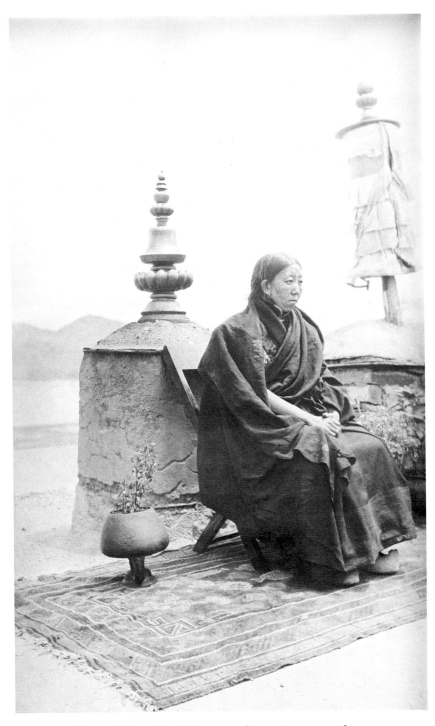

LESLIE WEIR Dorje Phakmo, female incarnate lama, at nunnery of
Samding, about 1930

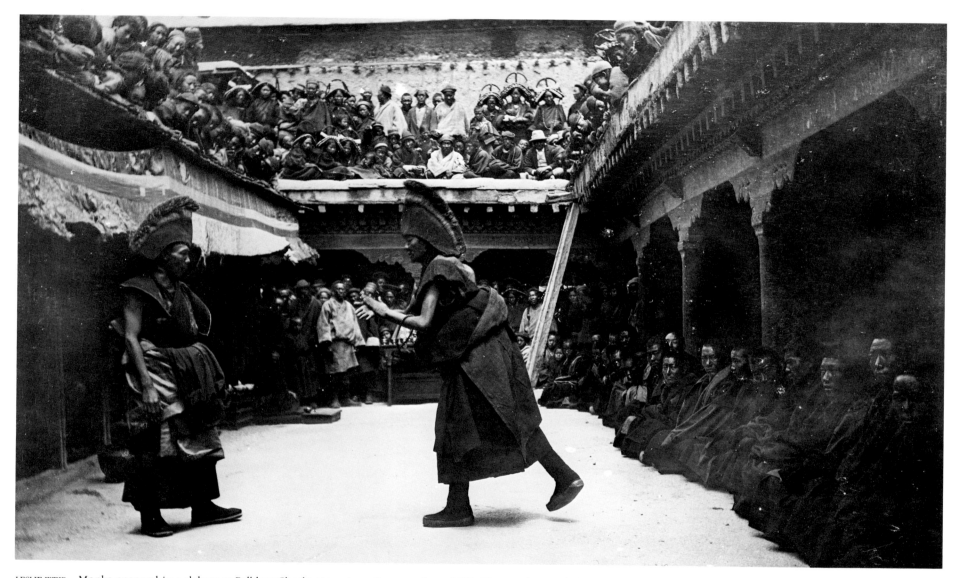

LESLIE WEIR Monks engaged in a debate at Palkhor Chode monastery, Gyantse, about 1930. The monk at right has just finished speaking and signifies that his question is complete by clapping his hands.

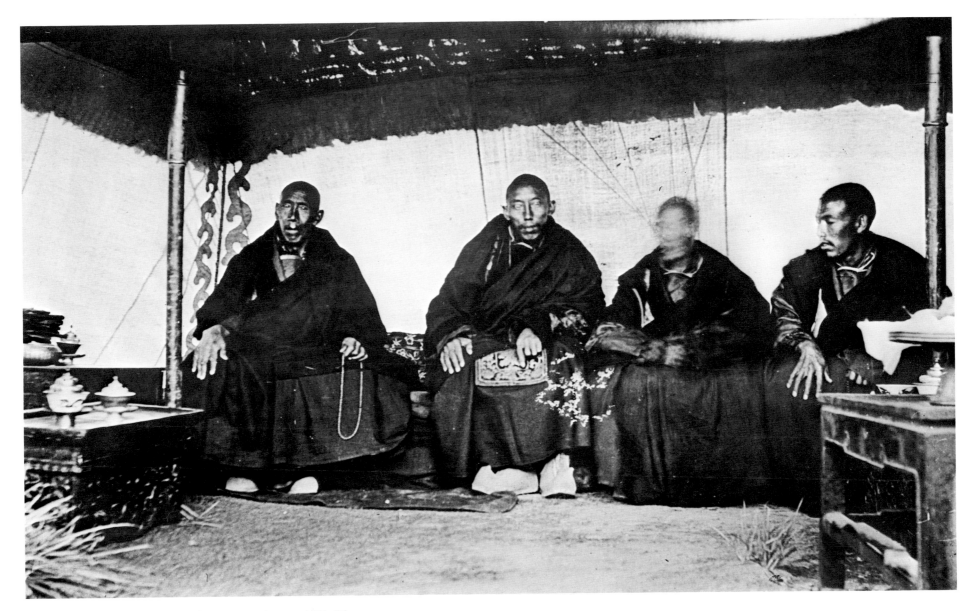

ALEXANDRA DAVID-NÉEL Monastic administrators in tent, 1921–24

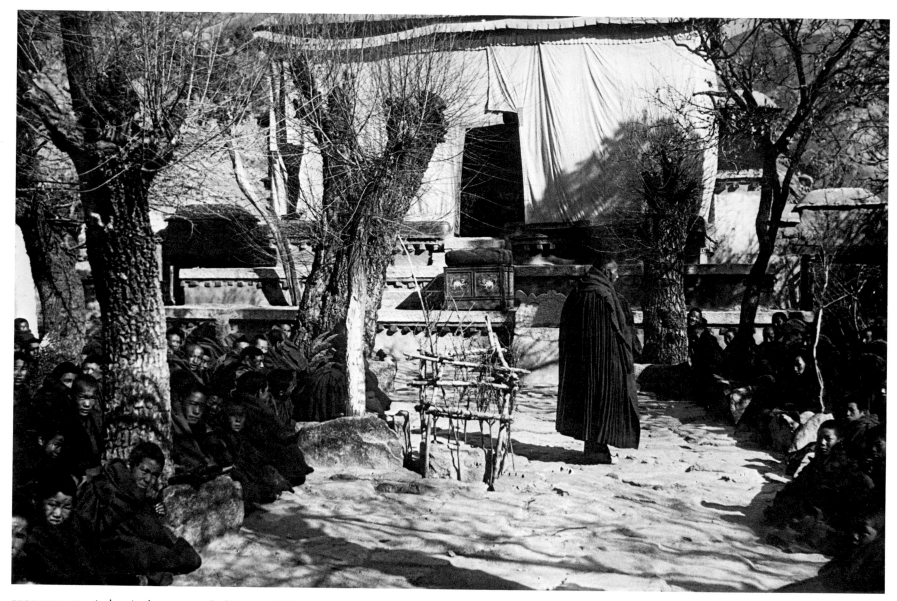

BROOKE DOLAN A class in the courtyard of Deyang College, Drepung monastery, 1942–43

BROOKE DOLAN Tantric ceremony at Ngakpa College, Sera monastery, 1942–43. The monks gradually "became" the tantric deity they invoked, in part by assuming qualities of its appearance.

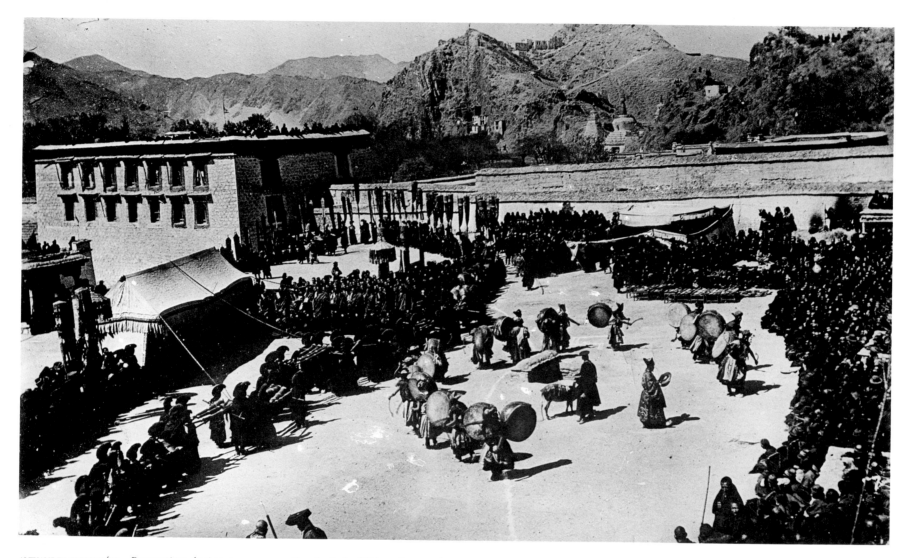

ALEXANDRA DAVID-NÉEL Procession during commemorative festival of Tshogcho, marking death of fifth Dalai Lama, courtyard below Potala Palace, March 1924. Four or five weeks in preparation, this procession was one of the most impressive spectacles in Lhasa. The lamas spent more than a month preparing for the event, unpacking and distributing the special costumes used year after year. The monk drummers at left are passing in review before the cabinet ministers stationed in the tent. In the background is the west gate of Lhasa, seen closest from the opposite side on pages 53 and 120.

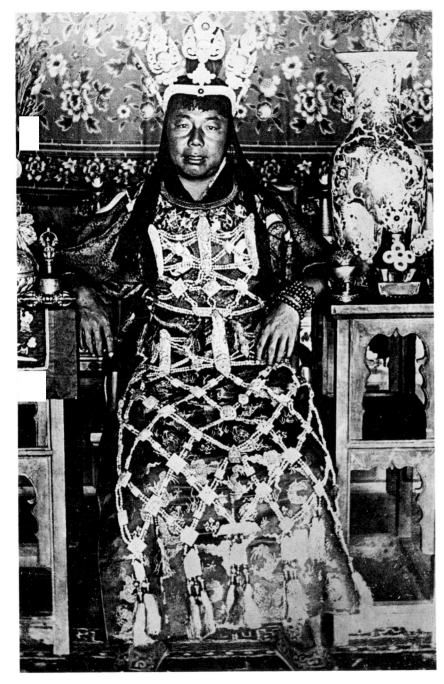

ALEXANDRA DAVID-NÉEL Bon priest in ceremonial costume and flame
headdress, 1921–24

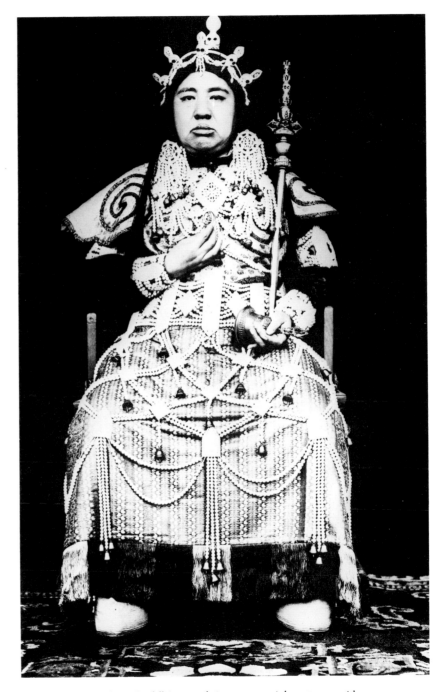

ALEXANDRA DAVID-NÉEL Buddhist monk in ceremonial costume with
ivory headdress and mystic staff, 1921–24

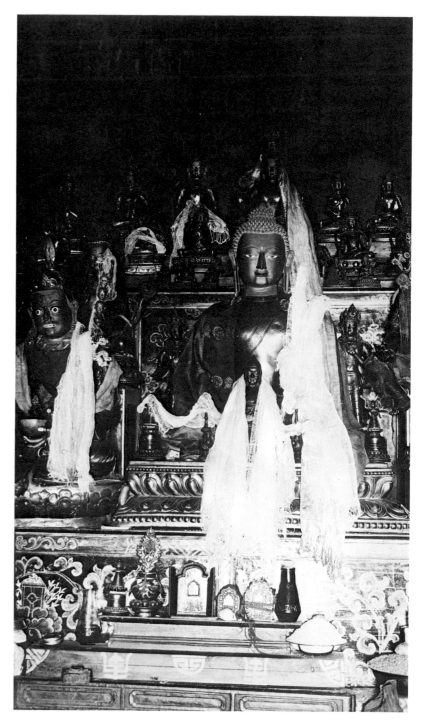

LESLIE WEIR Entrance to Buddhist temple at Gyantse, about 1930.
(Seen also on page 66, left)

LESLIE WEIR Interior of temple at Gyantse with statues of
Padmasambhava (left) and Buddha covered with *khata* offerings,
about 1930

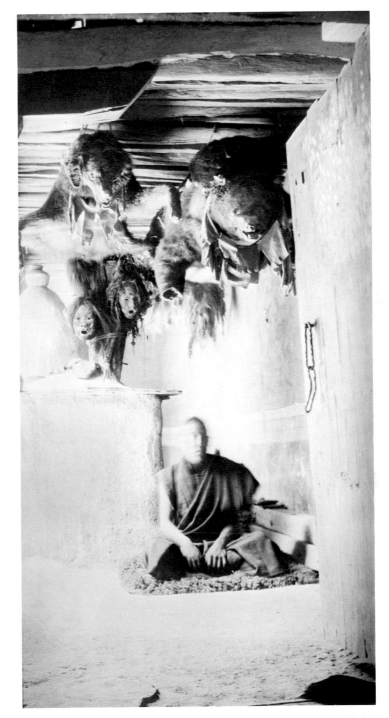

LESLIE WEIR Mystic walled into cave, about 1930. Hand is extended at opening to receive food.

LESLIE WEIR Temple at Tangna, dedicated to Bon gods, with stuffed animals and human heads hanging from rafters, about 1930. As offerings to the gods, worshipers brought live animals to the temple, which were preserved after death.

ALEXANDRA DAVID-NÉEL Meeting hall for communal prayer at Kumbum monastery, 1918–21

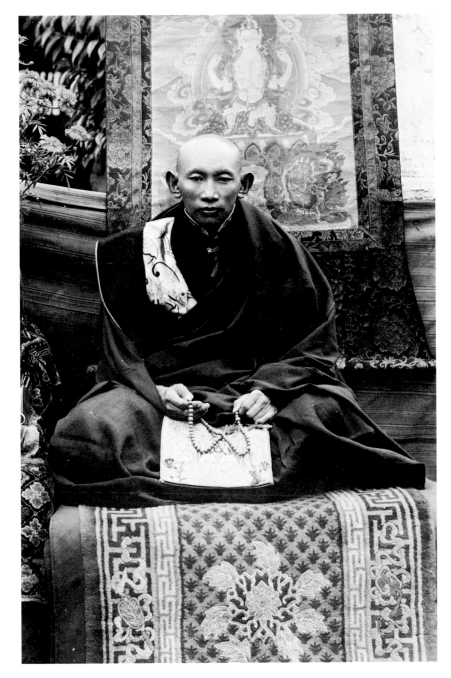

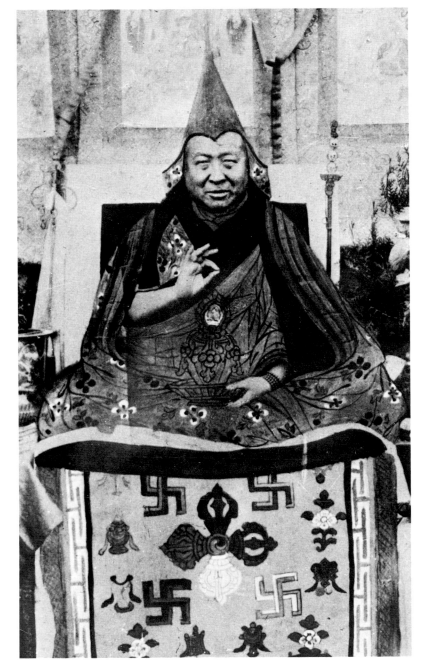

ALEXANDRA DAVID-NÉEL Lama from eastern Tibet in lotus posture on carpet with frog-foot design, 1921–24

ALEXANDRA DAVID-NÉEL Phabong Khapa, high lama from Lhasa, 1921–24

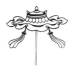

On the following day he paid us a visit in our private chapel. He was still suffering from the after-effects of his trance and complained that his whole body was hurting. He asked whether we had any medicine to relieve the pain, and we gave him some aspirin, which he gladly accepted. But to our surprise he refused to take tea or anything to eat, because, as he explained, it was his rule never to accept food or even tea prepared by others. He lived on a very simple and strictly vegetarian diet and prepared everything with his own hands, because he had to be exceedingly careful to preserve the purity and perfect balance of his body. Any mistake in his diet, any uncleanliness in body or mind, could have fatal consequences, and only by a life of austerity, devotion, and discipline could he protect himself from the dangers to which anybody who offered his body to the Spirit-Kings of the Great Oracle would be exposed.

Anagarika Govinda

ILYA TOLSTOY Chief state oracle at Nechung monastery, southwest of Lhasa, 1942–43. The cabinet ministers (with their backs to the camera) await the oracle's pronouncement of the future, which he sees in the polished steel mirror held in front of him.

Roads! There are no other paths there than those beaten out by wild yaks, wild asses and antelopes. We made, literally made, our way, while I charted the country and captured for the pages of my sketch-book as many views as possible of glorious mountain giants with snow-capped peaks and labyrinths of winding valleys. We penetrated deeper and deeper into the unknown, putting one mountain chain after the other behind us. And from every pass a new landscape unfolded its wild, desolate vistas towards a new and mysterious horizon, a new outline of rounded or pyramidal snow-capped peaks.

Those who imagine that such a journey in vast solitude and desolation is tedious and trying are mistaken. No spectacle can be more sublime. Every day's march, every league brings discoveries of unimagined beauty.

Sven Hedin

SVEN HEDIN View southeast from camp at Tso Ngonpo (Koko Nor, or "Blue Lake"), in Amdo near Chinese border, 1900

SVEN HEDIN Western Tibet, 1907–08

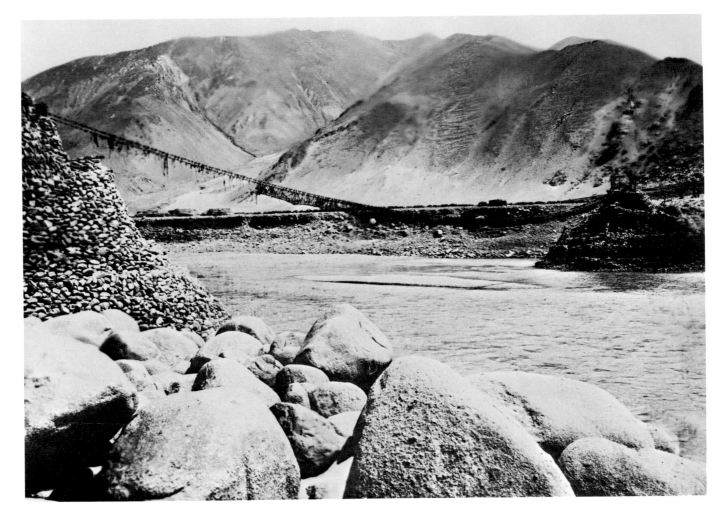

SVEN HEDIN Bridge over Tsangpo between Tangna and Pinsoling, 1907

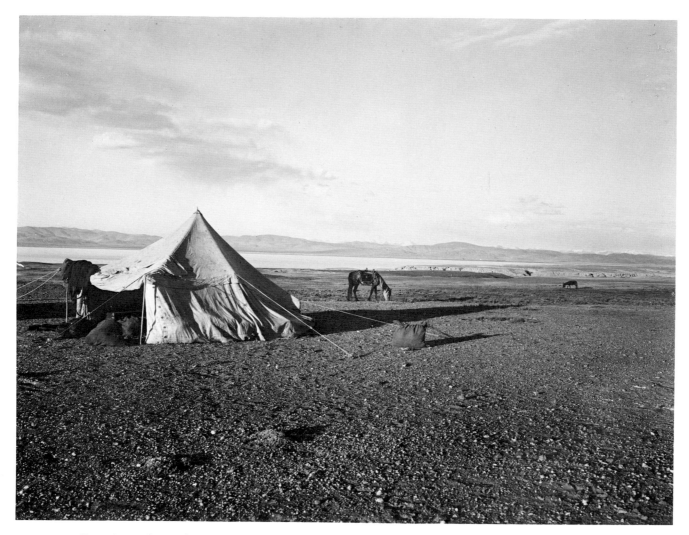

SVEN HEDIN Camp in northern Tibet, 1901

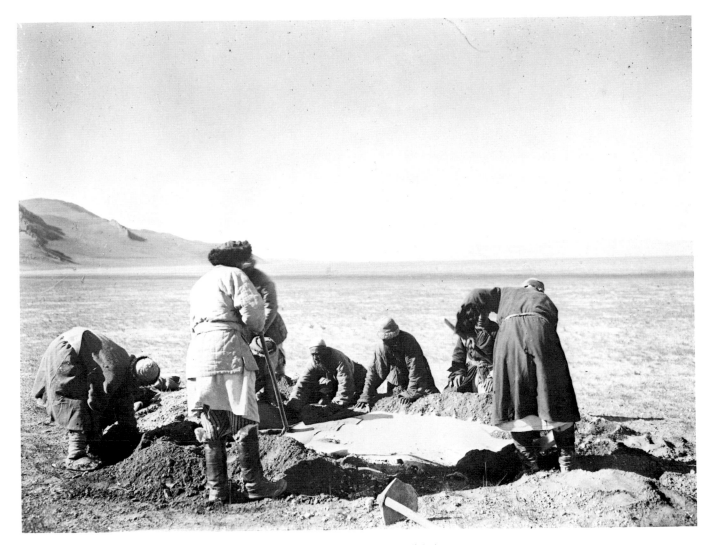

SVEN HEDIN Burial of Calpet, a Chinese Muslim porter, near Nagtshang Tso (lake), 1901

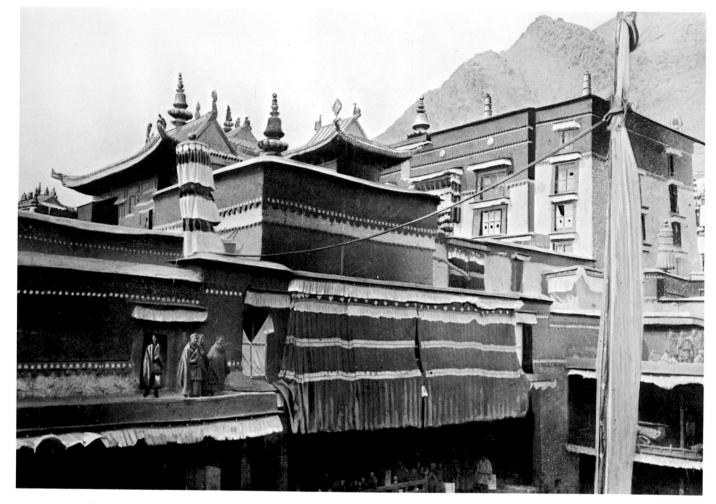

SVEN HEDIN Labrang, one of the monastic colleges of Tashilhunpo monastery, 1907

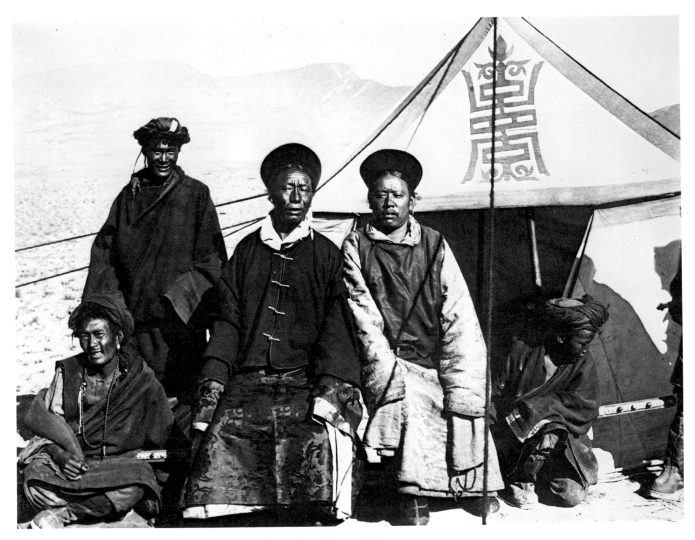

SVEN HEDIN Tsering, governor of Hor region, and another official, 1901

SVEN HEDIN Tsang people at Tangna, 1907

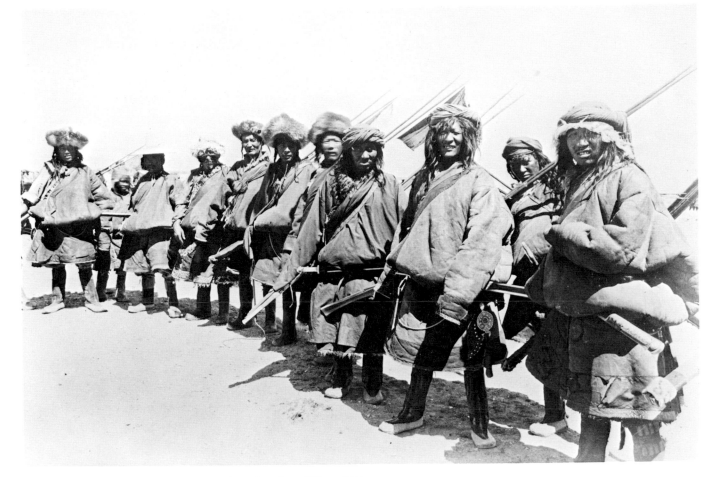

SVEN HEDIN Horpa militia guarding northern border of Tibet, 1901

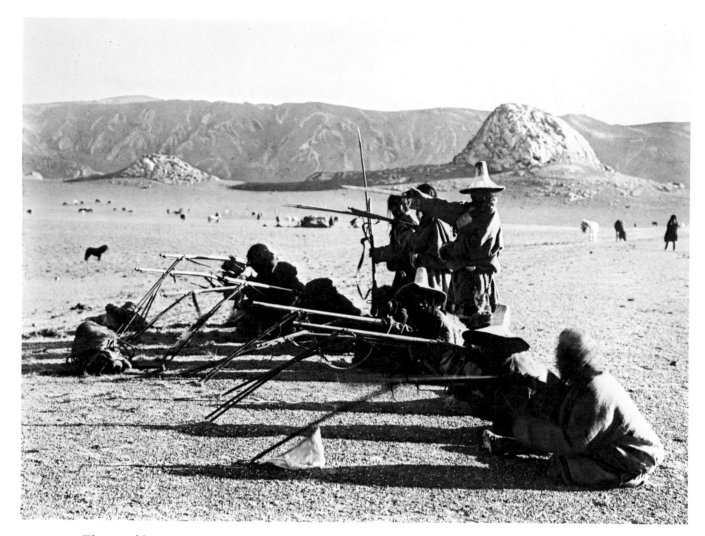

SVEN HEDIN Tibetan soldiers at Yagyu Ragpa, 1901

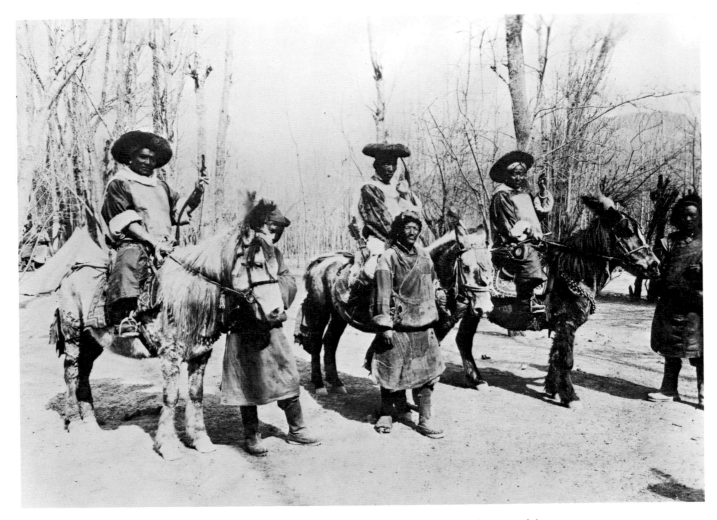

SVEN HEDIN Horse cavalry in Monlam (New Year's) festival, Shigatse, 1907. For this annual event celebrants dressed in the costumes of ancient Mongol warriors.

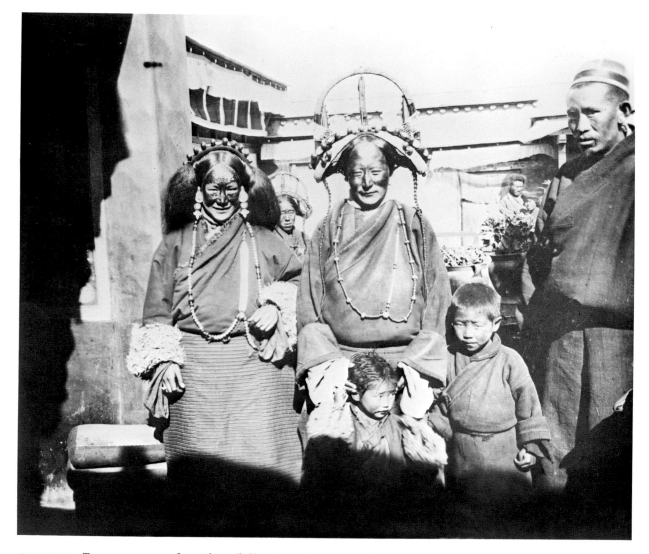

SVEN HEDIN Two women, one from Lhasa (left) and one from Tsang (right), with younger brother of
Panchen Lama (beside a servant at right), Shigatse, 1907

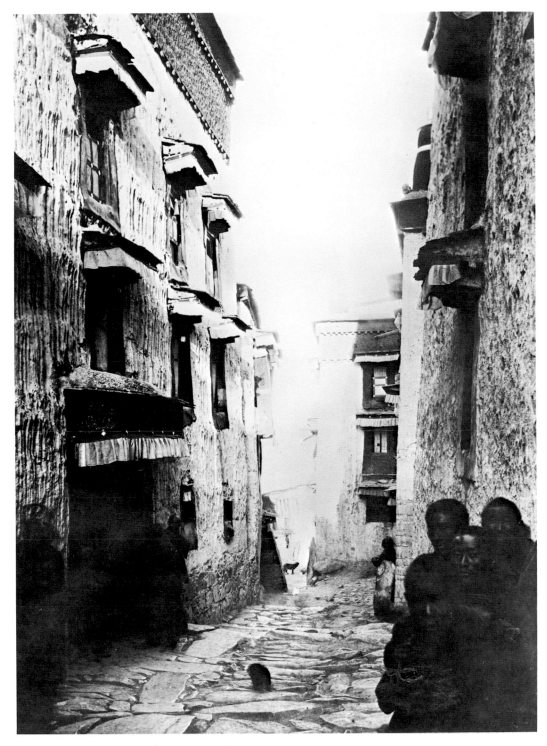

SVEN HEDIN Street in Tashilhunpo, near Shigatse, 1907

Monlam, the big prayer festival, began
on the third or fourth day of the New Year,
depending on whether or not a day was missing
in the first month. This festival celebrated
the Lord Buddha's victory over the malicious spirits
who tempted him during his meditations.
Over twenty thousand monks came to Lhasa
from the nearby monasteries, including the
three greatest monasteries of Tibet, Ganden,
Drepung and Sera, where only a few monks
remained as caretakers. During Monlam the two
City Magistrates of Lhasa had no power,
and discipline was kept very strictly in the city
by the two chief monks of Drepung,
helped by a full staff from the monastery.

During Monlam, tea for twenty thousand
monks was served three times daily at the
Jokhang. There was a special big tea-kitchen,
with several huge caldrons, attached to the
temple, and for months beforehand fuel had
to be collected. Many people gave tea
and butter, because to feed holy monks
is considered very meritful.

Rinchen Dolma Taring

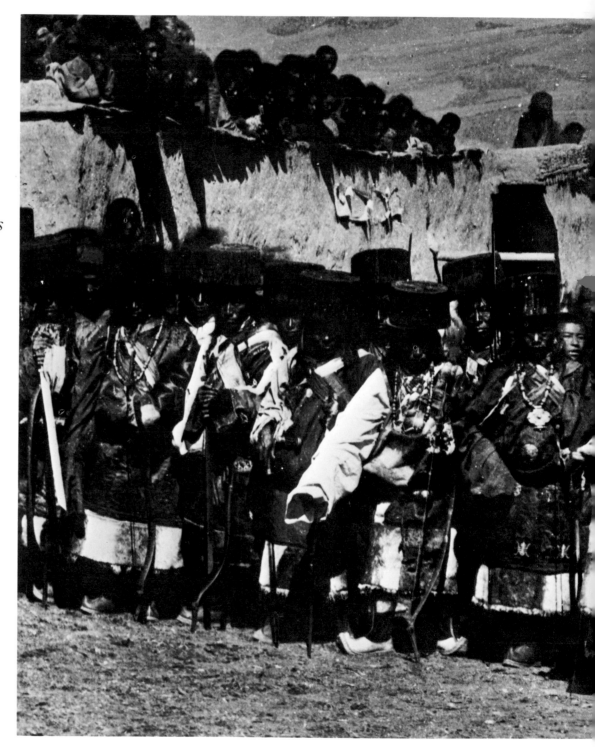

ALEXANDRA DAVID-NÉEL Khampa nomads dressed as soldiers for archery contest, part of Monlam festival, 1924

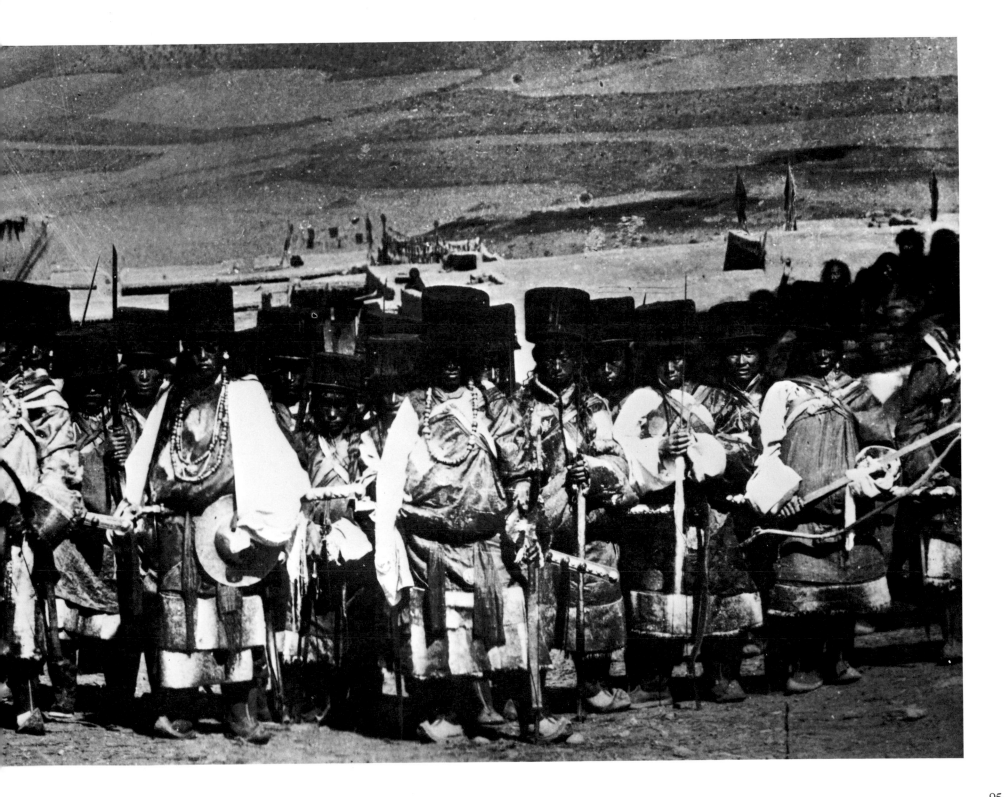

It is one of the great differences between your civilization and ours, that you admire the man who achieves worldly success, who pushes his way to the top in any walk of life, while we admire the man who renounces the world; you, the successful man; we, the saint. The Tibetan does not struggle for worldly success. It would be of no use if he did for he would get nowhere. The top in the hierarchy is the state of incarnate Deity which is of Heaven. No amount of ability will get you there. You are born a Living Buddha or you are not. Next, there is the hermit's cell which is open to all. Then the high dignity of the Abbot. It will come to you, if at all, through self-effacement, that being the quality we think the mark of a good man, priest or layman. It does not occur to the average Tibetan to thrust himself forward.

Rinchen Lhamo

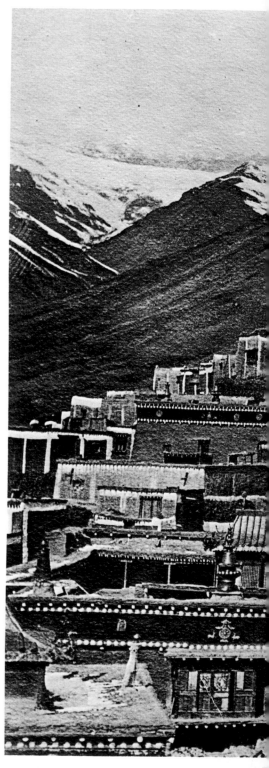

ALEXANDRA DAVID-NÉEL Monastic complex of Jyekund

96

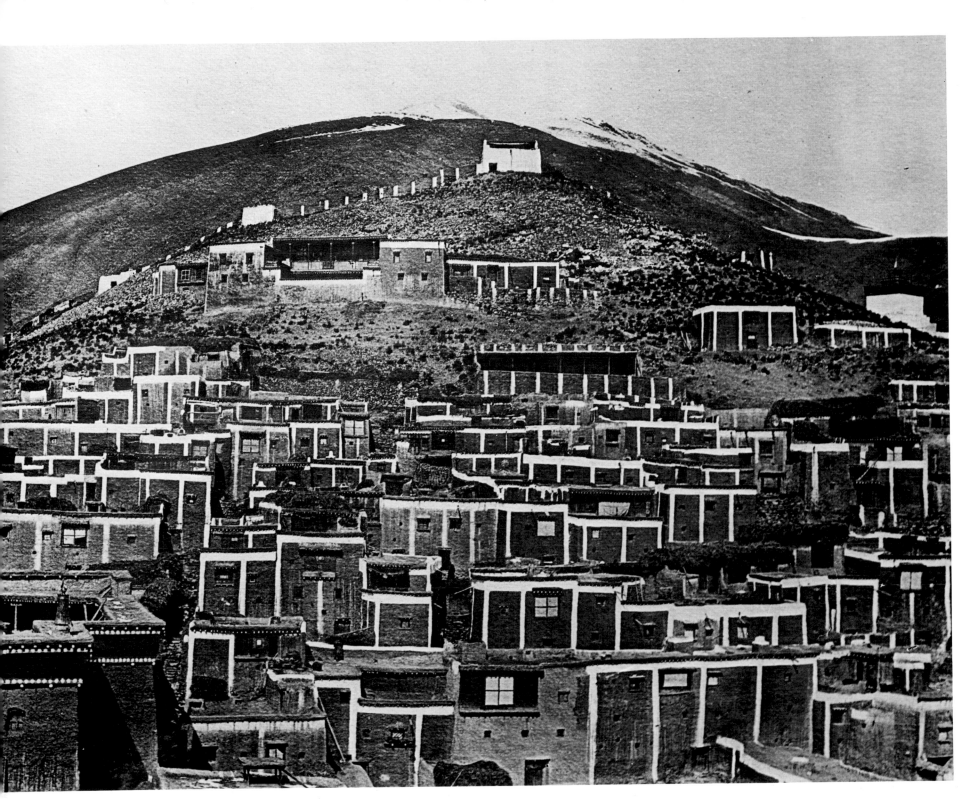

Sakya order, eastern Tibet, October 1921

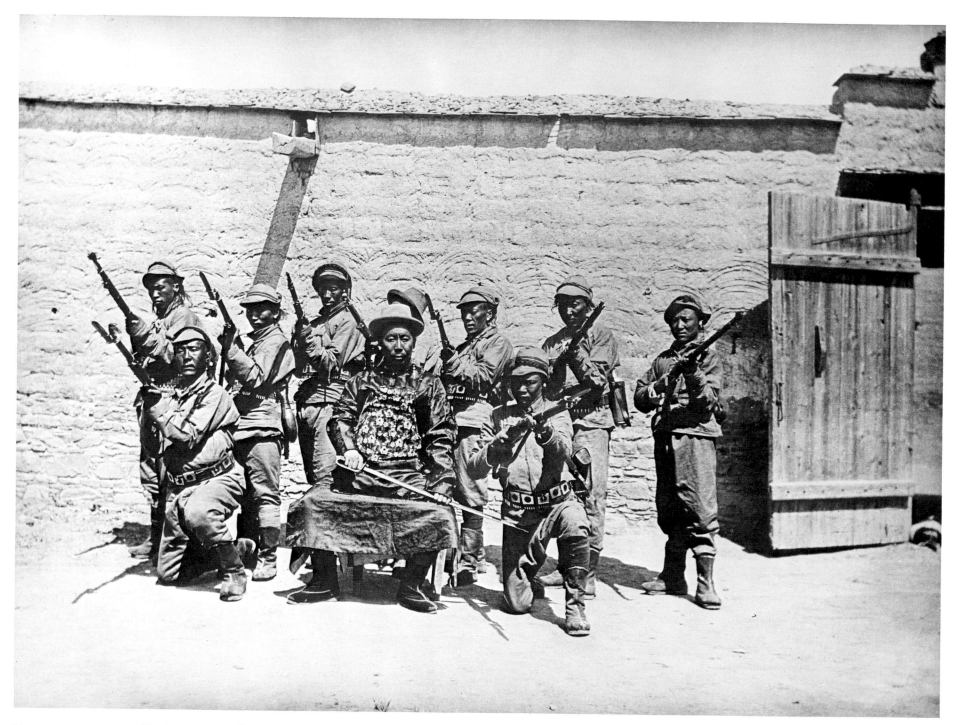

SONAM WANGFEL LADEN-LA District governor of Tsang with soldier-bodyguards, Gyantse Dzong, 1912

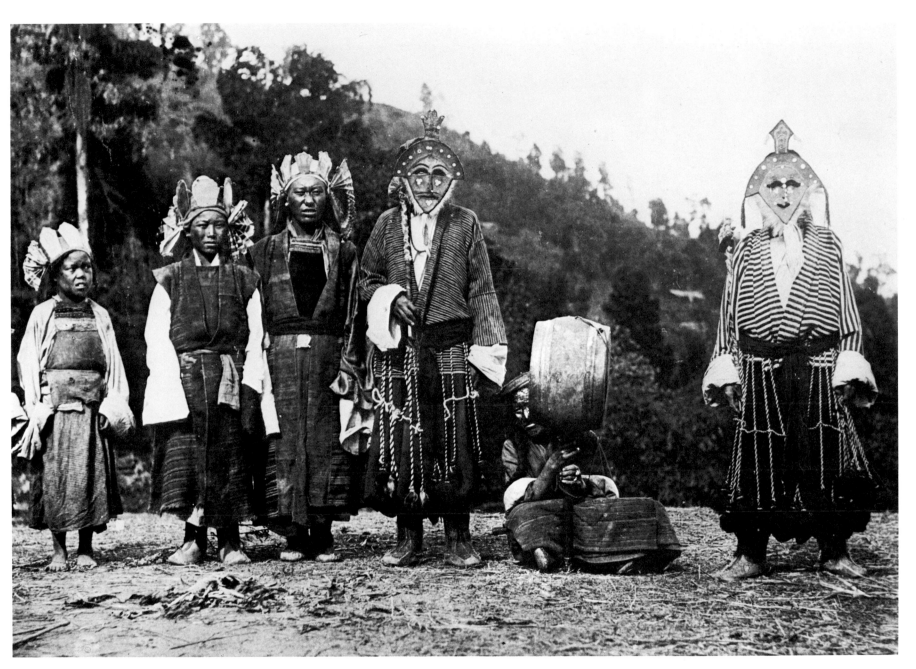

ALEXANDRA DAVID-NÉEL Troupe of professional comedians, 1921–22

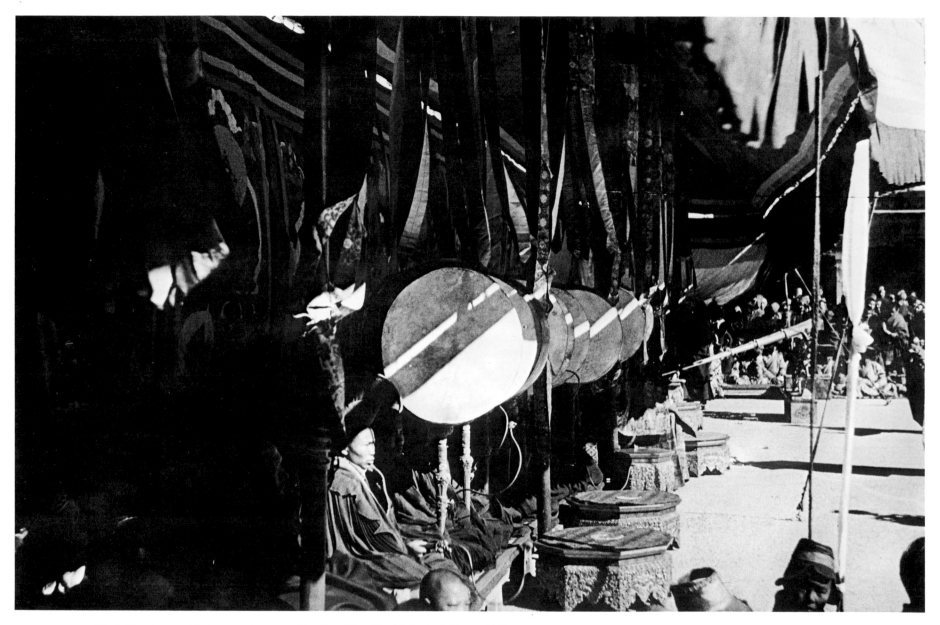

BROOKE DOLAN Black Hat dance with lama orchestra at Monlam (New Year's) festival, Lhasa, 1943

100

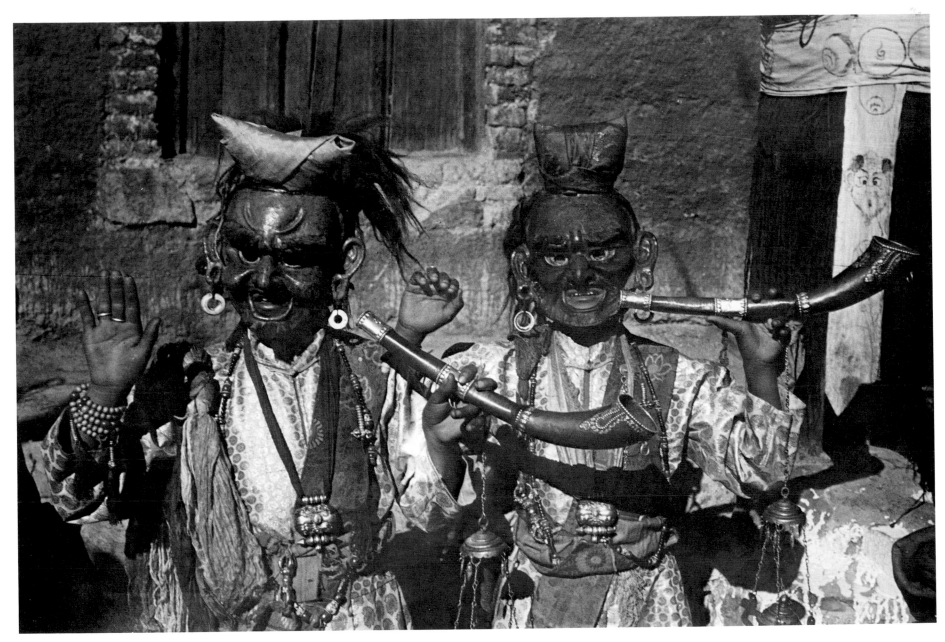

ILYA TOLSTOY Dancers in Cham dance, 1943. The masked dancers provided comic relief in the long ritual.

101

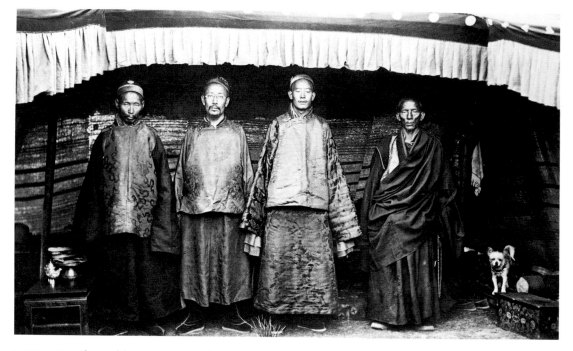

LESLIE WEIR Three abbots and a lama from eastern Tibet, about 1930

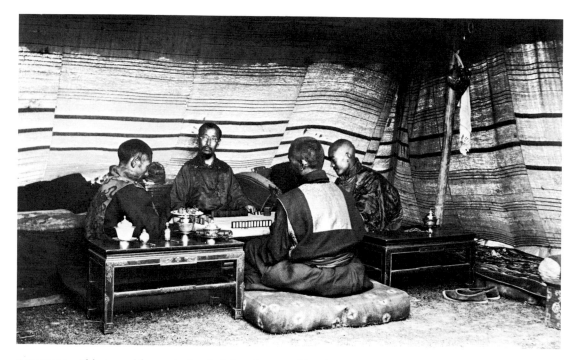

LESLIE WEIR Abbots and lama playing *bakchen* (a game like dominos) inside tent, about 1930

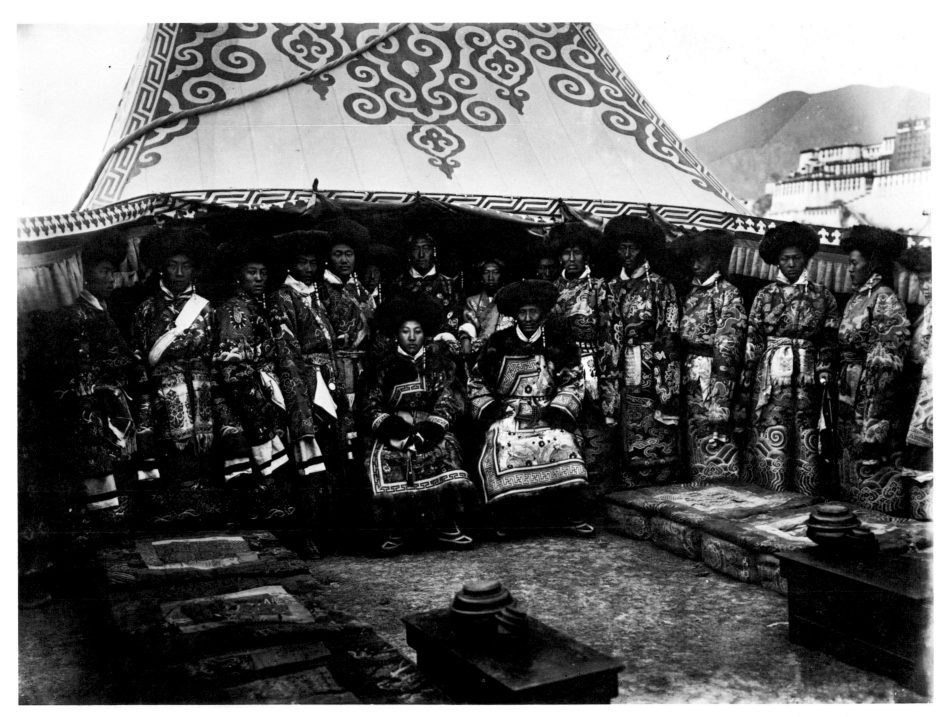

SONAM WANGFEL LADEN-LA Two Lhasa aristocrats chosen as commanders of "troops" at Monlam (New Year's) festival, surrounded by secretaries and attendants, 1924.
A meal has been laid out on tables in foreground: large bowls hold traditional dish called *tsampa,* small dish holds dried cheese.

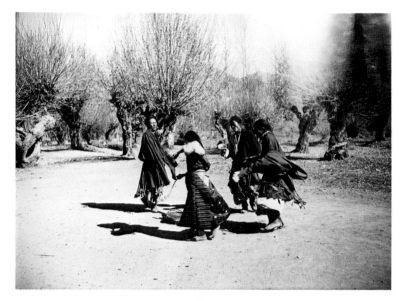

FREDERICK SPENCER-CHAPMAN Group of *ralpa,* traveling
entertainers, performs acrobatic dances, 1936–37

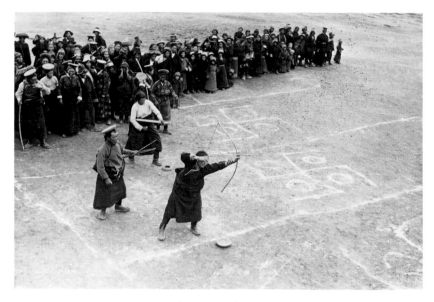

FREDERICK SPENCER-CHAPMAN Monlam festival archery contest, Trapchi Thang,
near Lhasa, 1936–37. Buddhist symbols are marked in chalk on ground.

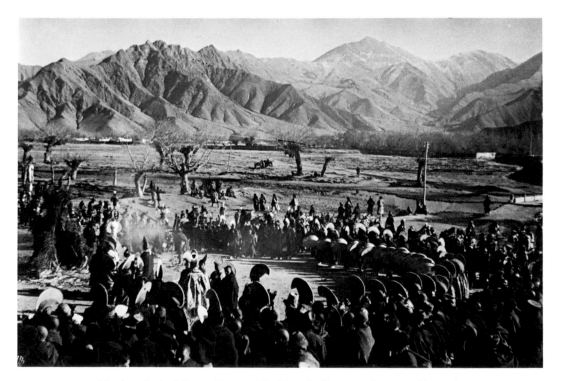

BROOKE DOLAN Monlam festival fire at Lhasa, 1943. *Tormla* (huge sculptures of butter)
were burned to eliminate negative influences, which they symbolized.

FREDERICK SPENCER-CHAPMAN Porters felling trees at camp of diplomatic mission, 1936–37

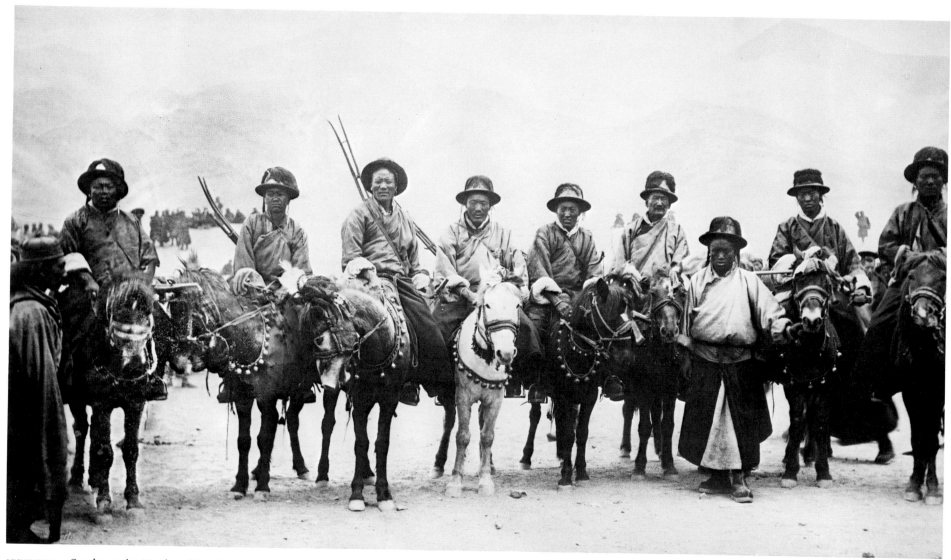

LESLIE WEIR Cavalry at the Monlam (New Year's) festival, about 1930

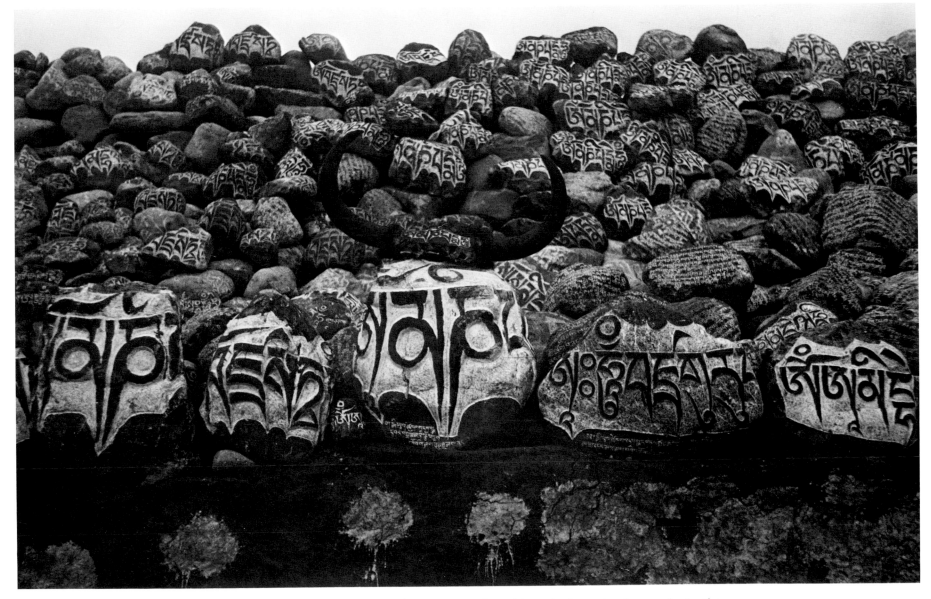

ILYA TOLSTOY *Mani* stones at Kema Gompa, 1942–43. Such intricately carved stones were often whitewashed or painted to emphasize the relief of the mantras carved on them.

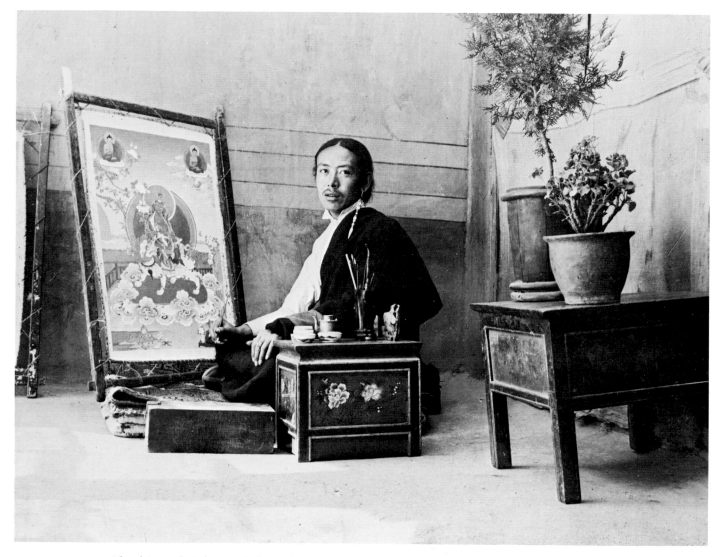

C. SUYDAM CUTTING The thirteenth Dalai Lama's favored artist painting a *tanka,* 1937.
His long earring identifies him as a lay official.

*For the divinity lodged in the painting saves
the bearer from the perils of his journey.*

Giuseppe Tucci

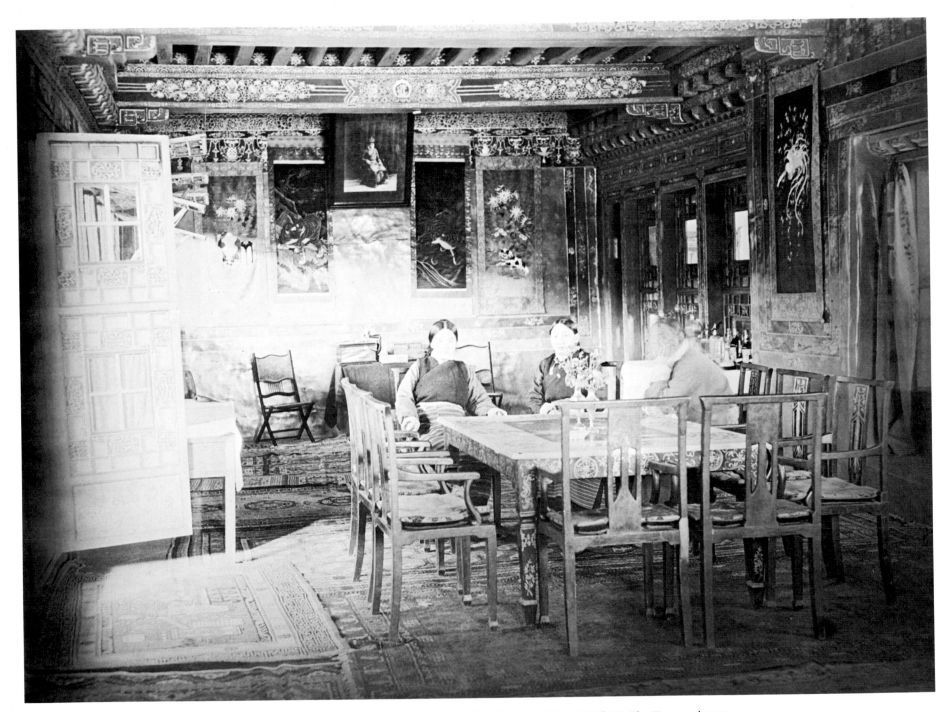

FREDERICK SPENCER-CHAPMAN Tsarong family—one of the wealthiest families in Tibet—in their house in Lhasa, 1936–37. The Tsarong house was probably the only dwelling in Tibet with a room decorated with Western-style furniture. Rinchen Dolma Taring, the woman at left, sister of the wife of the man at right, emigrated to London, where she published *Daughter of Tibet* in 1970.

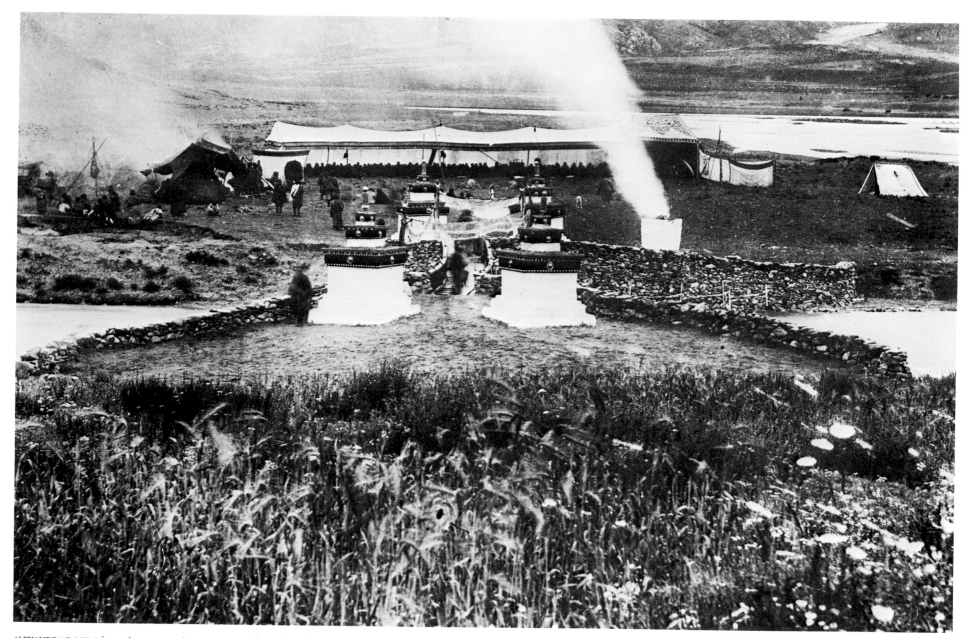

ALEXANDRA DAVID-NÉEL A summertime monastic festival following a religious retreat, 1923–24

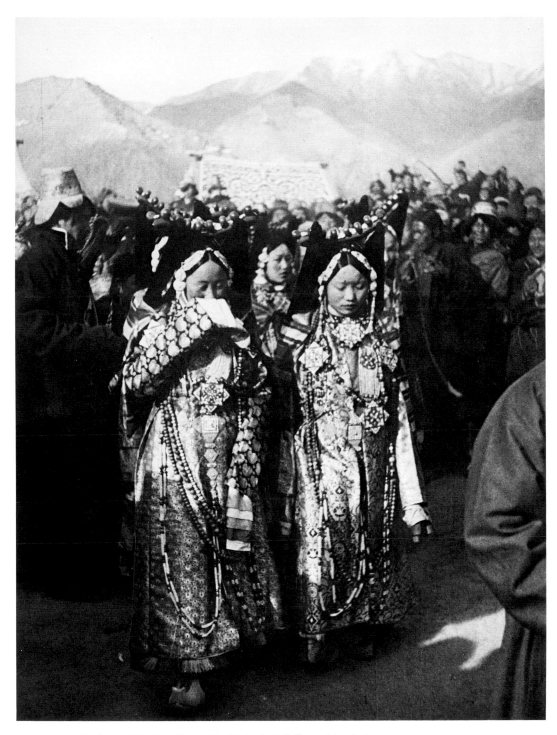

ILYA TOLSTOY Ladies at Monlam (New Year's) festival, followed by their
maids, Trapchi Thang, outside Lhasa, 1943

Seek a master thoroughly enlightened in spiritual matters,
learned, and overflowing with goodness.
Seek a quiet and pleasant place which appears to you suitable
for study and reflection, and remain there.
Seek friends who share your beliefs and habits and in whom you can put your trust.
Think of the evil consequences of gluttony and content yourself, in your retreat,
with the amount of food that is indispensable for keeping you in good health.
Follow the regime and the mode of living that are calculated
to keep you healthy and strong.
Practice such religious or mental exercises as develop your spiritual faculties.
Study impartially all teachings that are accessible to you,
whatever be their tendencies.
Keep "the knower" within you ever fully active, whatever you may do
and in whatsoever state you may find yourself.

Gampopa

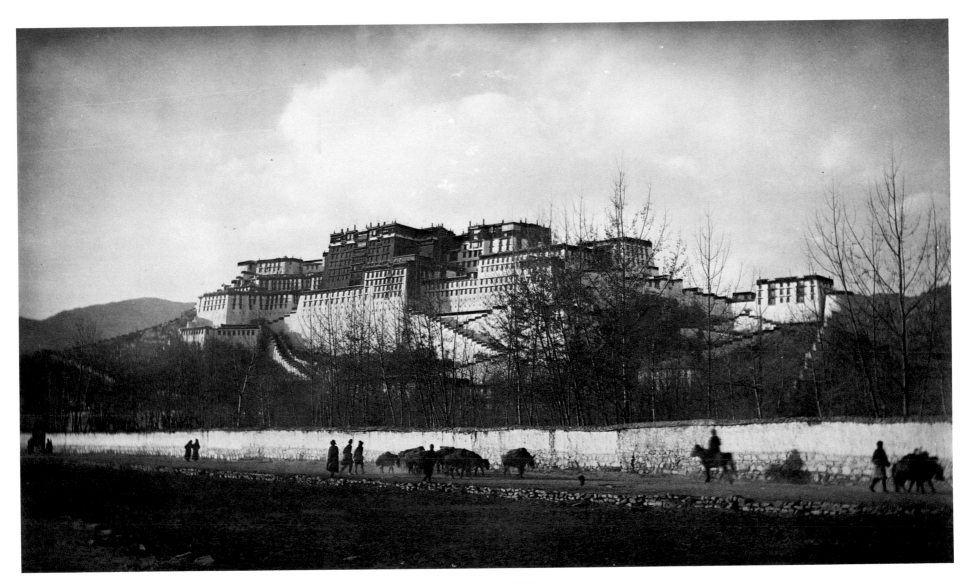

LESLIE WEIR Potala Palace from the southeast, with road to center of Lhasa in foreground, about 1930

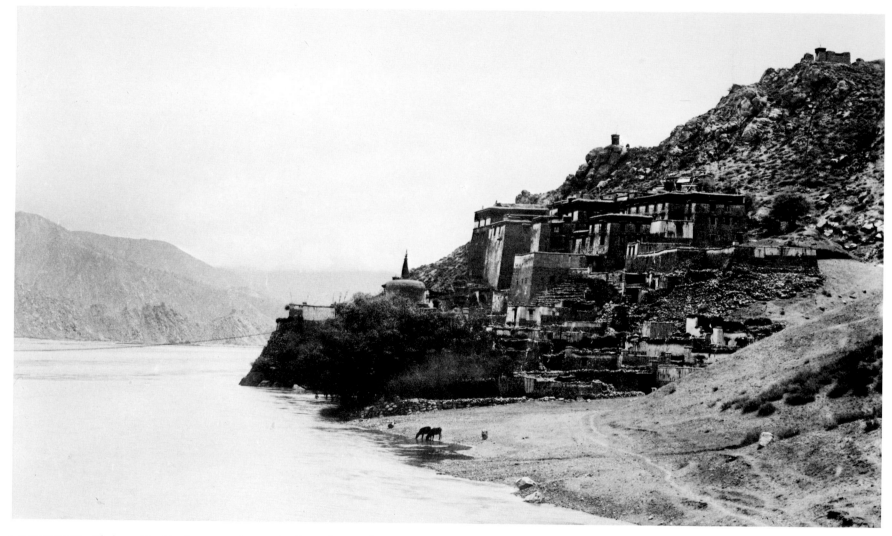

J. CLAUDE WHITE Chakzam Drukha ferry crossing on the Tsangchu, 1904

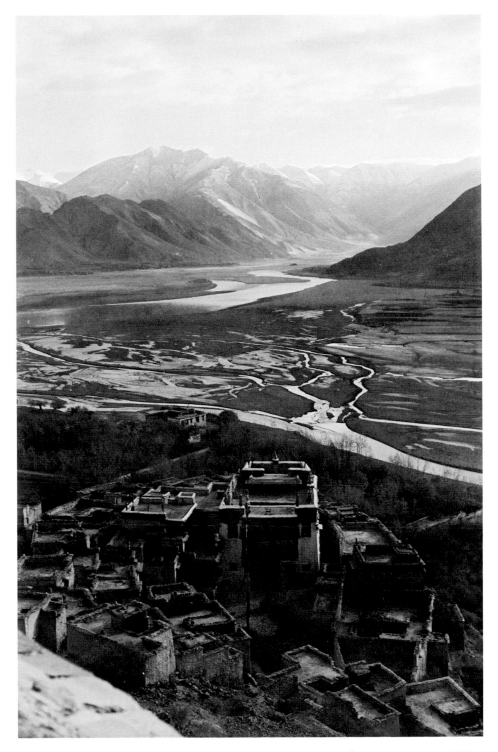

GEORGE TAYLOR Monastery on Tsangchu in southern Tibet, taken from Rong Dzong, 1938

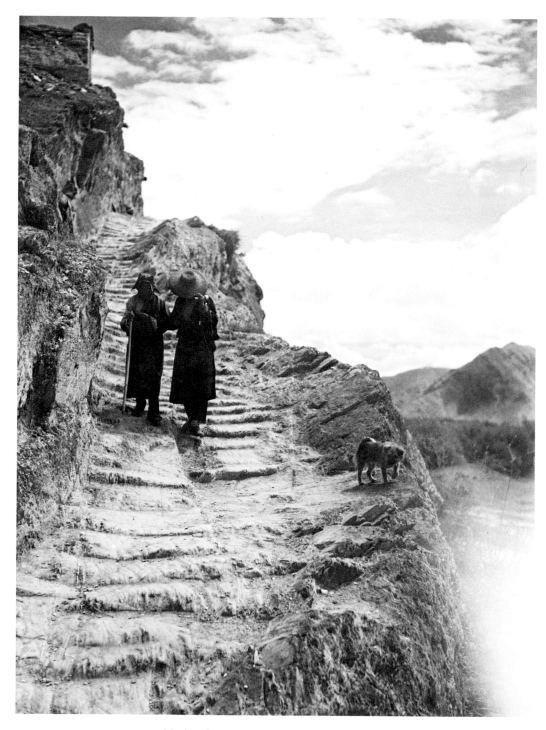

FREDERICK SPENCER-CHAPMAN Elderly pilgrims descending Chakpori (Iron Hill) opposite Potala
Palace, to begin pilgrimage around Lhasa on Lingkor, 1936–37. Traditionally, pilgrims to Lhasa
demonstrated their devotion by circumambulating the holy city on the Lingkor road.

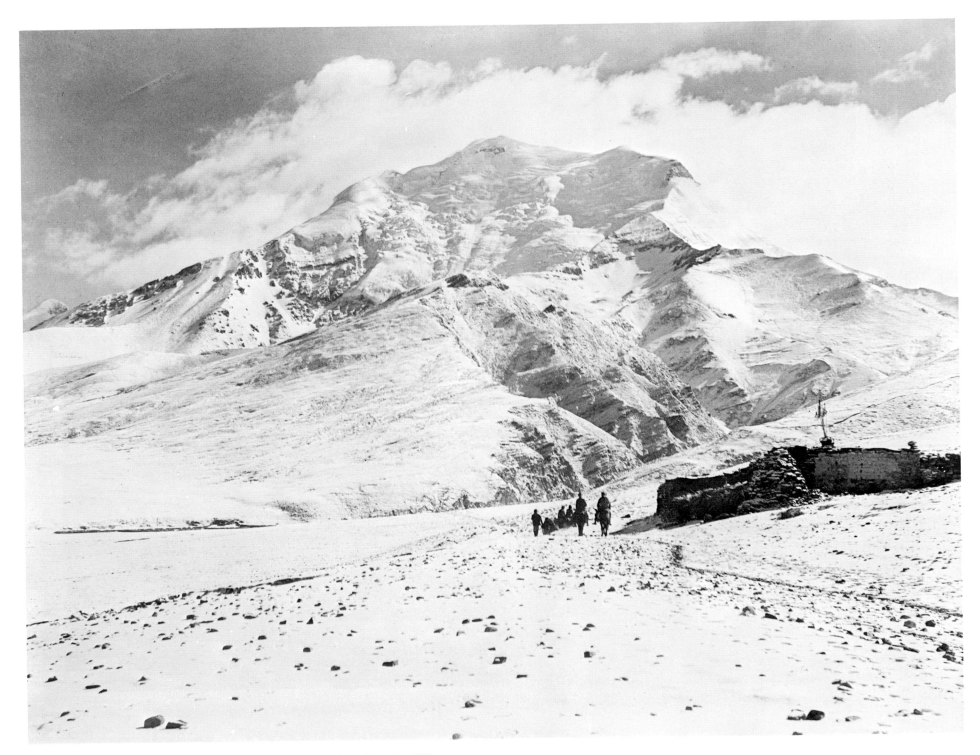

GEORGE TAYLOR Travelers on caravan route at Nodzin Kanza from Karo La, 1938

117

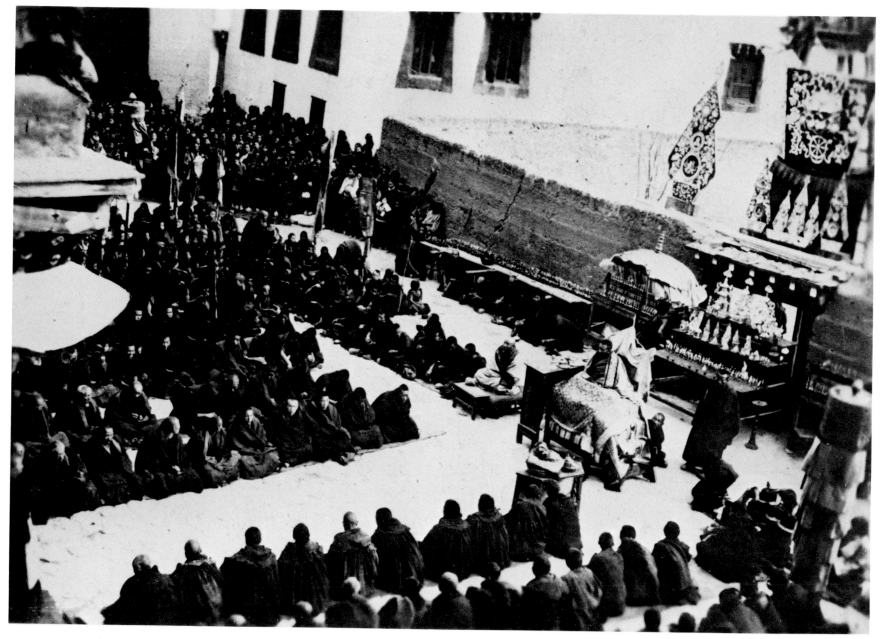

ALEXANDRA DAVID-NÉEL *Tormla* (butter sculpture) festival at Kumbum, 1918–21

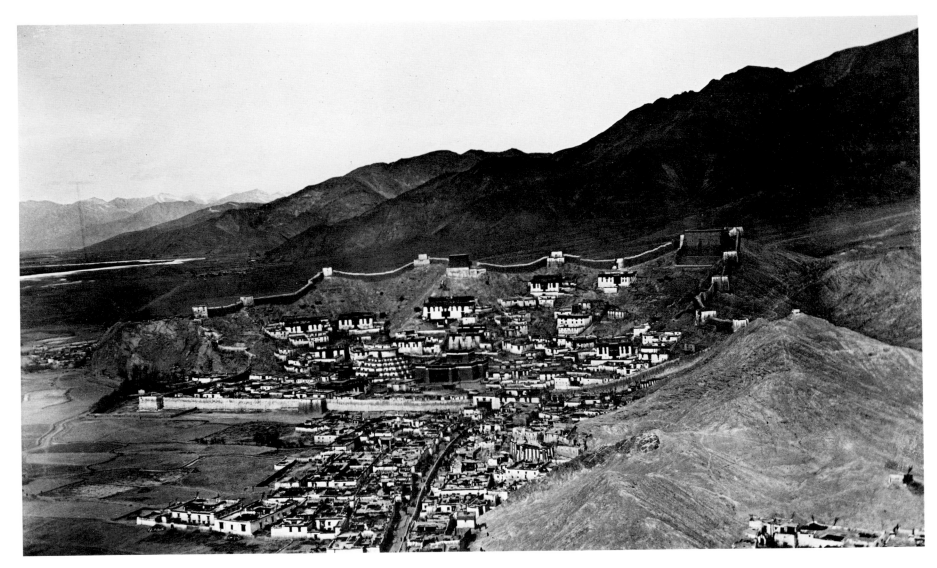

LESLIE WEIR Gyantse, dominated by its hilltop fortress, 1930–32

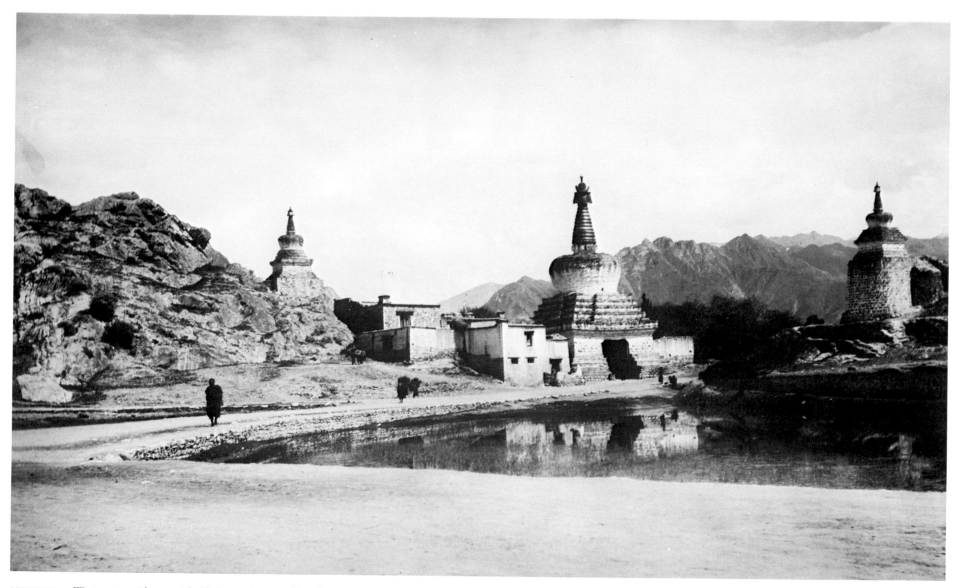

LESLIE WEIR West gate to Lhasa, with Chakpori (Iron Hill) at left, about 1930

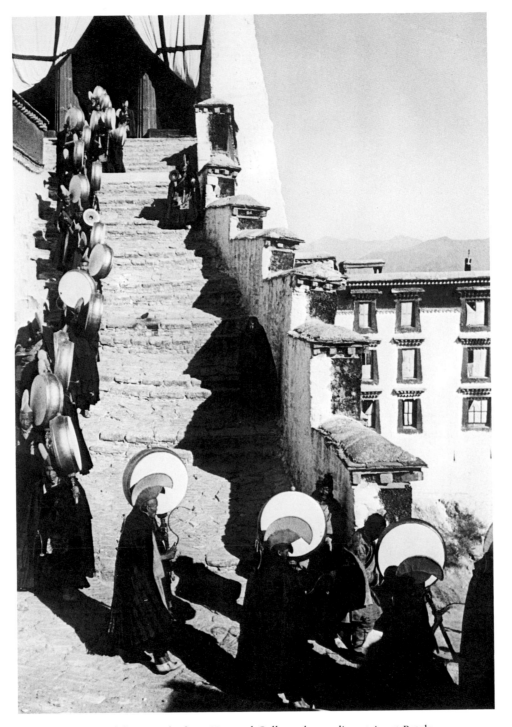

BROOKE DOLAN Gelukpa monks from Namgyal College descending stairs at Potala Palace on their way to the Torgyak ceremony on nineteenth day of the Monlam (New Year's) festival, February 1943.

A lonely hermitage on a mountain peak,
Towering above a thousand others—
One half is occupied by an old monk,
The other by a cloud!

Last night it was stormy
And the cloud was blown away;
After all a cloud is not equal
To the old man's quiet way.

Ryokwan

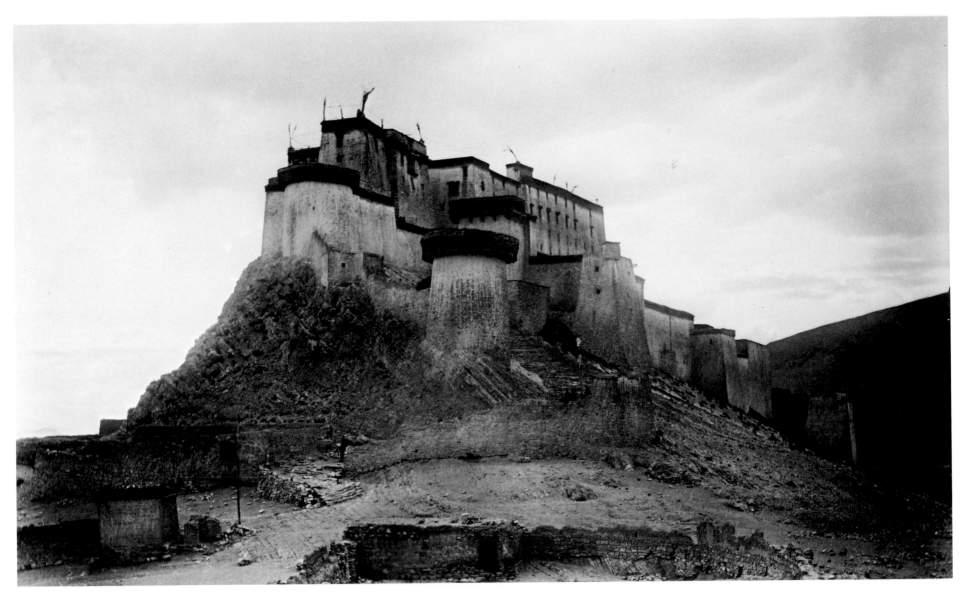

J. CLAUDE WHITE Kampa Dzong, fortress in southern Tibet, 1903

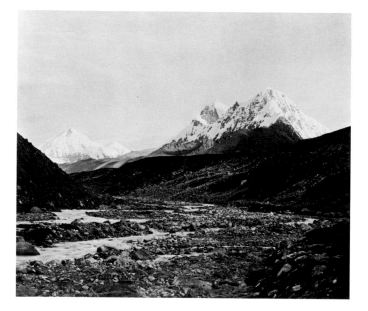

J. CLAUDE WHITE View up Langpo River,
Sikkim-Tibet border, 1902

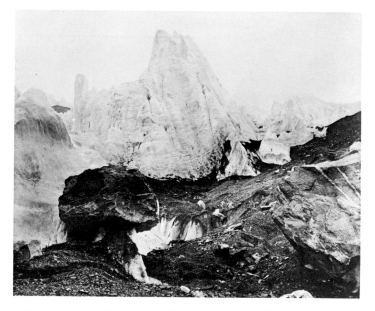

J. CLAUDE WHITE Glacier at the head of Langpo Valley,
Sikkim-Tibet border, 1902

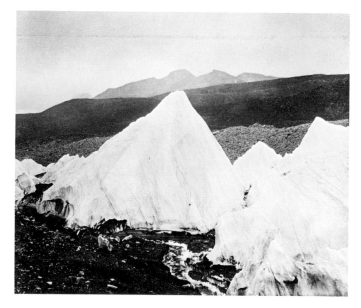

J. CLAUDE WHITE Glacier at the head of Langpo Valley,
Sikkim-Tibet border, 1902

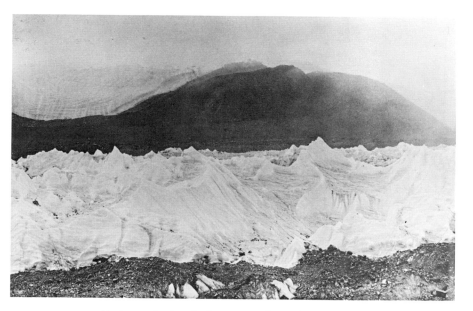

J. CLAUDE WHITE Glacier at the head of Langpo Valley, Sikkim-Tibet border, 1902

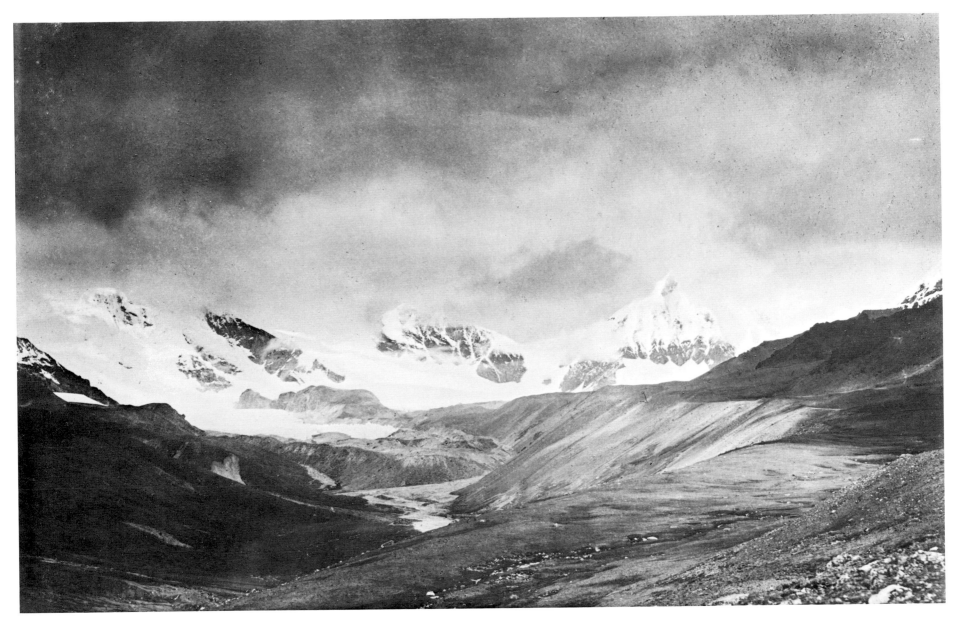

J. CLAUDE WHITE Head of Langpo Valley, Sikkim-Tibet border, 1902

J. CLAUDE WHITE Pedey Dzong at the Turquoise Lake of Yamdok, looking south on the descent, 1904

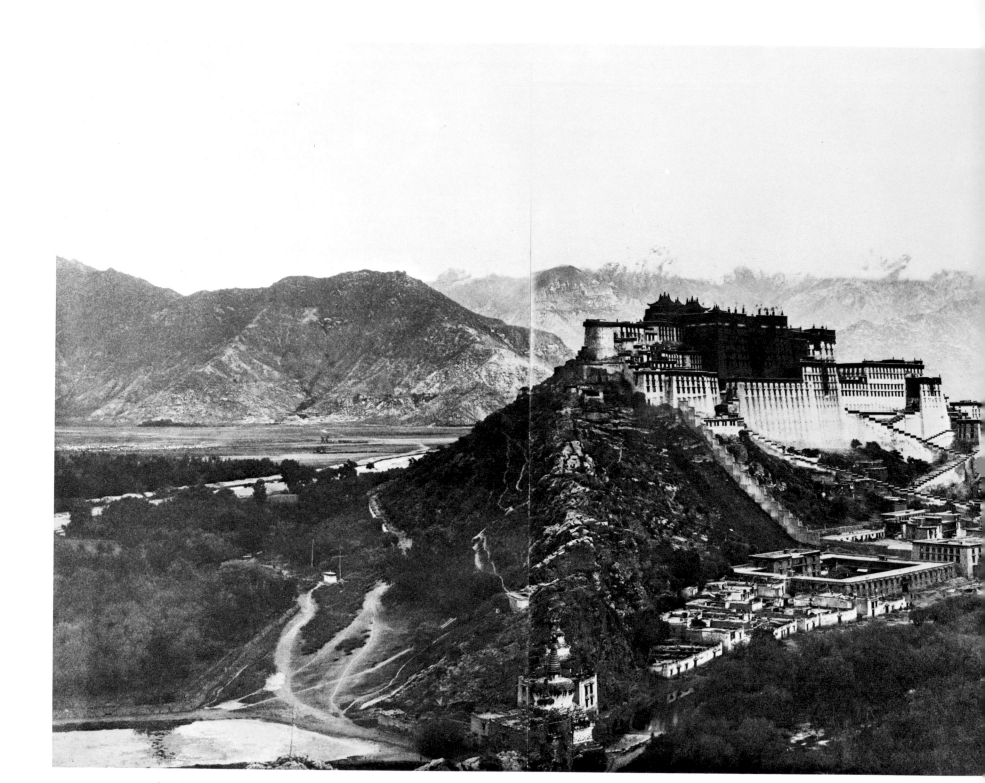

J. CLAUDE WHITE Potala Palace, 1904

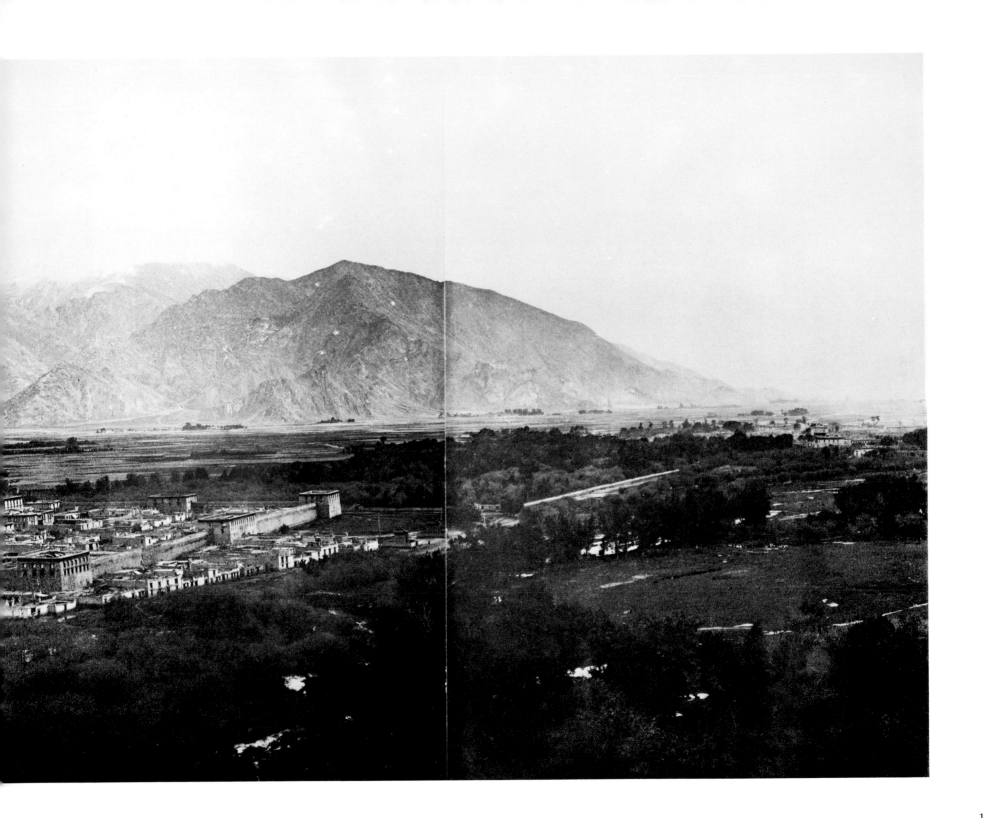

With us neither the one sex nor the other is considered the inferior or the superior.
Men and women treat each other as equals. The women are not kept in seclusion,
but take full part in social life and in business affairs
The Tibetan woman from her childhood learns to be useful and self-reliant
and capable. She is at ease with men, for she has mixed with them,
with her brothers and boys in general, on an equality from the start.

The Tibetan woman is not work-shy. The lady of the house
will sweep the floor as well as any domestic, she does not
consider it derogatory in any way.

Rinchen Lhamo

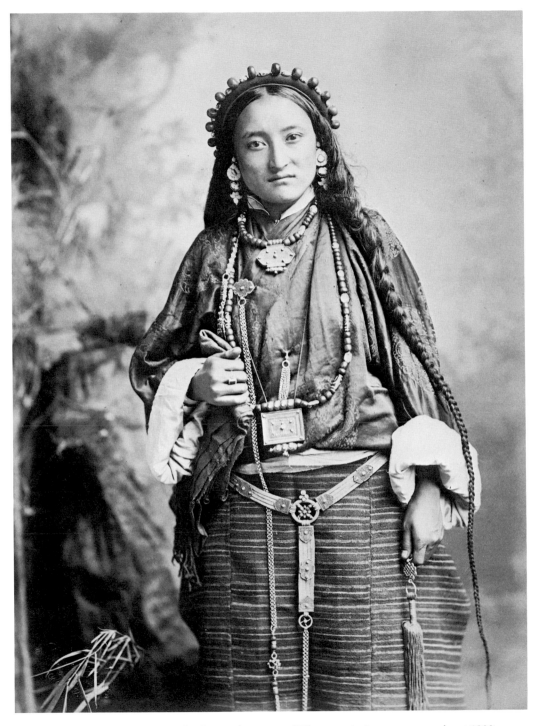

R.F. JOHNSTON AND HOFFMANN Wife of Tasi, Pheroopa of Tibet, aged nineteen years, about 1900

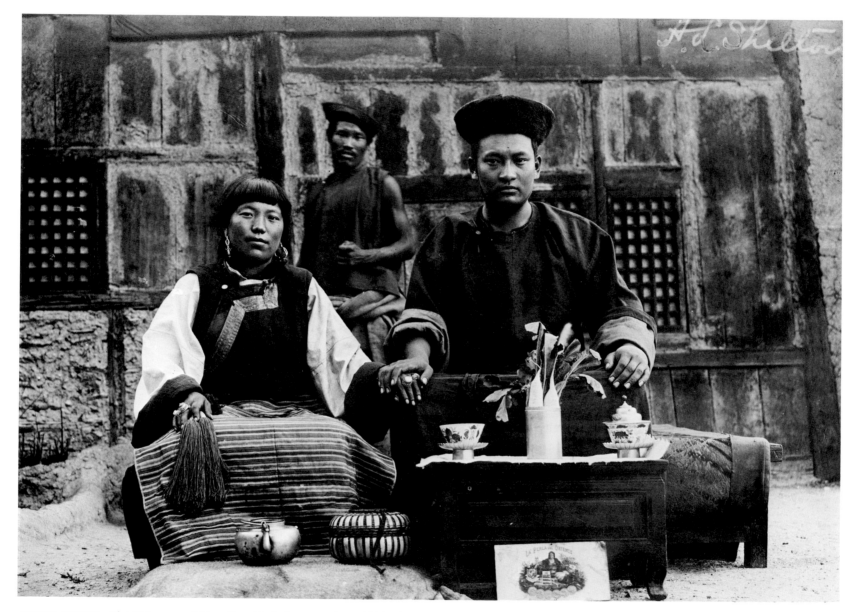

ALBERT L. SHELTON The Jö Lama and his wife with their possessions, 1913–19

JOSEPH ROCK Tebbu tribesman in a rhododendron grove, 1927

133

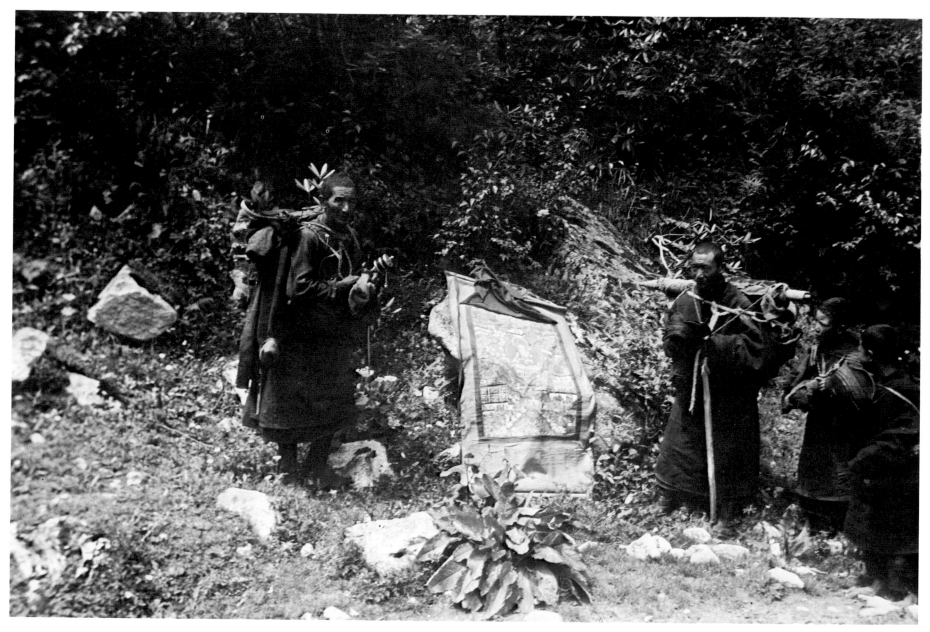

FREDERICK SPENCER-CHAPMAN Travelers in western Tibet hang a *tanka* and chant the religious story it depicts, 1936–37

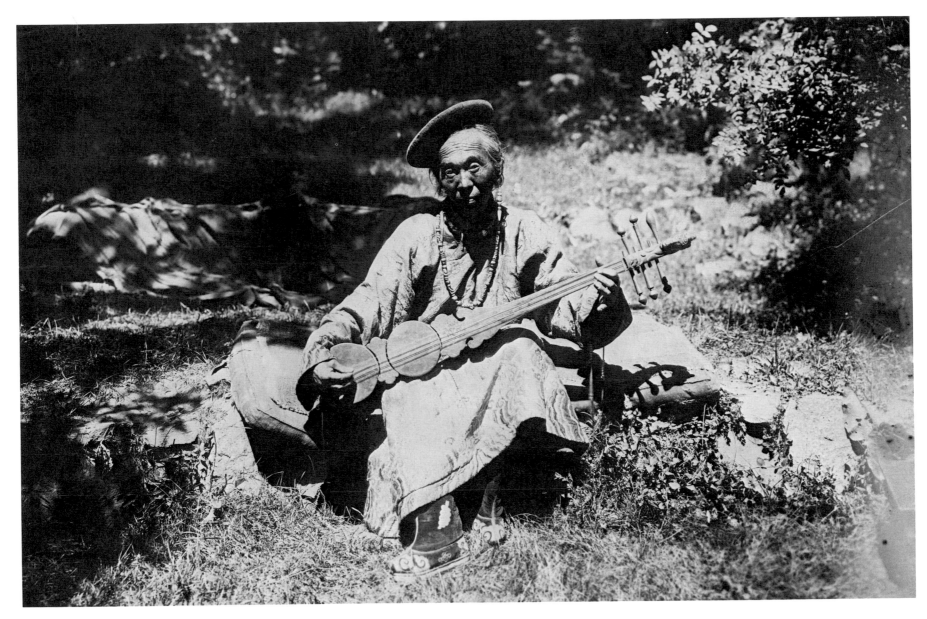

ALEXANDER F. R. WOLLASTON Head man of Kharta with a *damnyen,* 1921

JOHN NOEL Stuffed yaks hanging in entrance to main temple, Gyantse monastery, 1922

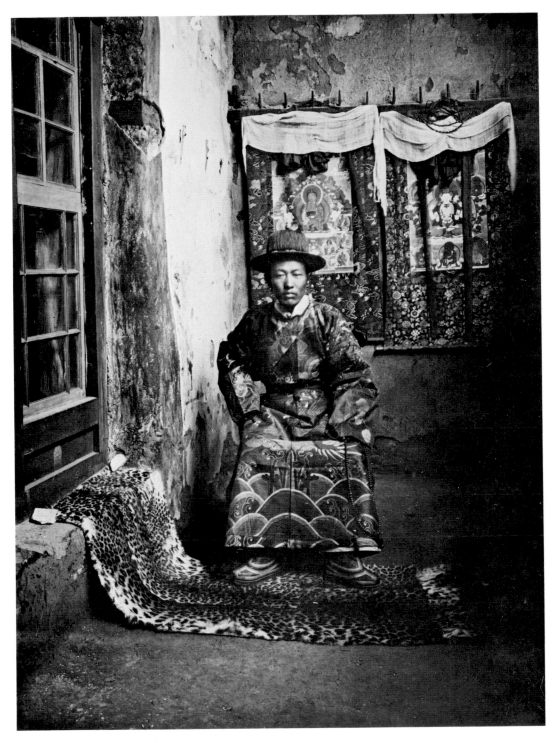

JOHN NOEL Dvongpon at Phari, 1922

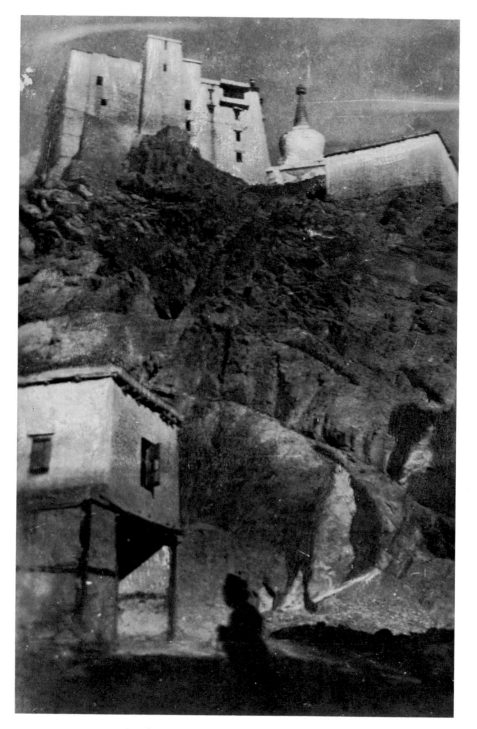

GEORGE N. ROERICH Leh Palace and Tibetan temple in Ladakh, 1925

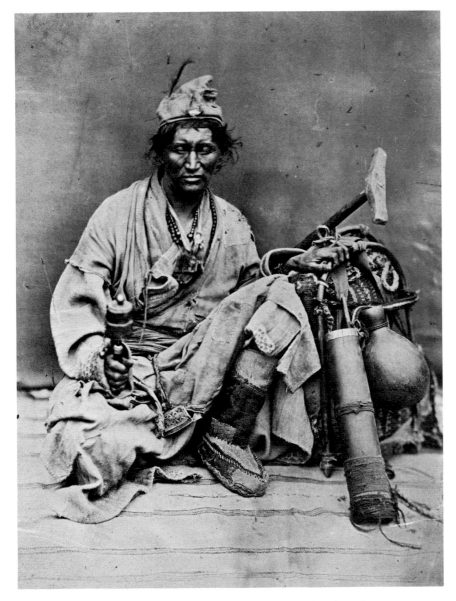

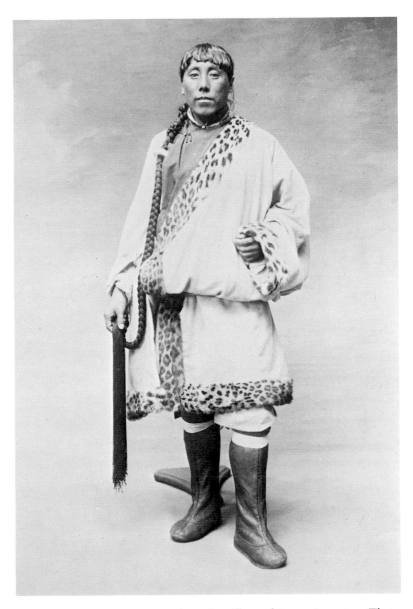

PHOTOGRAPHER UNKNOWN Medicant singer wearing prayer beads and holding a prayer wheel, about 1890. The cylindrical object in the right foreground is a tea maker.

JACQUES BACOT Adrup Gompo, from the village of Patong in eastern Tibet, on a trip to Paris with the photographer, 1909

139

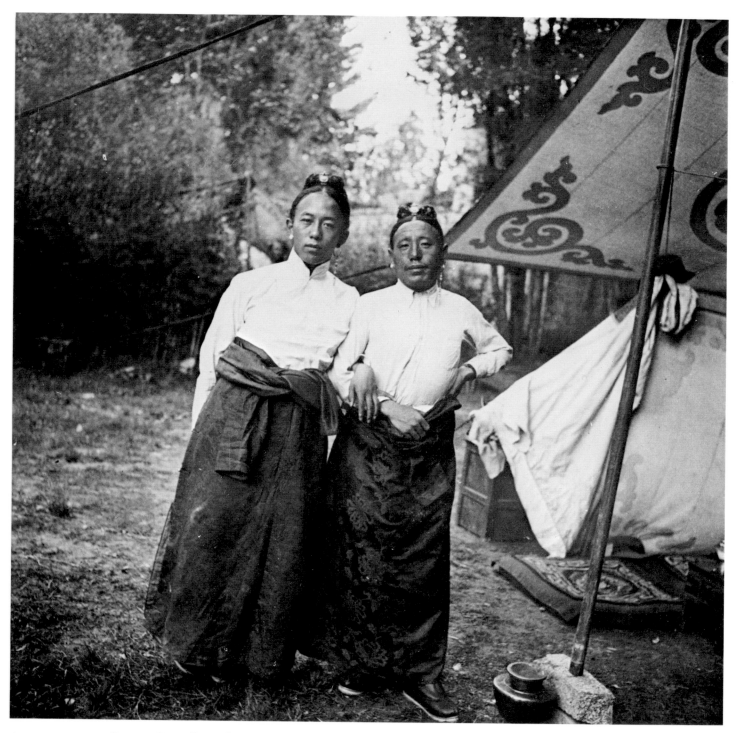

C. SUYDAM CUTTING Commanding officer of troops in Shigatse with the leading banker, 1937

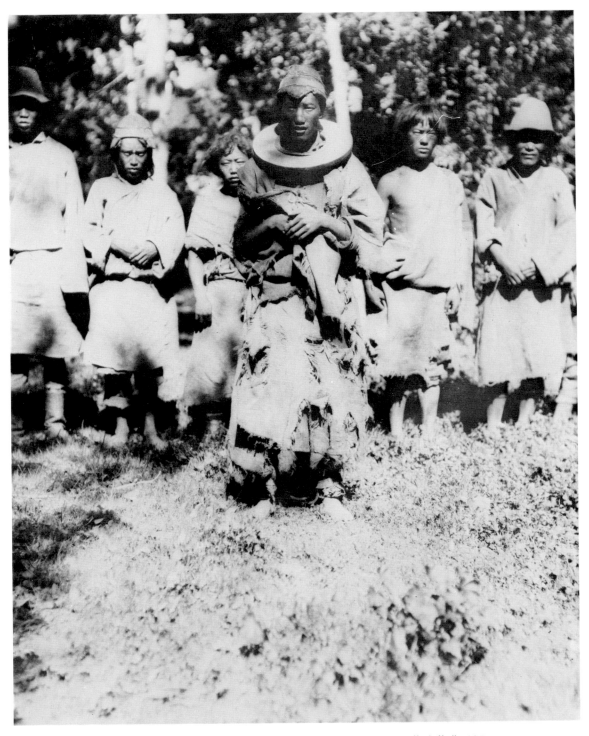

C. SUYDAM CUTTING "A murderer after almost unbearable flogging, which usually kills," 1937

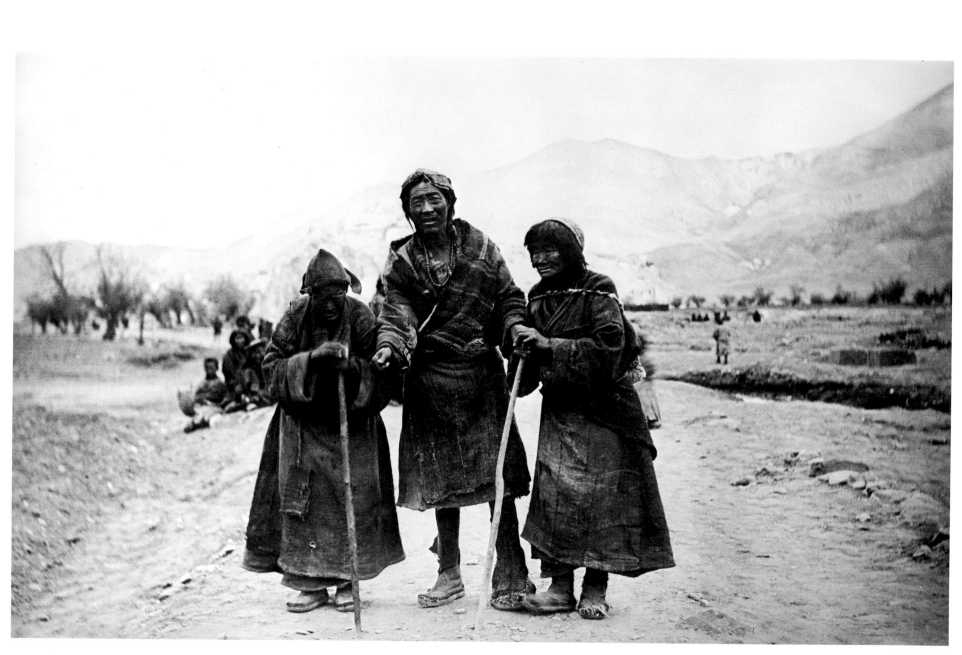

LESLIE WEIR Beggars on main caravan road near Lhasa, about 1930

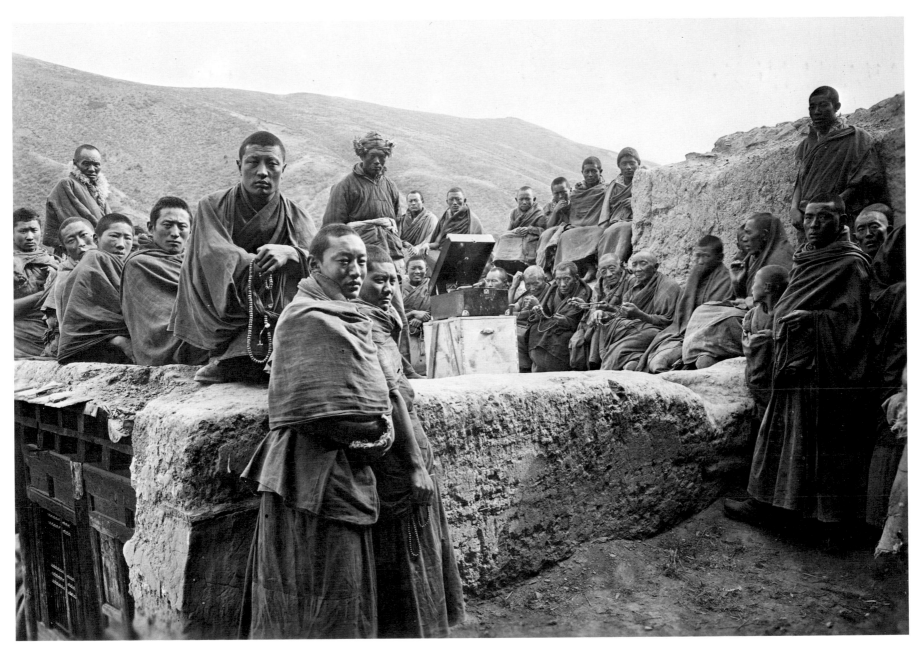

JOSEPH ROCK Golok nomads in Amdo, northeastern Tibet, with monks, listening to visitors' gramophone, 1926

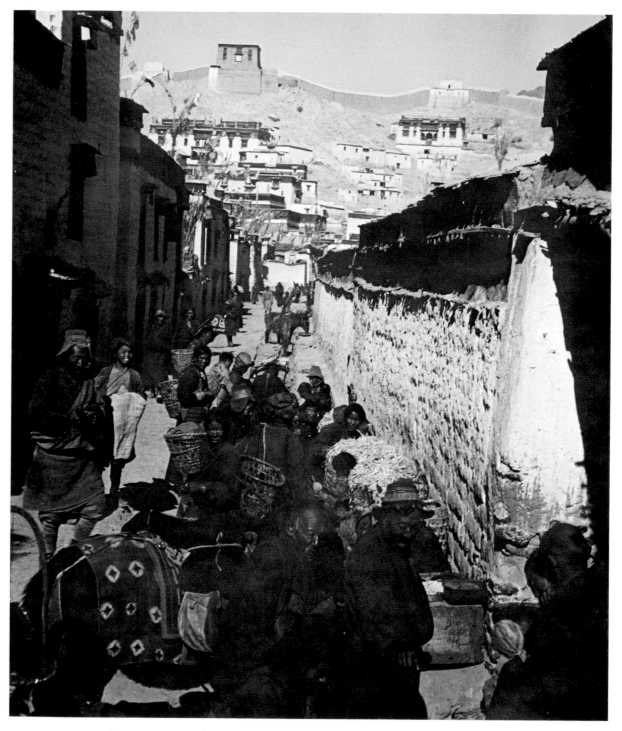

BROOKE DOLAN Market at Gyantse, 1942

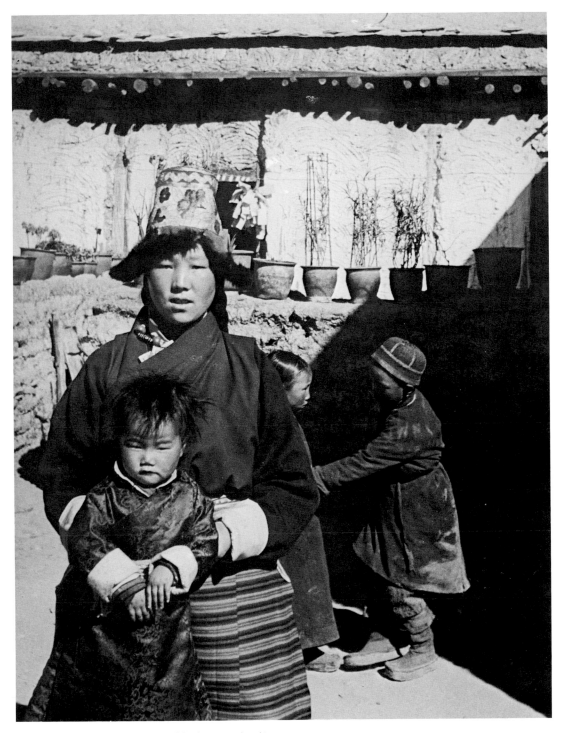

BROOKE DOLAN Mother and child, Lhasa, 1942–43

A CHRONOLOGY OF TIBETAN HISTORY

Tibet traces its beginnings to the second century B.C., but reliable written records give its history only from the seventh century A.D.

About 600 King Namri Songtsan of Yarlung, the territory south of the Tsangpo River, begins the unification of Tibet's many kingdoms.

About 627 Songtsan Gampo succeeds his father and continues to consolidate Tibet under his rule.

641 Songtsan Gampo introduces Buddhism to Tibet. Having already married three Tibetan princesses and a Nepalese princess, Brikuthi, he takes a Chinese princess, Wen-ch'eng, as his bride, thus creating alliances with the countries to the west and east. Both Brikuthi and Wen-ch'eng are Buddhists. Songtsan Gampo drafts Tibet's first code of law. His minister, Thonmi Sambhota, adapts the Gup script of India for Tibetan.

649 Songtsan Gampo dies; Mangsong Mangtsan succeeds to the throne.

670 Warfare breaks out between Tibet and the T'ang dynasty of China. Tibet gains influence along trade route through central Asia.

754 Tritsong Detsan takes the throne.

About 779 Samye, first Buddhist monastic university, fifty miles southeast of Lhasa, founded by Padmasambhava. The Sanskrit Buddhist sutras and tantras—the Tripitaka—translated into Tibetan; establishment of the tantric meditation system.

About 792 Indian teacher Kamalasila defeats Chinese teacher Hwashang in Buddhist debate, thus establishing primacy of Indian Buddhism over Chinese Buddhism. Tritsong Detsan names Buddhism state religion.

815 Tritsug Detsan (known as Ralpachen) succeeds Tride Songtsan (popularly called Seynalek).

821–22 Treaty between Tibet and China commemorated by an inscription carved on a monument that stands in front of the Potala Palace.

About 836 Langdarma succeeds Tritsug Detsan and, under pressure from Bon priests, begins to suppress Buddhism in central Tibet, burning monasteries and driving out monks.

842 Assassination of Langdarma by Buddhist monk. Succession contested. Kingdom dissolves, leaving Tibet in a state of political upheaval.

866 Descendants of the royal family establish the Guge kingdom in western Tibet.

1012 Marpa, "the great translator," born (d. 1097).

1040 Milarepa, student of Marpa and poet-saint of Tibet, born (d. 1123).

1042 At invitation of Guge royal family and lamas, Dipankara Atisa (982–1054), a great Buddhist scholar, teacher, and religious leader, comes to Tibet and assists Tibetans in prompting Buddhist revival.

1056 Kadampa monastery of Rading (Reting), north of Lhasa, established by Atisa's disciple Dom Tonpa.

1073 Sakyapa monastery in western Tibet founded by Khon Konchog Gyalpo.

1110 Gampopa becomes student of Milarepa and founds the Dwakpo Kagyupa School. First Karmapa, founder of Kagyupa order, born.

1207 Tibetan leaders quietly submit to Genghis Khan.

1249 Sakya Pandita (1182–1251) appointed Tibetan viceroy by Mongols.

1253 Phakpa (1235–80) succeeds Sakya Pandita.

1260 Kublai Khan, as emperor of China's Yüan dynasty, bestows title Ti-shi ("Imperial Preceptor") upon Phakpa, making Sakyapa order most powerful in Tibet.

1270 Kublai Khan converted to Tibetan Buddhism.

About 1325 Franciscan Friar Odoric claims to have passed through Tibet in search of lost kingdom of Prester John.

1357 Tsongkhapa, founder of the Gelukpa order, born (d. 1419).

1358 Jangchub Gyaltsan (1302–1373) of Phakmodru family assumes power from Sakyapa order, as Yüan dynasty declines.

1368 Fall of Yüan dynasty frees Tibet from dependence on China. Factions begin to struggle for control over Tibet.

1391 First Dalai Lama, Gedun Drubpa, born (title conferred posthumously, when third Dalai Lama receives title in 1578).

1409 First Gelukpa monastery, Ganden, founded by Tsong Khapa.

1447 Tashilhunpo monastery, future seat of Panchen Lamas, founded by the first Dalai Lama.

1474 Second Dalai Lama, Gedun Gyatsho, born.

1481 Princes of Rinpung take over power from Phakmodru.

1543 Third Dalai Lama, Sonam Gyatsho, born.

1565 Karma Tsheten of Tsang takes over power from Rinpung.

1570 First Panchen Lama, Lozang Chokyi Gyalthen, the teacher of the fifth Dalai Lama, born. Title "Panchen" ("The Great Scholar") conferred by fifth Dalai Lama. The Panchen Lamas became the second most important religious leaders in Tibet.

1578 Sonam Gyatsho receives title of Dalai Lama ("Ocean of Wisdom") from Mongol ruler Altan Khan.

1589 Fourth Dalai Lama, Yontan Gyatsho, born (great-grandson of Altan Khan).

1617 Fifth Dalai Lama, Ngawang Lozang Gyatsho, born in southern Tibet. One of the greatest Dalai Lamas, he later reestablishes Tibet's independence and extends his authority to outermost Tibetan territories, reopens trade with India, and visits China.

1623 Karma Tankyong succeeds Karma Tsheten as King of Tsang.

1624 Antonio de Andrade, a Portuguese Jesuit missionary and the first Westerner known to have entered Tibet, establishes mission in Tsaprang, capital of western Tibet (closes 1635).

1626 Andrade establishes mission in Shigatse (closes 1635).

1627 Jesuits Estavão Cacella and João Cabral received by the king at Shigatse.

1642 Gushri Khan, ruler of Khoshot Mongols, defeats Karma Tankyong and installs fifth Dalai Lama as ruler of Tibet.

1644 Manchu Ch'ing dynasty ousts Ming from Chinese throne.

1652 Shun-chih, first Manchu emperor, invites fifth Dalai Lama to Peking and honors him.

1661 Jesuits John Grüber and Albert d'Orville are first Westerners to reach Lhasa.

1683 Sixth Dalai Lama, Tshangyang Gyatsho, born.

1705–08 Lhazang Khan, leader of the Khoshot Mongols, treacherously attacks Lhasa and kills the Dalai Lama's regent.

1708 Capuchin missionaries found mission to Lhasa. Seventh Dalai Lama, Kalzang Gyatsho, born.

1716–21 Ippolito Desideri and Emanuel Freyre, Jesuit priests, visit Lhasa.

1717 Dzungar Mongols occupy Lhasa; driven out by Tibetan forces under Pholhawa (Pholanas).

1718 Rome awards Tibetan parish to Capuchins rather than Jesuits.

1720 Ch'ing dynasty emperor, K'ang Hsi, establishes his mission in Lhasa.

1723 Chinese withdraw from Tibet.

1725–35 Samuel van de Putte, Dutch traveler, makes several journeys to Tibet.

1728 Pholhawa, as one of a council of ministers who govern Tibet after defeat of the Dzungars, forces out Tibetan nationalist rivals, governs Tibet with Chinese support.

1740 Pholhawa crowned king of Tibet by Chinese emperor.

1745 End of unsuccessful Catholic missionary attempts in Tibet.

1758 Eighth Dalai Lama, Jampal Gyatsho, born.

1775 George Bogle, first British East India Company envoy, arrives in Tibet.

1783 Samuel Turner, second East India Company envoy, visits Tashilhunpo.

1788 Gurkha (Hindu) army invades Tibet from Nepal, turns back on promise of tribute, invades again when second installment of tribute is not paid, sacking Shigatse.

1792 Peace agreement with Gurkhas reached, but power of Chinese representatives (Ambans) in Tibetan government increases.

1806 Ninth Dalai Lama, Tsultrim Gyatsho, born.

1811 Thomas Manning, eccentric British traveler, visits Lhasa.

1816 Tenth Dalai Lama, Lungtok Gyatsho, born.

1838 Eleventh Dalai Lama, Khedrub Gyatsho, born.

1842 Dogra army from Kashmir defeated by Tibet.

1846 Lazarist priests Evarist Huc and Joseph Gabet reach Lhasa, the last Westerners to do so until 1904.

1856 Twelfth Dalai Lama, Trinley Gyatsho, born. Gurkha army again invades Tibet.

1865–85 British-trained Indian pundits clandestinely survey Tibet.

1876 Thirteenth Dalai Lama, Thubten Gyatsho, born (d. 1933).

1879 Russian explorer Nicolai Przhevalsky enters Tibet.

1896 Swedish explorer Sven Hedin enters Tibet, never reaches Lhasa.

1903–04 British expeditionary mission invades Tibet under command of Colonel Francis Younghusband, reaches Lhasa. Thirteenth Dalai Lama flees to Mongolia, where he remains for four years. Tibet forced to sign an agreement on trade and border rights.

1906 British accept a vaguely defined Chinese suzerainty over Tibet after invasion of eastern Tibet by Chinese troops.

1908 Thirteenth Dalai Lama returns to Tibet.

1910 Chinese troops invade Lhasa and occupy parts of the city. Thirteenth Dalai Lama flees to India under British protection. Tibetans continue to fight Chinese until they are expelled.

1911 Ch'ing dynasty falls. Civil war breaks out in China. Chinese republic proclaimed.

1912 Tibet expels the Chinese. Thirteenth Dalai Lama returns to Tibet.

1913 Thirteenth Dalai Lama proclaims Tibetan independence. Conference at Simla, India, among the British, Chinese, and Tibetans divides Tibet into two parts: Inner Tibet, far eastern provinces to be controlled by China; and Outer Tibet, to remain "autonomous." Chinese expelled from central Tibet but do not sign agreement. Britain and Tibet sign, canceling pro-Chinese provisions.

1913–33 Period of unparalleled peace in Tibet under thirteenth Dalai Lama. Tibet begins to modernize slowly, maintains ties with British India.

1933 Death of thirteenth Dalai Lama.

1935 Fourteenth Dalai Lama, Tenzin Gyatsho, born.

1939 Fourteenth Dalai Lama installed.

1947 India wins independence, removing British deterrent to Chinese incursions.

1948 Tibetan trade delegation visits United States.

1949 Communist forces under Mao Tse-tung defeat Chiang Kai-shek's army.

1950 People's Republic of China invades Tibet, claiming Tibet has always been Chinese territory. India objects. Tibet files protest with United Nations. Security Council approves a British proposal to let the parties negotiate among themselves.

1951 Tibetan delegation in Peking forced to sign seventeen-point agreement, making Tibet a "national autonomous region" of China.

1959 Tibetan uprising against Chinese occupational forces quelled by Chinese army. Fourteenth Dalai Lama flees south to India, followed by some 100,000 refugees, and establishes his residence at Dharamsala.

1967 During Chinese Cultural Revolution, Tibetan temples, monasteries, libraries, and sacred monuments destroyed or made into state museums.

1979 Tibet is tentatively reopened to foreign visitors, carefully screened by Chinese.

THE PHOTOGRAPHERS
Martha Chahroudi

JACQUES BACOT
(French, 1877–1965)

A historian, geographer, and scholar, Jacques Bacot undertook several Asian explorations, which led him to the Yangtze Valley (1907), northern Indochina (1909–10), and various parts of the Himalayas (1913–14 and 1930–31). A specialist in Asian civilization, Bacot contributed in his works to Western knowledge of Asian peoples, particularly the Tibetans. Among his many publications are *Le Tibet révolté* (1912), *Trois mystères tibétains* (1921), and *Dans les marches du Tibet* (1909).

C(HARLES) SUYDAM CUTTING
(American, 1889–1972)

Reputedly the first American to visit the holy city of Lhasa, C. Suydam Cutting was an independently wealthy world traveler and naturalist. Born in New York, Cutting was educated at Harvard University and worked briefly for the M. W. Kellogg Company in sales. From 1919 until his death he was actively involved in the management of the estate of his father, R. Fulton Cutting, a financier and philanthropist. Competing with and winning against such opponents as Jay Gould, Cutting played championship indoor court tennis.

In 1925 Cutting accompanied Kermit and Theodore Roosevelt on an expedition to Ladakh and Turkestan in search of the golden snub-nosed monkey and giant panda. From that time Cutting was captivated by the experience of travel in exotic parts of the globe. His travels on behalf of the Field Museum of Natural History, Chicago; the American Museum of Natural History, New York; and the New York Botanical Gardens took him to Ethiopia, Assam, Szechuan and Yunnan in China, the Galápagos Is-

lands (on Vincent Astor's yacht), and Burma.

His three trips to Tibet are described in his book *The Fire Ox and Other Years* (1940). In 1930 he traveled to Gyantse and Kampa Dzong and began negotiations with the thirteenth Dalai Lama, asking for permission to visit Lhasa. He sent many gifts to Lhasa, including hunting hounds, gold watches, and heating appliances. Two years after the Dalai Lama's death in 1933, Cutting accepted an invitation from the regent to come to Lhasa with Arthur Vernay, a famous American big-game hunter, and in 1937 Cutting again traveled to Lhasa with his wife, Helen.

Cutting corresponded with both the thirteenth and fourteenth Dalai Lamas (neither of whom he ever met) and the interim regent. Although the United States never recognized Tibet as an autonomous nation, Cutting served as a kind of unofficial good-will ambassador and personal liaison between the American presidents and the Dalai Lama. Cutting was responsible for bringing the 1948 Tibetan trade delegation to Washington, D.C.—the first Tibetans to visit North America.

ALEXANDRA DAVID-NÉEL
(French, 1869–1969)

A woman of unique experience who lived to the age of one hundred, Alexandra David-Néel became a practicing Buddhist and traveled widely in the Orient for forty years. As a young woman she studied philosophy, orien-

tal languages, and music in Paris and worked as a comic-opera singer and then as a journalist. Both careers took her to exotic parts of the world, including Tonkin, Greece, Tunisia, and Algeria. After her marriage to Philippe Néel in 1904, she traveled in the East with his financial support.

In 1912, while in Sikkim, she received an audience with the thirteenth Dalai Lama, with whom she felt a great accord and who advised her to learn the Tibetan language. She arranged through the maharaja of Sikkim, Sidkeong Namgyal, to enter the forbidden land, and in 1914 began a sojourn of ten years in central and eastern Tibet. Recognized as a serious student of Buddhism, she was assimilated into the Tibetan culture to a remarkable extent. She was allowed to visit and study at monasteries at Shigatse, Gyantse, Samye, Jyekundo, and at Kumbum, where she lived for three years under the guidance of the Pegye Lama. She was the first Western woman to enter the city of Lhasa, staying there for two months disguised as a beggar and aided by her adopted Tibetan son, the lama Yongden. In 1938 she returned briefly to Tatsienlu ("Dartsedno" in Tibetan) in eastern Tibet. She also traveled to monasteries in Burma, Japan, Korea, and China.

Néel wrote many books about Tibet and Buddhism, among them *My Journey to Lhasa* (1927), *Magic and Mystery in Tibet* (1931), and *Initiations and Initiates in Tibet* (1932).

CAPTAIN BROOKE DOLAN II
(American, 1908–1945)

Brooke Dolan, a naturalist educated at Princeton and Harvard Universities, had previously made two trips to Tibet when he was selected by fellow OSS officer Colonel Ilya Tolstoy to join the 1942–43 mission to Tibet. (*See under* Lieutenant Colonel Ilya Tolstoy for details of this mission.) Dolan planned and organized both previous expeditions for the Academy of Natural Sciences, Philadelphia, of which he was an active member and trustee. In 1931–32 he traveled to Szechuan province in China and to northeastern Tibet, bringing back to the United States the first specimens of the giant panda and the Szechuan takin, a kind of goat-antelope.

In 1934, together with Dr. Ernst Schäfer of Göttingen University and Marion H. Duncan, Dolan returned to northeastern Tibet to collect specimens of all fauna of the

high Tibetan steppes. In fifteen months the expedition covered approximately 200,000 square miles, explored the eastern slopes of the Amne Machin (elevation 23,490 feet), and returned with rare specimens of the wild ass, wild yak, white-lipped deer, and MacNeill's deer. The expedition was acclaimed a great success, adding to the academy's world-renowned bird collection and forming the basis of its Asian habitat groups, which Dolan helped to design. The only mammals the expedition failed to collect were the leopard and the snow leopard. During this trip, Dolan studied Tibetan and Chinese dialects and began a serious study of Tibetan Buddhism, which gained him the respect of the Tibetans he encountered on the 1942–43 mission.

In 1945 Dolan undertook a second mission for the OSS that led to his early death. He was killed while attempting the rescue of Allied bomber crews downed behind enemy lines in Chungking.

HEINRICH HARRER
(Austrian, 1912–)

Heinrich Harrer was already a well-known mountain climber and Olympic skier when he was asked to join the 1939 expedition to Nanga Parbat, a then-unconquered peak in Kashmir. The outbreak of World War II cut the expedition short, leaving Harrer stranded in Karachi, India. He was arrested and held in a succession of British internment camps from which he made repeated attempts to escape. In 1943, together with Peter Aufschnaiter and others, he escaped from Dehra Dun camp and crossed the border into Tibet.

Harrer and Aufschnaiter walked across southern Tibet from its western border, along the Tsangpo River and across the Changthang, to Lhasa. They had virtually no supplies, little money, and no official passports. The men camped and ate with the Tibetan nomads they encountered along their route and bluffed their way past district officials whose responsibility it was to stop them. Once, they fell into the hands of Kampa bandits, but escaped. In 1946, penniless and in rags, they walked into the city of Lhasa and were taken in as guests by a prosperous Tibetan family.

The Tibetans welcomed Harrer and Aufschnaiter with a round of parties and visits. The parents of the fourteenth Dalai Lama, then in his minority, were the first to receive the two, who soon settled into the everyday life of Lhasa

and were eventually granted official asylum.

Aufschnaiter was commissioned to build an irrigation canal on the outskirts of the city. Harrer became a versatile odd-job man. He was commissioned to rebuild the garden of the Tsedrung lamas, to draw up a plan of the city, make translations from Western news sources, and regild statues, among other things. He built a tennis court, gardened, and gave private English and mathematics lessons to Tibetan children.

The Dalai Lama, who was more or less confined to the Potala, asked Harrer to make films of Tibetan games and festivities and to build a small movie theater in the Potala for private viewings. This led to a personal friendship, and Harrer, a first-hand source of information about the world outside Tibet, became a kind of informal tutor to the adolescent Dalai Lama. Their close contact lasted until 1950 when both Harrer and the Dalai Lama left Tibet for India because of the Chinese invasion.

Harrer wrote *Seven Years in Tibet* and co-authored *Tibet Is My Country* with Thubten Jigme Norbu, a brother of the Dalai Lama. Harrer's photographs of Tibet were made in 1949 and 1950 with a Leica camera.

SVEN ANDERS HEDIN
(Swedish, 1865–1952)

One of the most renowned explorers of central Asia, Sven Hedin was also a highly regarded artist and photographer. His many books on his travels are illustrated with hundreds of his own drawings and photographs.

As a youth, Hedin was obsessed by exploration. He studied geography, geology, and languages at Stockholm University, Uppsala University, the Berlin Institute of F. von Richthofen, and the University of Halle. From 1893 to 1908, with the support of Oscar II of Sweden and Nicholas II of Russia, Hedin explored and mapped large areas of Chinese Turkestan (Sinkiang), Tibet, and China.

Among Hedin's most notable adventures were his crossing of the Takla Makan Desert of central Asia, where he discovered the remains of two ancient Buddhist communities and lost his entire caravan in the process. He followed the Tarim River to Lop Nor, the "Wandering Lake," whose migrations he charted on several journeys. He is credited with discovering the sources of the Indus and Brahmaputra (Tsangpo) Rivers in western Tibet.

Hedin made many expeditions into Tibet. In 1896 he crossed the high northern Tibetan plateau from west to east. In 1900 and 1901 he journeyed south into Tibet with the aim of entering the "Forbidden City" of Lhasa. No European had entered Lhasa since the Lazarist fathers Evarist Huc and Joseph Gabet in 1846. Many people had tried and failed, including the Russians Nicolai Przhevalsky and Pyotr Kozlov, the Frenchmen Gabriel Bonvalot and Henri d'Orléans (*see under* Prince Henri d'Orléans) and the American William Rockhill. Hedin disguised himself as a lama, left his caravan behind, and traveled to within two days march of Lhasa, when he was stopped by a district official. Although Hedin was a fearless and even ruthlessly persistent traveler who many times evaded assigned escorts, he was unable to overcome the Dalai Lama's strictly enforced prohibitions against Westerners in Lhasa. For aiding the disguised Hedin a Tibetan lama was forever exiled from the holy city. Not until 1904, when the British invaded Tibet by force, did Europeans again set foot in Lhasa (*see under* J[ohn] Claude White).

In 1901 Hedin traveled west through the central lake region of Tibet to Ladakh and then returned to Sweden, traveling through Tibet and Turkestan. In 1906 and 1907 he was allowed to visit the monastery at Tashilhunpo, where he was granted an audience with the sixth Panchen Lama. During 1907 and 1908 he explored the Transhimalayan range, an uncharted mountainous region in southern Tibet lying parallel to the Himalayas across the Tsangpo Valley. He spent one month at Manasarowar, a

lake sacred to both Buddhists and Hindus, and at Mount Kailas, reputedly one of the most beautiful regions of the world.

Among Hedin's books on Tibet are *Through Asia* (1899), *Central Asia and Tibet: Towards the Holy City of Lhasa* (1903), *Trans-Himalaya* (1909); *Southern Tibet* (nine volumes, 1917–22), and *A Conquest of Tibet* (1934).

At sixty-three Hedin returned to Asia to lead a camel expedition in northwestern China and Mongolia, and at sixty-nine he explored parts of the ancient Asian Silk Route, the trade link between the Near East and China across central Asia. Leading geographical societies in Europe awarded Hedin their highest honors; the Swedish government knighted him in 1902; and the Indian government made him an honorary knight commander of the Indian Empire in 1909.

R. F. JOHNSTON AND HOFFMANN
(English, dates unknown)

R. F. Johnston and Hoffmann were proprietors of a photographic studio in Calcutta and publishers of the J. Claude White albums (*see under* J[ohn] Claude White). They also established smaller studios along the border between Tibet and Nepal, where they specialized in photographing the local inhabitants.

SONAM WANGFEL LADEN-LA
(Tibetan, 1876–1936)

Sonam Wangfel Laden-La was born in 1876 to a long-established Tibetan-Sikkimese border family of the Darjeeling district. One of the first Tibetan boys to be educated by Jesuit priests, he became fluent in English, as well as in several of the languages of the region. Between 1894 and 1898, he worked with the scholar-explorer Sarat Chandra Das in the preparation of a Sanskrit-Tibetan dictionary. During this period, he lived with and studied under Lama Sherab Gyatso, a learned abbot of Ghoom monastery, furthering his knowledge of classical Tibetan and the Buddhist religion.

Laden-La joined the Darjeeling police in 1899 to see more of the Himalayan region and was rapidly promoted. In 1905, after a short time in liaison work in the Chumbi Valley on the staff of the Younghusband expedition to Tibet, he accompanied the Panchen Lama on a tour of the holy places in India. As a member of a border family, Laden-La could appreciate the feelings and aspirations of the various Himalayan peoples and the political implications of the borderlands. In the following years, he worked to foster good relations between Tibet and British India, in the belief that the consequent political stability and economic prosperity would benefit the peoples of Tibet and the borderlands. When the thirteenth Dalai Lama fled Tibet in 1910 as the Chinese invaded, Laden-La was responsible for organizing much of His Holiness's visit to the viceroy in Delhi, his tour of India, and his stay in the Darjeeling district. In 1912, when the invading Chinese army was stranded in Lhasa after the Chinese revolution, Laden-La was sent by the viceroy, with the approval of the Dalai Lama, to negotiate a ceasefire and to arrange for the repatriation of the Chinese through India. That same year the Dalai Lama conferred on him the title of General and the Order of the Golden Lion and the Panchen Lama made him Lord Chamberlain of the Court of Tashilhunpo for his personal assistances to them. Laden-La accompanied a group to England in 1913 that included the first Tibetan boys to study abroad, and he visited other European countries as well.

During the First World War, Laden-La was awarded the title of Sardar Bahadur by the British Indian government for his help in recruitment and fundraising. In 1921, Sir Charles Bell, the British political officer in Sikkim, asked for Laden-La as his personal assistant on his mission to Lhasa to cement relations between Tibet and Britain. One result of this mission was the Dalai Lama's request for Laden-La's assistance in establishing a police force in Lhasa. This work began in 1923, and in the same year the title of Dzasa (of Mongolian origin for high-ranking officials) was conferred upon him.

During the mid-1920s strong opposition developed in Tibet to the cooperation with British India and to new institutions such as the army and police. At the end of the decade, relations between Tibet and Nepal were brought to a low point by the same faction, and in 1929 when a serious dispute developed both armies were mobilized. War seemed imminent. The viceroy offered Laden-La's help as mediator between the two parties, and Laden-La proceeded to Lhasa, where after some negotiation, peace was restored. The anti-British faction was discredited in the eyes of the Dalai Lama, and permission was granted for the British political officer in Sikkim to visit Lhasa and re-establish the close links between Tibet and the British government in India that had developed during Sir Charles Bell's time. In 1930, Laden-La was made a Commander of the British Empire, and in 1931 he retired from official duties. A devout Buddhist, he was active in the reconstruction and administration of the local monasteries and in philanthropic activities during his retirement. Shortly before he died he assisted in the translation of the Tibetan life of Padmasambhava for *The Tibetan Book of the Great Liberation* edited by W. Y. Evans-Wentz.

Laden-La was intensely interested in his Tibetan heritage and in developing a true understanding of Tibetan religion and culture in the outside world. In 1912, he started making photographs and films of ceremonial occasions, customs, various peoples, and their living conditions. His interests were shared by his son, P. W. Laden-La, who has been able to preserve many of his father's plates and photographs.

THE REVEREND RODERICK A. MacLEOD
See under Dr. Albert L. Shelton

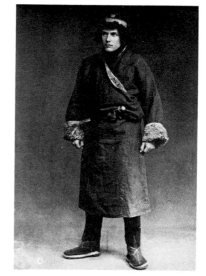

CAPTAIN JOHN NOEL
(English, 1890–)

John Noel served as official photographer on the 1922 and 1924 Everest expeditions, the pioneer ascents of the highest mountain in the world. Educated at the Royal Military College at Sandhurst, Noel received his commission and was sent to India in 1909. An alpine climber during his school years in Switzerland, Noel had long been in-

trigued by mountaineering in the Himalayas and in 1913 ventured into Tibet disguised as a Muslim for the purpose of scouting a route to Mount Everest, called Jomo Langmo by Tibetans. He crossed from Sikkim into Tibet through an unguarded pass at Chorten Nima. Then, following routes described by Sarat Chandra Das, who had clandestinely surveyed the area for the British in the 1870s, he approached to within forty miles of the mountain's base before he was stopped and told to turn back.

In 1921 the Royal Geographical Society and the Alpine Club organized the first official expedition to Mount Everest. Sir Charles Bell, political officer in Sikkim, secured the permission of the Dalai Lama. Led by Colonel Charles K. Howard-Bury the members of the expedition included a mountaineering party, Dr. Alexander Wollaston (see under Alexander F. R. Wollaston), the naturalist and medical officer, and a Captain Wheeler as surveyor. They discovered an access route to Everest and a probable route of ascent up the northeast ridge.

The first Royal Geographical Society-sponsored climbing expedition in 1922, with Noel as photographer, George Mallory in the climbing party, and General C. G. Bruce in command, attempted the first ascent toward the summit (29,028 feet). The expedition entered Tibet by way of the Jelep La and traveled through the Chumbi Valley to Phari, then turned west toward Everest. They stopped at the Rongbuk monastery at the foot of Everest, where they presented their papers from the Dalai Lama and had an audience with the chief lama. Four climbers ascended to 26,800 feet, but the expedition terminated prematurely when an avalanche on the "Ice Cliff" took the lives of the Sherpa porters.

Noel accompanied the next Royal Geographical Society expedition in 1924 and shot a film documenting the climb, *The Epic of Everest*. With great endurance and skillful management of equipment under severe climatic conditions, Noel worked for two weeks at 23,000 feet on the North Col to film the ascent. This time the team included Mallory, Andrew Irvine, and six others. Tragedy struck the expedition when Irvine and Mallory disappeared, last seen within 600 feet of the summit. Mallory was the man who coined the phrase, "Because it's there," when asked why he wanted to climb the world's highest peak.

In 1927 Noel published *The Story of Everest,* which describes these earliest expeditions and discusses his task as photographer. Noel is a life fellow and honorist of the Royal Geographical Society, an honorist of the Royal Photographic Society, a fellow of the Royal Society of Art, an honorary life member of The American Museum of Natural History and the Explorer's Club of New York. He saw active fighting service in World War I and was in the British Geographic Intelligence Service in World War II. He now lives in England.

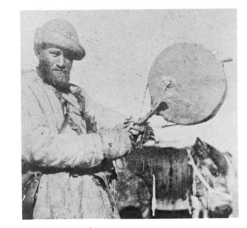

PRINCE HENRI D'ORLÉANS
(French, 1867–1901)

The eldest son of the Duc de Chartres, Henri d'Orléans was born and educated in England. In 1884 his family returned to France and he continued his studies in botany and geology at Stanislaus College. After being refused admission to the military academy at Saint-Cyr, Orléans went on a round-the-world tour via Greece, Egypt, India, Japan, and North America. He gained an unfortunate reputation for frivolity and indebtedness, but on his next journey he became a serious explorer and geographer.

In 1889–90, subsidized by his father, Orléans joined the French explorer, Gabriel Bonvalot, and the Belgian missionary, Father Dedeken, on an expedition into central Asia. Their goal was to explore a north-south route from Moscow through China, into Tibet and Lhasa, and on to Haiphong Harbor as their final destination. The expedition, which traveled entirely undisguised, was stopped just north of Lhasa. The Ta Lama and the Chinese Amban met them and advised them, as with all European travelers, to turn back. With a logic that made absolutely no impression on the Tibetans, Bonvalot insisted that, as they had come so far, it was reason enough to allow them to enter the holy city. Eventually, the expedition was allowed to proceed, revising their course to the east toward Batang and then heading south to China.

Orléans co-authored an account of their journey with Bonvalot entitled, *De Paris au Tonkin à travers le Thibet inconnu* (1892). The book reproduces many of Orléans's photographs, which are some of the earliest pictures made of the northern plains and eastern regions of Tibet. He also organized an exhibition of Tibetan artifacts for the Musée Guimet in Paris and was awarded the gold medal of the Société de Géographie.

Orléans's subsequent expeditions took him to the Gulf of Aden, Ethiopia, Tonkin, Laos, and Bangkok in 1892, after which he organized another exhibition of his collections and photographs. In 1894 he traveled to Madagascar and Indochina, and explored the Red and Mekong Rivers, and the sources of the Irrawaddy and Brahmaputra Rivers. He received the gold medal of the Société de Géographie for the second time and the Legion of Honor in recognition of his work on this expedition. Orléans made two trips to Africa between 1896 and 1900. On his last journey to Annam in 1901 he became ill and subsequently died in Saigon.

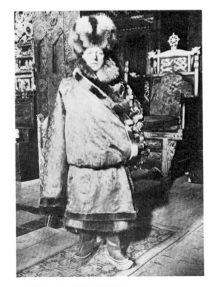

JOSEPH FRANCIS CHARLES ROCK
(American, 1884–1962)

Born in Austria, Joseph Rock became a naturalized American citizen in 1913. Little is known of his youth, although

he was probably largely self-educated in the subjects of his expertise—botany, biology, and Chinese. From 1908 to 1911 he worked for the Hawaiian Board of Agriculture and Forestry as a botanist. He taught at the University of Hawaii from 1911 to 1919 and became professor of systematic botany in 1919. In 1920 he left academic life to accept a position as agricultural explorer for the Office of Foreign Seed and Plant Introduction of the United States Department of Agriculture.

His first expedition for the USDA took him to India and Burma on a successful search for the kalaw tree, whose fruit produced an oil used in the treatment of leprosy. He traveled for the next thirty years, mainly in western China, eventually settling in Yunnan, a province on China's border with Tibet. A prolific and exhaustive collector, Rock is credited with gathering more plant specimens from western China than any other botanist.

He led many expeditions into western China and Tibet in the 1920s and 1930s for American natural-history institutions, particularly for the Arnold Arboretum of Harvard University and the National Geographic Society. Articles written and illustrated by Rock about his explorations appeared regularly in *National Geographic Magazine.* Rock had a flair for adventure to which the titles of his articles bear witness: for instance, "Experiences of a Lone Geographer: An American Agricultural Explorer Makes His Way Through Brigand-Infested Central China en Route to the Amne Machin Range, Tibet."

Rock was an avid student of the history and culture of the areas in which he lived and traveled, and he published a number of scholarly monographs on indigenous religions, languages, and literature, as well as on botanical subjects. He lived with the Golok tribe of the Amne Machin region, the northeasternmost extension of ethnographic Tibet. In 1956 he published his monographic study, *The Amnye Ma-chhen Range and Adjacent Regions,* which is illustrated with eighty-two of his photographs of tribesmen, pilgrims, monasteries, mountain ranges, and river valleys of the region.

Rock left his home in Yunnan after China fell to the Communists in 1949.

GEORGE N. ROERICH
(Russian, 1902–1961)

George Roerich was one of Russia's greatest orientalists. He studied Asian languages at London University, Har-

vard University, the School of Oriental Languages, Paris, and the Collège de France. He spoke twenty-seven Asian and European languages, including several Tibetan dialects, and compiled the first Tibetan-Russian-English-Sanskrit dictionary.

In 1923 he joined his father, the well-known painter Nicholas Roerich, on a five-year expedition to central Asia, which he describes in *Trails to Inmost Asia* (1931). The expedition set out from Darjeeling, crossed Sikkim, then moved northwest toward Kashmir and Ladakh and on to Chinese Turkestan (Sinkiang) and Mongolia. Their route took father and son over much of the terrain traversed by Sven Hedin (*see under* Sven Anders Hedin), including the Takla Makan, the vastest completely dry desert in the world.

In 1927 the members of the expedition crossed the northern Tibetan plateau but were detained short of Nagchu, spending five winter months in bitter cold and snow before being allowed to proceed southward. They then crossed the central lake region and the Transhimalayan range, making no attempt to reach Lhasa.

While his father executed nearly five hundred paintings during the expedition, George Roerich, together with a group of scientists, collected information on the dialects, folklore, history, and religion of Tibet. Roerich received permission to spend time at a Bon monastery, and he brought back a complete three-hundred-volume set of the sacred texts of the Bon. He also photographed and made studies of the nomadic tribes encountered and of ancient megalithic monuments, which he discovered to be remarkably similar to the Carnac stones in Brittany.

On his return to India in 1928, Nicholas Roerich established the Urusvati Institute for Himalayan studies in the Kulu Valley. George Roerich, as director, began compiling his research and publishing monographs on Tibetan languages and culture, including his translation of the *Blue Annals,* an important fifteenth-century text on the sacred history of Tibet. In 1940 the onset of war forced the Roerichs to close Urusvati, but George Roerich continued to live there until his father died in 1947, when he moved to Kalimpong. In 1957 he returned to Moscow and pursued his scientific research at the Oriental Institute of the U.S.S.R. Academy of Sciences.

DR. ALBERT L. SHELTON
(American, 1875–1922)

A dedicated medical missionary for the Disciples of Christ Church, Albert Shelton was one of a handful of Protestant missionaries from America who ministered to the Tibetan people. The Foreign Christian Missionary Society sent him to China in 1903 from his home in Indiana. His first mission hospital was in Tatsienlu (Dartsedno) near the province of Kham, a border area largely inhabited by Tibetans. In 1908 the mission moved into Kham to the town of Batang. Except for the years from 1910 to 1913, when he returned to the United States, Shelton lived in Batang until 1919 with his wife, Flora, and their two daughters, both born in China. He was joined in his missionary work by the Reverend Roderick A. MacLeod, who remained in Batang from 1917 to 1927.

The Sheltons collected Tibetan "curios": paintings, books, domestic objects, and the like. In 1911, their collection was displayed at the Newark Museum and was subsequently purchased for the museum. When Shelton returned to Batang in 1913, he accepted a commission to continue collecting for the Newark Museum.

In 1919 the Sheltons were leaving Batang for the United States when their caravan was attacked by Chinese robbers. Dr. Shelton was taken hostage and held for seventy-one days. He was finally released upon payment of a ransom by the American legation to Peking. Travelers through the border provinces of China and Tibet were often set upon by bandits, and Shelton's experience in 1919 was but a presentiment of the future.

In 1922 he returned to Batang alone. His dream was to start a mission hospital in Lhasa. On February 15 he set

out, but received a warning from the Governor of Mar Kham that the area was especially dangerous for travelers. Tragically, on his way back to Batang the following day, Shelton was attacked and killed by bandits.

Shelton was the author of *Pioneering in Tibet: A Personal Record of Life and Experience in Mission Fields* (1921) and his wife wrote several books about her husband and their life in Tibet.

MAJOR GEORGE SHERRIFF
(Scottish, 1898–1967)

George Sherriff, professional soldier and naturalist, was educated at Sedburgh and the Royal Military Academy at Woolwich. In 1918 he received his commission in the Royal Garrison Artillery and led a command briefly in World War I. From 1928 to 1932, he served as British vice consul and consul general in Kashgar, Chinese Turkestan (Sinkiang).

While in Kashgar, Sherriff met Frank Ludlow, naturalist and headmaster of the first British school in Gyantse, Tibet, for the children of aristocratic and middle-class Tibetan families. Sherriff and Ludlow discovered a mutual passion for plant collecting and the Himalayan region.

Between 1933 and 1949 they undertook seven expeditions in southeastern Tibet and Bhutan, collecting over 6,000 plants, including rare examples of rhododendron, *meconopsis* (poppy), and primula. They also obtained several thousand bird skins, often making their kills secretly by catapult in areas where the taking of any form of life was banned by the Tibetans, in keeping with the tenets of their Buddhist faith. In 1938, accompanied by Sir George Taylor (*see under* Sir George Taylor), they made their most ambitious and comprehensive ten-month ex-

pedition within the Tsangpo drainage area. One result of this exploration was the first dispatch of living plants from Tibet to Britain by air. The photographs in this book by Sherriff and Taylor were all made during the 1938 trip.

During World War II, Sherriff commanded Indian troops in Assam and was posted to Gangtok, Sikkim, to organize the Tibetan wool trade. He served as British resident in Lhasa from 1943 to 1945. An accomplished photographer and technician, Sherriff made color films of life in Lhasa and of public religious ceremonies. He was a member of the Royal Photographic Society.

LIEUTENANT-COLONEL FREDERICK SPENCER-CHAPMAN
(English, 1907–1971)

Frederick Spencer-Chapman led a varied and adventuresome life as a soldier, mountaineer, and photographer, among many other pursuits. He was educated at Sedburgh and Saint John's College, Cambridge. He joined the British Arctic Air Route Expedition to Greenland (1930–31) and the Pan-American Arctic Airways Expedition to Greenland (1931–32). He was a member of the Marco Pallis Himalayan Expedition (1935), and in 1937, made the first ascent of Jomo Lhari (24,000 feet) on the Bhutan-Tibet border.

During World War II, he trained commando troops in Scotland, Australia, and Singapore. From 1942 to 1945, he lived behind enemy lines in charge of stay-behind parties in the Malayan jungle, about which he wrote in his best-known book, *The Jungle is Neutral* (1948). He served as first organizing secretary of Outward Bound Trust, and in various academic posts.

His experience in Tibet came about while serving as

private secretary to Sir Basil Gould, the British political officer in Sikkim. In 1936 and 1937, at the request of the Tibetan regent, Gould led a diplomatic mission to Lhasa, on which Spencer-Chapman served as educational advisor and photographer. The mission's purpose was to mediate in the complex negotiations for the return of the sixth Panchen Lama to Tibet from China, and to be prepared to serve as his escort from the Chinese border if necessary. (After a fourteen-year, self-imposed exile, the Panchen Lama, second only to the Dalai Lama, died in China in December, 1937.)

Spencer-Chapman, a keen observer, describes the daily life of the five-month-long mission in *Lhasa, the Holy City* (1927). While in Tibet, he pursued his interests in cinematography, photography, surveying, and nature studies.

SIR GEORGE TAYLOR
(Scottish, 1904–)

One of Britain's leading botanists, Sir George Taylor was educated at George Heriot's School, Edinburgh, and at Edinburgh University. In 1928 he was appointed to the botany department of The British Museum (Natural History) and served as deputy keeper and keeper from 1945 to 1956. From 1956 to 1971 he was director of the Royal Botanic Gardens, London. At present he is director of the Stanley Smith Horticultural Trust, East Lothian, Scotland.

His work in the field was carried out primarily in Africa and Tibet. In 1927–28 he was a member of the Botanical Expedition to South Africa and Rhodesia, and in 1934–35 he was joint leader of The British Museum expedition to Mount Ruwenzori and the mountains of East Africa.

In 1938, Taylor took a leave of absence from The British Museum to join George Sherriff (*see under* Major George Sherriff) and Frank Ludlow on their plant-gathering expedition along the Tsangpo from Chaksam to the gorge of the Tsangpo. As an expert on the *meconopsis* poppy, Taylor made many discoveries that added to the great success of the expedition. He published an account of their findings in the *Journal of the Royal Horticultural Society* (1947). His historical introduction to *A Quest of Flowers* by Harold R. Fletcher gives an account of plant exploration in eastern Tibet and the circumstances of Sherriff and Ludlow's collaboration.

Taylor is an honored member of the most prestigious British botanical and scientific societies, in which he has also held office, including the Linnean Society, the Royal Horticultural Society, the National Trust, the Royal Geographical Society, the British Association for the Advancement of Science, and the Botanical Society of the British Isles. He has received high awards from many international, European, and American scientific societies.

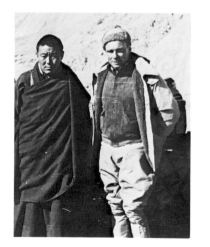

LIEUTENANT COLONEL ILYA TOLSTOY
(American, 1903–1970)

Born in Russia, Ilya Tolstoy was a grandson of the world-famous author Leo Tolstoy. He served with the Russian Army in World War I and fought with the White Russian cavalry during the Revolution, before emigrating to the United States.

Tolstoy was educated at the Moscow School of Agriculture. He studied agronomy and animal husbandry at William Penn College, Oskaloosa, Kansas, and Iowa State University. In 1931–32 he worked for the United States Department of the Interior on the development of McKinley National Park in Alaska.

During World War II, as an officer in the Office of Strategic Services (OSS), the army intelligence unit that was the prototype for the CIA, Tolstoy was asked to lead a diplomatic mission to Tibet on behalf of President Franklin D. Roosevelt. The purpose of the mission was twofold: to negotiate with the Tibetans for permission to transport military supplies through Tibet into China, and to assess a prospective route from Darjeeling to Lanchow.

The Japanese had closed the Burma Road. The proposed Tibet land route followed ancient caravan trails and was seen as a viable alternative to flying heavy cargo planes at high altitude over the largely uncharted Himalayan range. It turned out, however, that the Tibetans were unwilling to be part of any agreement involving commitments to China.

Together with Captain Brooke Dolan (*see under* Captain Brooke Dolan II), Tolstoy started out from Darjeeling in October 1942 and traveled through Sikkim to Gyantse, Tibet, where they waited for a month while Dolan recovered from pneumonia. They then proceeded to Lhasa by way of Samding monastery, the abode of the six-year-old incarnate goddess Dorje Phakmo, whom they met. On December 20, they were received by the eight-year-old fourteenth Dalai Lama and his regent, to whom they presented a photograph of Franklin D. Roosevelt. Tolstoy and Dolan spent several months in Lhasa as the guests of the British resident Frank Ludlow. The Tibetans granted them permission to proceed onward to Jyekundo, and after a brutal three-month journey through western China, they reached Lanchow. Tolstoy received the Legion of Merit for his part in the mission and wrote about their travels in an article illustrated with their photographs, "Across Tibet from India to China," in *National Geographic Magazine* (August 1946).

Over the years, Tolstoy kept up a correspondence with the fourteenth Dalai Lama, and through the Tolstoy Foundation, an organization that aids Russian emigrants, he was helpful in assisting Tibetan refugees who fled Tibet after the Chinese invasion. He helped establish the Tibetan Foundation in the United States.

After the war, Tolstoy returned to his career as an ichthyologist and became director and general manager of Marineland Oceanarium in Florida.

G. TS. TSYBIKOFF
(Russian, dates unknown)

A Buryat Mongol and Russian subject, G. Ts. Tsybikoff was a follower of the Gelukpa order of Tibetan Buddhism. He was educated in Russia. In 1900 he journeyed openly as a pilgrim to Lhasa with a group of seventy lamas from Mongolia and Amdo. His intention in making the pilgrimage was not entirely devotional: he studied and made notes on the Tibetan structure of government, its national character, standard of living, social and economic structure, educational facilities, trade, and climate, etc. His findings were published in 1903 in the journal of the Imperial Russian Geographical Society in an article illustrated with his photographs.

Tsybikoff stayed in Lhasa for more than a year. He traveled also to Tsetang, Shigatse, Samye, Gyantse, Sera, Brebung, Galdan, and Tashilhunpo. Previously, he had stayed at the Labrang and Kumbum monasteries in Amdo. While in Lhasa, he collected more than three hundred ancient and modern books by Tibet's learned lamas on philology, medicine, astronomy, astrology, history, and geography. This collection also included books of *kurim* (chants, incantations, and other forms of worship).

LIEUTENANT COLONEL JAMES LESLIE R(OSE) WEIR
(English, 1883–1950)

Born in India, Leslie Weir was educated in England and Scotland, attending the Royal Military Academy at Woolich. He joined the British Indian Army in 1904. Five years later, he entered the Indian Foreign and Political Service, and was appointed trade agent at Gyantse and special duty officer in Sikkim, serving in both posts simultaneously from 1909 until 1915. Weir became political officer in Sikkim in 1928.

As a result of his asking the Indian government's help in solving a border problem, the thirteenth Dalai Lama invited Weir to travel to Lhasa in 1930 to discuss encroachments along Tibet's eastern border with China by a Szechuanese warlord, Liu Wen-hai. Weir's wife was asked to accompany her husband, becoming the first European woman ever invited to Lhasa. They remained in Lhasa for two months. In 1932, they returned to Lhasa concerning the same business, this time accompanied by their nineteen-year-old daughter. Shortly thereafter civil war broke out in Szechuan, which brought about a ceasefire with Tibet. and in 1933 an armistice was concluded.

During his career in the Foreign Service, Weir served, among other places, in Persia, Kashmir, and Kenya, where he died in 1950.

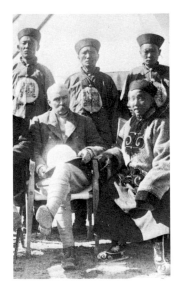

J(OHN) CLAUDE WHITE
(English, 1853–1918)

J. Claude White lived for twenty-one years in the Himalayan region. Trained as an engineer, he was appointed to the Public Works Department of the government of India in 1877. He was promoted to the post of political officer in charge of the administration of Sikkim in 1889 and of Bhutan in 1905. Upon retirement he published *Sikkim and Bhutan,* an account of his political career. His photographic albums, *Sikkim* (1902) and *Tibet and Lhasa* (1908), were published by Johnston and Hoffmann, Calcutta, in both carbon and bromide print editions. These albums, which contain some of the most sublime and otherworldly images of Tibet and the Himalayan landscape, were oddly enough compiled as official documents of two armed British missions by a man who was disdainful of the Tibetans and their way of life and exasperated by their refusal to take part in what Rudyard Kipling called "The Great Game"—British and Russian imperialism in Asia.

In the early 1900s, when White served as political officer in Sikkim, the British saw Tibet primarily as a buffer zone protecting the Indian border from Russian expansion into central Aisa. They were also interested in reciprocal trade rights with Tibet and had for many years negotiated boundaries and trade rights with the Chinese government. The Tibetans, who considered themselves autonomous and not bound by any agreements made by China on their behalf, frequently infringed negotiated boundaries and grazing rights. In 1888 White went as assistant political officer with an expeditionary force sent to settle a Tibet-Sikkim border war, and in 1902 he led the Sikkim-Tibet Commission Boundary Escort to enforce land rights under the 1890 Anglo-Chinese Convention and to reset border markers allegedly destroyed by the Tibetans.

The border problems between Tibet and the government of India were on the whole a minor irritation to the British, who were much more concerned with Russia's influence in Tibet. Rumors of a secret treaty between Russia and Tibet, exchanging China's interest in Tibet in return for a promise of no further expansion into Chinese territory, reached Lord George Curzon, viceroy of India, in 1902. This fueled the flames of an already volatile situation. For some time, the British had been hearing about the Russian Dorjieff, a Buryat Mongol and Buddhist lama who was an intimate and tutor of the Dalai Lama, suspected by the British as a political emissary between the Dalai Lama and the czar. Dorjieff apparently convinced the Dalai Lama that Nicholas II was interested in converting to Buddhism, but many Tibetans in the National Assembly were unhappy about Dorjieff's (indeed any outsider's) influence in Tibetan affairs.

In 1903 Curzon felt that the time had come for the British to force their way into Tibet, open direct communications with the Tibetan government, and establish a British representative in Lhasa. The inability of the Chinese to govern the Tibetans was acknowledged. With the concurrence of the Home Government, Curzon selected Colonel Francis Younghusband, with J. Claude White as second in command, to lead the Tibet Frontier Commission, as the mission was called. Brigadier-General J.R.L. Macdonald led the military escort of 3,000 British and Indian troops, and a supply caravan of mules, yaks, ponies, buffalo, camels, and 10,000 coolies into Tibet in midwinter at altitudes over 13,000 feet.

The first stage of the mission, initially led by White in July 1903, advanced across the Kangra La to Kampa Dzong. There they waited five months for someone with authority to arrive. The highest official to meet them was the abbot of Tashilhunpo, but he could not negotiate on behalf of the Dalai Lama. The expedition regrouped in Sikkim and again passed into Tibet in January 1904, this time intending to go all the way to Lhasa if necessary. The Tibetans repeatedly requested the British to turn back and refused to send delegated negotiators to meet them. The Tibetans offered slight armed resistance with weaponry that was no match for the modern British equipment and suffered about 1,000 casualties.

By the time the force reached Lhasa, the Dalai Lama had fled to Outer Mongolia, leaving the regent, Tri Rinpoche, and representatives of the three greatest monasteries and the National Assembly to deal with Younghusband. After seven weeks in Lhasa the British left with a signed Anglo-Tibetan Convention agreeing to boundaries, trade rights, and an indemnity. The Home Government, then working on detente with Russia, would not sanction a British representative in Lhasa as part of the agreement. After the British left, Lhasa was again closed to Westerners.

DR. ALEXANDER F. R. WOLLASTON
(English, –1930)

A fellow and honorary secretary of the Royal Geographical Society, Alexander Wollaston served as medical officer on many expeditions. In 1906 he went on the British Museum expedition to Mount Ruwenzori, and traveled to New Guinea and Tibet on behalf of the Royal Geographical Society. He was medical officer and naturalist for the 1921 Everest expedition (*see under* Captain John Noel). A fellow and tutor of King's College, Cambridge, he met an untimely death in 1930, when he was shot by a student.

ALEXANDRA DAVID-NÉEL Khampa wearing typical local dress, including fox fur hat, eastern Tibet, 1923–24

BIBLIOGRAPHY

Aitchison, Charles. *A Collection of Treaties, Engagements, and Sanads.* 3rd. ed., rev. 13 vol. Calcutta: Superintendent Government Printing, 1892–1909.

Aoki, Bunkyo. *Study on Early Tibetan Chronicles.* Tokyo: Japanese Society for the Promotion of Science, 1955.

Bell, Sir Charles Alfred. *The People of Tibet.* Oxford: Clarendon Press, 1928.

———. *Portrait of the Dalai Lama.* London: Collins, 1946.

———. *The Religion of Tibet.* Oxford: Clarendon Press, 1931.

———. *Tibet, Past and Present.* Oxford: Clarendon Press, 1968.

Blofeld, John. *The Tantric Mysticism of Tibet: A Practical Guide.* New York: E. P. Dutton, 1970.

Bonvalot, Gabriel. *Across Tibet.* Translated by C. B. Pitman. New York: Cassell, 1892.

Burang (Theodore Illion). *The Tibetan Art of Healing.* London: Robinson and Watkins, 1974.

Bu-ston. *History of Buddhism.* Translated by Y. Obermiller. Heidelberg: O. Harrassowitz, 1931–32.

Cammann, Schuyler. *Trade through the Himalayas.* Princeton, New Jersey: Princeton University Press, 1951.

Chang, Garma C. C., trans. *The Hundred Thousand Songs of Milarepa.* Boulder, Colorado, and London: Shambhala Publications, 1977.

Cutting, C. Suydam. *The Fire Ox and Other Years.* New York: Charles Scribner's Sons, 1947.

Dalai Lama (fourteenth). *My Land and My People.* New York: Potala Corporation, 1977.

———. *The Opening of the Wisdom Eye and the History of the Advancement of Buddhadharma in Tibet.* Wheaton, Illinois: Theosophical Publishing House, 1972.

Das, Sarat Chandra. *Contributions on the Religion and History of Tibet.* New Delhi: Manjusri Publishing House, 1970.

———. *Journey to Lhasa and Central Tibet.* Edited by William W. Rockhill. New Delhi: Manjusri Publishing House, 1970. Originally published London: John Murray, 1902.

David-Néel, Alexandra. *Initiations and Initiates in Tibet.* Translated by Fred Rothwell. Berkeley, California: Shambhala Publications, 1970. Original French edition published Paris, 1930.

———. *Magic and Mystery in Tibet.* New York: Dover Publications, 1971. Original French edition published Paris: Plon, 1929.

Dawa Norbu. *Red Star over Tibet.* London: Collins, 1974.

Disalkar, D. B., "Bogle's Embassy to Tibet." Calcutta: *The Indian Historical Quarterly* 9 (1933).

Downs, Hugh R. *Rhythms of a Himalayan Village.* San Francisco: Harper and Row, 1980.

Evans-Wentz, W. Y., ed. *The Tibetan Book of the Great Liberation.* Commentary by C. G. Jung. London, Oxford, and New York: Oxford University Press, 1972.

———. *Tibetan Yoga and Secret Doctrines.* London, Oxford, and New York: Oxford University Press, 1970.

Fisher, W. H. *To Light a Candle.* London, 1962.

Forest, George W. *Selections from the Letters, Despatches, and Other State Papers Preserved in the Foreign Department of the Government of India, 1772–1785.* 3 vols. Calcutta, 1890.

Francke, August Hermann. *Antiquities of Indian Tibet.* 2 vols. New Delhi: S. Chand, 1972.

———. *A History of Ladakh.* New Delhi: Sterling, about 1977. Reprint of *A History of Western Tibet.* London: S. W. Partridge and Company, 1907.

Getty, A. *The Gods of Northern Buddhism.* Oxford: Clarendon Press, 1928.

Gordon, Antionette K. *The Iconography of Tibetan Lamaism.* 2d. ed. Tokyo and Rutland, Vermont: C. E. Tuttle Company, 1959.

Govinda, Anagarika. *Foundations of Tibetan Mysticism.* New York: Samuel Webster, 1974.

———. *Psycho-Cosmic Symbolism of the Buddhist Stupa.* Emeryville, California: Dharma Publishing, 1976.

———. *The Psychological Attitude of Early Buddhist Philosophy.* London: Rider and Company, 1961.

———. *The Way of the White Clouds.* Berkeley, California: Shambhala Publications, 1970.

Guenther, Herbert V. *Treasures on the Tibetan Middle Way.* Berkeley, California: Shambhala Publications, 1971.

Guenther, Herbert V., and Kawamura, Leslie. *Mind in Buddhist Psychology.* Emeryville, California: Dharma Publishing, 1975.

gZi-brjid. *Nine Ways of Bon.* Edited and translated by David L. Snellgrove. London and New York: Oxford University Press, 1967.

Haas, Ernst, and Minke, Gisela. *Himalayan Pilgrimage.* New York: Viking Press, 1978.

Harrer, Heinrich. *Seven Years in Tibet.* Translated by Richard Graves. New York: E. P. Dutton and Company, 1954.

Hedin, Sven. *Sven Hedin as Artist.* Translated by Donald Burton. Stockholm: Statens Etnografiska Museum, 1964. English revision of *En Lernads Teckning (Sketches of a Lifetime).* Stockholm: 1920.

International Commission of Jurists. *Tibet and the Chinese People's Republic.* Delhi: Sterling Publishers, 1966.

Kawaguchi, Ekai. *Three Years in Tibet.* Benares and London: Theosophical Publishing Society, 1909.

Kvaerne, Per. *A Norwegian Traveller in Tibet: Theo Sörensen and the Tibetan Collection at the Oslo University Library.* Bibliotheca Himalayica, series 1, vol. 13, edited by H. K. Kuloy. New Delhi: Manjusri Publishing House, 1973.

Landon, Perceval. *Lhasa: An Account of the Country and People of Central Tibet.* Delhi: Kailash, 1978. Reprint of *The Opening of Tibet.* New York: Doubleday, Page and Company, 1905.

Lati, Rinbochay, and Napper, Elizabeth. *Mind in Tibetan Buddhism.* New York: Gabriel/Snow Lion, 1980.

Lauf, Detlef Ingo. *Tibetan Sacred Art: The Heritage of Tantra.* Berkeley, California, and London: Shambhala Publications, Inc., 1976.

Lhalungpa, Lobsang P. "Buddhism in Tibet." In *The Path of the Buddha,* edited by K. W. Morgan, New York: The Ronald Press Company, 1956.

———. "The Interdependence of Contemplation and Action in Tibetan Buddhism." In *Contemplation and Action in World Religions,* edited by Y. I. and I. Marculescu. Houston: Rothko Chapel, 1977.

———. *The Life of Milarepa.* New York: E. P. Dutton, 1977.

———. *Mystic Circle.* Catalogue of the Burnaby Art Gallery, Burnaby and Vancouver, British Columbia, 1973.

———. "The Religious Culture of Tibet." Dharamsala, India: *The Tibet Journal* 1 (1976).

———. "Tibetan Buddhism: The Way of Inward Discovery."

In *Sacred Tradition and Present Need,* edited by J. Needleman and D. Lewis. New York: Viking Press, 1975.

——."Tibetan Music: Sacred and Secular." In *Studies in Comparative Religion.* Bedfont, England: Tomorrow Publications, 1969.

Lhamo, Rinchen. *We Tibetans.* London, 1926.

London. India Office Library. MSS-EUR-E-226, Vol. 53. Bogle Papers.

Ludwig, Ernest. *The Visit of the Teshoo Lama to Peking.* Peking, 1904.

MacGregor, John. *Tibet—A Chronicle of Exploration.* London: Routledge and Kegan Paul, 1970.

Markham, Sir Clements R., ed. *Narratives of the Mission of George Bogle to Tibet and the Journey of Thomas Manning to Lhasa.* 2nd ed. New Delhi: Manjusri Publishing House, 1971. Originally published London: 1879.

Michael, Franz, and Lhalungpa, Lobsang P. *Rule by Incarnation: Tibetan Buddhism and Its Impact on Society and State.* Boulder, Colorado: Westview Press, 1982.

Nebesky-Wojkowitz, R. *Oracles and Demons of Tibet.* The Hague: Mouton, 1956.

Noel, John. *The Story of Everest.* Boston: Little, Brown and Company, 1927.

Norbu, Thubten Jigme. *Tibet.* New York: Simon and Schuster, 1968.

Pallis, Marco. *Peaks and Lamas.* New York: Alfred A. Knopf, 1949.

"Papers Relating to Tibet." From *Blue Book I.* London, 1904.

Petech, L. *China and Tibet in the Early 18th Century: History of the Establishment of a Chinese Protectorate in Tibet.* 2nd ed. rev. Leyden: Brill, 1972.

Princep, Henry T. *Tibet, Tartary and Mongolia.* London: W. H. Allen, 1851.

Prjevalsky, Nikolai Mikhailovich. *Mongolia, the Tangut Country and the Solitudes of Northern Tibet.* Translated by E. D. Morgan. London: S. Low Marston, Searle and Ribington, 1876.

Rato, Khyongla Mawang Losang. *My Life and Lives: The Story of a Tibetan Incarnation.* New York: E. P. Dutton and Company, 1977.

Richardson, Hugh E. *A Short History of Tibet.* New York: E. P. Dutton, 1962.

——. *Tibet and Its History.* London: Oxford University Press, 1962.

Rockhill, William Woodville. *The Dalai Lamas of Lhasa and Their Relations with the Manchu Emperors of China, 1644–1908.* Leyden: Oriental Printing Office, 1910.

Roerich, George N. *Trails to Inmost Asia.* New Haven: Yale University Press, 1931.

Sandberg, Graham. *The Exploration of Tibet: History and Particulars.* Delhi: Cosmo Publications, 1973. Originally published Calcutta: Thacker Spink and Company, 1904.

Sen, Chanakya, ed. *Tibet Disappears.* London: Asia Publishing House, 1960.

sGam-po-pa (Gampopa). *The Jewel Ornament of Liberation.* Translated by Herbert V. Guenther. Berkeley, California: Shambhala Publications, 1971.

Shakabpa, W. D. *Tibet—a Political History.* New Haven: Yale University Press, 1967.

Sinha, Nirmal C. *How Chinese Was China's Tibet Region?* Calcutta: Firma K. L. Mukhopadhyay, 1981.

Snellgrove, David L. *Himalayan Pilgrimage.* Boulder, Colorado: Prajna Press, 1981.

Snellgrove, David L., and Richardson, Hugh. E. *A Cultural History of Tibet.* Boulder, Colorado: Prajna Press, 1968.

Spencer-Chapman, Frederick. *Lhasa, the Holy City.* New York and London: Harper and Brothers, 1939.

Stein, R. A. *Tibetan Civilization.* Stanford, California: Stanford University Press, 1972.

Taring, Rinchen Dolma. *Daughter of Tibet.* London: The Camelot Press, 1970.

Tolstoy, Ilya. "Across Tibet from India to China." *National Geographic* (August 1946).

Trungpa, Chögyam. *Born in Tibet.* As told to Esmé Cramer Roberts. Boulder, Colorado: Prajna Press, 1981.

——. *Cutting through Spiritual Materialism.* Berkeley, California: Shambhala Publications, 1973.

Trungpa, Chögyam, and Fremantle, F. *The Tibetan Book of the Dead.* Berkeley, California: Shambhala Publications, 1975.

Tsongkapa. *Tantra in Tibet.* Edited by J. Hopkins. London: George Allen and Unwin, 1977.

RODERICK A. MacLEOD Khampa bride, 1917–27

Tsybikoff, G. Ts. "Lhasa and Central Tibet." *Annual Report of the Smithsonian Institution* (1903).

——. *Tibet: Land of Snows.* Translated by J. E. Stapelton Driver. New York: Stein and Day, 1967.

Tucci, Giuseppe. *To Lhasa and Beyond.* Rome: Libraria dello Stato, 1956.

——. *Tibetan Painted Scrolls.* Rome: Libraria dello Stato, 1949.

Tucci, Giuseppe, and Ghersi, E. *Secrets of Tibet.* Translated by Mary A. Johnstone. London and Glasgow: Blackie and Son, 1935.

Tulka, Tarthang. *Gesture of Balance.* Emeryville, California: Dharma Publishing, 1977.

Tung, Rosemary Jones. *A Portrait of Lost Tibet.* New York: Holt, Rinehart and Winston, 1980.

Vostrikov, Andrei. *Indian Studies: Past and Present.* Calcutta, 1970.

White, John Claude. *Sikkim and Bhutan: Twenty-one Years on the North-East Frontier, 1887–1908.* New York: Longmans, Green and Company, 1909.

Woodman, Dorothy. *Himalayan Frontiers.* London: Barrie and Rockliff, 1969.

Acknowledgments

Great appreciation is extended to the following for making photographs available for use in this book and the exhibition and for services provided: Academy of Natural Sciences, Philadelphia; Alexandra David-Néel Foundation, Digne, France; The American Museum of Natural History, New York; Archives Nationales, Paris; Anthony Aris; Bibliothèque Nationale, Paris; India Office Library, London; Joan Mary Jehu; The P. W. Laden-La Collection; Musée de l'Homme, Paris; National Army Museum, London; Newark Museum; Philadelphia Museum of Art; Howard and Jane Ricketts Collection, London; Rose Art Museum, Brandeis University, Riverside Museum Collection, Waltham, Massachusetts; Royal Botanic Garden, Edinburgh; Royal Geographical Society, London; Saint-Louis Foundation, Paris; The Saland Family Collection; The Right Honorable The Viscount Scarsdale, Kedleston Hall, Derby, England; Société de Géographie, Paris; Faith Spencer-Chapman; Sven Hedin Foundation, Ethnographical Museum of Sweden, Stockholm; Sir George Taylor.

Special thanks are given to Diane Lyon for the initial research for the book and to Gisela Minke for her research and help in editing. Special thanks also are extended to the following for the information they provided: Kevin Donovan; Zara Fleming; Jon Goodman; Barbara Nagelsmith; Torgny Wärn; and to the following photographic printers: James B. Abbott, Philadelphia; A. C. Cooper, Ltd., London; Tom Jenkins, New York; Jean-Pierre Sudre, Lacoste, France.

Many thanks also to Valrae Reynolds, Curator of Oriental Collections, Newark Museum, for her support and special assistance, as well as the following individuals, who gave assistance on research and loans: Michael Aris; Françoise Borin; Cathleen Calmer, Rose Art Museum, Brandeis University, Waltham, Massachusetts; His Highness Chogyal Palden Thondup Namgyal; R.G.C. Desmond, Deputy Librarian, India Office and Records, London; Jacques Duval, Saint-Louis Foundation, Paris; Sina Fosdick, Executive Vice President, Nicholas Roerich Museum, New York; Suzanne d'Huart, Chief Curator, Archives Nationales, Paris; Maybe Jehu; Stella Kramrisch; Dolma Laden-La; Yvette Laplaze, Chief Photo Librarian, Musée de l'Homme, Paris; Rebecca Leuchak; N. Tenzin Lhalungpa; Roger Lipsey; Natalka Lucenko, Tibetan Desk, Tolstoy Foundation, New York; Sarah Ann McNear; Ann McPhail; Anne Murray, Curator of Documentation, Ethnographical Museum of Sweden, Stockholm; Thupten Norbu; John Noel; le Comte de Paris; Monique Pelletier, Chief Curator, Cartes et Plans, Bibliothèque Nationale, Paris; Marie-Madeleine Peyronnet, Director, Alexandra David-Néel Foundation, Digne, France; Sarah Dolan Price; Hugh E. Richardson; Pauline Rohatgi, India Office Library, London; Marjorie Sieger; Carol M. Spawn, Manuscripts-Archives Librarian, Academy of Natural Sciences, Philadelphia; Margaret Warhurst, Liverpool Museum.

Sources

TEXT

Details of the sources quoted are in the Bibliography.

David-Néel, *Initiations and Initiates in Tibet*: 112. Evans-Wentz, ed., *The Tibetan Book of the Great Liberation*: 64. Govinda, 1959, *Foundations of Tibetan Mysticism*: 44. Govinda, 1966, *The Way of the White Clouds*: 78, 122. Lobsang P. Lhalungpa, in conversation: 8. Lhamo, 1926, *We Tibetans*: 96, 130. Sven Hedin, 1920, *Sven Hedin as Artist*: 80. Richardson and Snellgrove, 1968, *A Cultural History of Tibet*: 129. Taring, 1970, *Daughter of Tibet*: 94. Tucci, 1967, *Tibet: Land of Snows*: 108. Tung, *A Portrait of Lost Tibet*: 56.

PHOTOGRAPHS AND ILLUSTRATIONS

Academy of Natural Sciences, Philadelphia—9, 30 bottom, 37 top, 51, 79, 100, 101, 107, 111. Academy of Natural Sciences, Philadelphia, copyright © Sarah Dolan Price: 70, 71, 104 bottom, 121, 144, 145. Alexandra David-Néel Foundation, Digne, France: 19, 23 top, 24–25, 32, 69, 72, 73, 76, 77, 94–97, 99, 110, 118, 156. The American Museum of Natural History, New York: 140, 141. Anonymous proprietor, photographs by Detlef Ingo Lauf: 30 top. Archives Nationales and Saint-Louis Foundation, Paris: 57–63. Bibliothèque Nationale and Société de Géographie, Paris: 53. India Office Library, courtesy of The Right Honorable The Viscount Scarsdale, Kedleston Hall, Derby, England: 23 bottom, 34–35, 37, 45–48, 114, 123, 126–129. Musée de l'Homme, Paris: 131, 139 right. Musée Royaux d'Art et Histoire, Brussels, photograph by Detlef Ingo Lauf: 22. National Army Museum, Paris: 124, 125. Collection of the Newark Museum: 39 bottom, 40–41, 108, 132, 159. Philadelphia Museum of Art: 26. Philadelphia Museum of Art, John T. Morris Fund: 27 top. Philadelphia Museum of Art, Stieglitz Restricted Fund and funds contributed by Harvey S. Shipley Miller, J. Randall Plummer, Ann and Donald W. McPhail, and the Atlantic Richfield Foundation: 55. Rose Art Museum, Brandeis University, Riverside Museum Collection, Waltham, Massachusetts: front dustjacket, 20, 138; Royal Botanic Garden, Edinburgh: 133, 143. Royal Geographical Society, London: 13, 135–137. Sven Hedin Foundation, Ethnographical Museum of Sweden, Stockholm, copyright © Voelkerkunde Museum of the University of Zurich, Switzerland: 14, 15, 81–93. Anthony Aris: back dustjacket. The Collection of Dr. Schuyler Cammann: 27 bottom. Joan Mary Jehu: 17, 33, 36, 38, 39 top, 65–68, 74, 75, 102, 106, 113, 119, 120, 142. The P. W. Laden-La Collection: 49, 98, 103. Howard and Jane Ricketts Collection, London: 139 left. The Saland Family Collection: 52, 54. Faith Spencer-Chapman: 21, 104 top left and right, 105, 109, 116, 134. Sir George Taylor: 2, 10–12, 16, 42–43, 50, 115, 117. Giuseppe Tucci Collection, photographs by Wim Swaan: 28–29, 31.

The Preface, by His Holiness the Dalai Lama, was translated into Tibetan and written in Tibetan script by Lobsang Lhalungpa: 6–7.